C000142181

The Record

By

Tim Darvell

To David and Gail

Thanks for your support.

Best Wishes

Tim

Tim Darvell was born in Taplow just across the River Thames from Maidenhead, where he grew up. He runs the family packaging materials business set up by his late father.

He lives in Reading, and his range of interests include photography, music, and sport.

To connect with Tim, join him at www.facebook.com/tim.darvell, Twitter @timdarv, or log onto www.rivers2cross.com to find out more.

ALSO BY TIM DARVELL:

Beating Bowel Cancer
Lives & Times

This book is for Mum, who was diagnosed with bowel cancer in 2012, and died in 2016. It is also for everyone who is living with this awful illness, and for all those people who are sadly no longer with us.

www.bowelcanceruk.org.uk

Table of Contents

Foreword

By Kelly Smith

You're probably thinking why is this young lady writing a foreword for a bowel cancer book? How has this impacted her life? This horrific disease that is the UK's second biggest cancer killer. This disgusting form of cancer that cruelly takes 16,000 lives every year in the UK. The cancer known as only common in the over-50s. I am writing this because I have it. I know others with it, or affected by it. And it has taken some of my friends' lives.

My life was turned upside down when I was given a stage 4 diagnosis at the age of 28. I set out to change the outlook on bowel cancer and to help others raising the roof on awareness. It was then I met Tim, a gentleman, a kind soul, who dedicates all his spare time to fundraising after sadly losing his mum to bowel cancer.

I was honoured when he asked me not only to be part of this book but to write the foreword. I won't lie – I have spent endless weeks thinking of the correct words for something so close to my heart. As the weeks grew into months, I discovered the unbelievably amazing people who feature in this book, and it really doesn't leave anything else other than for me to say this is real life, this is happening now. I think I can speak on behalf of everyone in this book when I say that this is all we want: for bowel cancer to become a real conversation. For it to be talked about, because talking is awareness, awareness leads to early diagnosis, and early diagnosis saves lives. So do go on to ask your loved ones if they have taken the free bowel cancer test available to everyone in the UK over the age of 50. If someone has symptoms, beg them to go to the doctor's no matter what their age, because – as you will find out in the book – bowel cancer doesn't care who you are, and you are #never2young.

Kelly Smith

4 March 2019

Letter from Susan George

Credited photograph copyright www.brianaris.com

Dear Tim,

I very much support what you are doing in memory of your lovely mother and to help raise awareness for Bowel Cancer. You got in touch to tell me how much she loved horses and wanted to visit me and my family of Arabians, a visit which we were planning but which very sadly wasn't to be. What better way to support this cause than your written words from the heart, and I wish you every success, for now and in future years. There is one very proud mum in God's garden.

SG

2 March 2019

I received this letter of support from the actress Susan George. Her husband, actor Simon MacCorkindale, died of bowel cancer in 2010, and she is now a patron of *Lasting Life: the Simon MacCorkindale Legacy*. My connection with Susan goes back to the time of my mother's illness, when she very kindly invited Mum to visit her Arabian horses on her farm in Exmoor. Unfortunately, Mum, who had a lifelong passion for horses, never got to make the trip as her health declined. Mum was still riding Shimara, her own Arabian horse, shortly before she went into hospital. Susan's support throughout has been greatly appreciated.

Preface

By Tim Darvell

The statistics say that one in two of us will get a cancer diagnosis during our lifetimes. These figures ring true in our family, as both my mum in 2012, and more recently my brother in 2018, were diagnosed with cancer. Mum lived with bowel cancer for four and a half years. She had the tumour from her bowel removed in 2012, followed by two operations on her lungs in early 2013. Mum was then in remission for 18 months, until the cancer came back on her left lung towards the end of 2014. She had her fourth operation at the beginning of 2015, and then another operation 12 months later when the lower lobe of her left lung was removed. During this time the cancer had also spread to her brain, so she had Cyberknife treatment on two lesions. Unfortunately this was unsuccessful, and she ended up in hospital paralysed down one side after a massive seizure. She was in hospital for over a month before moving to a nursing home, where she spent the last few weeks of her life. Mum died on 29 August 2016 one week after her 80th birthday. My brother Noel has been treated for Dermatofibrosarcoma Protuberans – a very rare form of skin cancer. He underwent surgery which successfully removed all the affected tissue, followed by some reconstructive surgery, which hopefully marks the end of his treatment.

Since I began fundraising in 2012 with my first book, *Beating Bowel Cancer,* I could never have predicted the path I would end up taking. I have met so many amazing people, and continue to do so – not just the ones that I have interviewed for this book, but also the people who continue to support my efforts to raise awareness of bowel cancer, and to raise funds for Bowel Cancer UK.

The importance of raising people's awareness of bowel cancer can't be emphasized enough. It is the fourth most common cancer in the UK, and second biggest cancer killer. Every year, around 42,000 people are diagnosed with bowel cancer, and 16,000 people will go on to die from it. If it's diagnosed at the earliest stage, almost everyone will survive the disease for five years or more. However, when diagnosed at the late stage 4, this

survival rate drops to around 7%. Only 15% of cases are currently detected at stage 1, so improving early diagnosis is vital to improving survival rates.

It is important to understand the symptoms of bowel cancer. In my mother's case it was a change in her bowel habit lasting more than three weeks. After a course of chemotherapy and radiotherapy to shrink the tumour, Mum underwent an operation to have the tumour removed. Bleeding from the bottom is a common symptom, which can be easily detected when you go to the toilet. There is still a stigma about this, but just by checking you really could save your life. Abdominal pain is another symptom of bowel cancer, as is a lump in your tummy. Weight loss and tiredness are the other symptoms. If you have these symptoms, make an appointment with your GP. In most cases the symptoms will result in some other treatable condition, but the earlier bowel cancer is detected the greater the person's survival chances are.

Scientists have estimated that about half of bowel cancer cases could be prevented through healthy lifestyle choices. These include stopping smoking, keeping your weight under control, cutting down on alcohol, exercising regularly, and eating healthily.

Unfortunately some people are more at risk of developing bowel cancer. People who have a strong family history of the disease, a history of polyps, or conditions such as type 2 diabetes or inflammatory bowel disease, are all at greater risk. Age-wise, the disease is usually associated with older people, but more than 2,500 people under 50 in the UK are diagnosed with it each year. With screening in the UK in place for over-60s (over-50s in Scotland, with England and Wales now committed to follow) it is very important for anyone worried about any of the symptoms to go to a GP. Sadly bowel cancer can go undetected, and there are still too many cases of misdiagnosis which ultimately can result in a correct diagnosis coming too late for some people.

In spite of the fact that five-year survival rates have doubled over the last forty years, and the additional fact that the survival rate is high as long as it is detected early, bowel cancer remains the second biggest cancer killer in the UK. Don't feel too embarrassed to seek advice from your GP if you are worried you might be experiencing any of the symptoms mentioned. Unfortunately, with this illness, the worst thing anyone can do is to brush it under the carpet hoping that it will go away. Bowel cancer doesn't discriminate…

Hopefully this introduction will give you a little more understanding of bowel cancer and its symptoms. There is a lot of information freely available. The charity I am supporting, Bowel Cancer UK, offers great support for anyone affected by bowel cancer, and has a lot of useful facts and information on understanding bowel cancer on its website, www.bowelcanceruk.org.uk.

Acknowledgements

There are many people without whose help this book could not have been written.

My family

My brother Noel, not just for being in the book, but for helping me with my dog, Prince, allowing me to go and meet many of the people featured here. My sister Ali, her husband Mike, and my niece Anna, who is growing up far too quickly. And also Mum and Dad, who are never too far away.

Friends

I am making more and more special friendships as a result of my fundraising, and my thanks goes to these people for their love and support. Special thanks to Michèle for her continued encouragement, and without whose help I wouldn't have been able to write this book.

The People

Kevin Sheedy, Eddie Gray, Christine Ohuruogu MBE, Carl Hester MBE, Anne Usher MBE, Jeanette Chippington MBE, Zac Purchase-Hill MBE, Rupert Moon, Kelly Smith, Deborah Alsina MBE, Gina and Esmée Shergold, Deborah Louise James, Steve Clark, Dilek Ercos, Deborah James, Dafydd Wyn Farr-Jones, Olivia Rowlands, Greg Gilbert and Stacey Heale, Richard and Sarah Haugh, Nicole Cooper, Gillian Wood, Susan George, Gaby Roslin, Nicola Bryant, Victoria Derbyshire, Jim Rosenthal, Nick Robinson, Bill Turnbull, Siân Lloyd, Matt Allwright, Gail Porter, Sean Fletcher, Jacquie Beltrao, David Baddiel, Lucy Porter, Basil Brush, Janet Ellis, Gregg Wallace, Colin Murray, Laura Boyd, Gareth Jones, Daniel Norcross, Natalie Germanos, Mike Selvey, Andrew White, Ian McMillan, Billy Ocean, Kim Wilde, Frank Turner, John Coghlan, Steve Norman and Sabrina Winter, Hazel O'Connor, Steve Hackett, Jules Peters, Steve "Smiley" Barnard, James Stevenson, Amy Macdonald, Jeremy Cunningham, Skinny Lister, Justin Sullivan, Rick Witter, Biff Byford, The Tearaways, and Ryan Hamilton.

Special Thanks to

Graham Lampen, for coming up with the title, and Greg Gilbert, who kindly allowed me to use his painting for the cover design.

The Editor

Joanna Rubery, who has done a wonderful job editing this book, and put in a huge amount of work in her own time. I can't thank her enough for making this possible.

People In The Background

In many instances I have received a significant amount of help from people who remain very much in the background, such as personal assistants, agents, managers, and staff. At times I have had to be persistent, but since so many of these people have pulled out the stops to make the meetings happen, I thank each and every one them. Many of them will be thankful that I am finally leaving them in peace!

The Ones That Got Away

During the course of writing this book, I have had a few close misses with people I'd wanted to take part, but who were sadly unable to. Sometimes it's just not meant to be, but I've enjoyed the challenge with all its highs and lows. I would like to thank everyone who took the time to consider and reply to my requests.

Introduction

Over the last couple of years since Mum died, I have been meeting a fascinating collection of people for *The Record*. Every single person taking part in this book has given up their own time to do it, and all proceeds raised from sales will be donated to Bowel Cancer UK (Beating Bowel Cancer Together), which is the UK's leading bowel cancer charity (www.bowelcanceruk.org.uk). It is a charity that is very close to my heart.

This book follows on from my previous book, *Lives & Times*, which was published in 2015. This time I decided to ask everyone about the first record that they bought, which keeps a common thread going through the book. I have met patients and families affected by bowel cancer who I have found to be truly inspirational, and who are a big part of the reason why I continue with my fundraising. Sadly, while I was writing this book, Deborah Louise James died of bowel cancer, not long after we met in 2017. Her chapter remains in the book, and is written in the present tense, as we both agreed it should be.

I have also been very fortunate to have received support from many celebrities, and these meetings have taken me on a whole new set of adventures. Over the course of two and a half years I have travelled all over Great Britain. I have been to sports stadiums, concert and theatre venues, major cities, and beautiful scenic locations. I met up with Olympic gold medallists, television and radio presenters, authors, comedians, musicians, and even a fox!

Every chapter is unique, and it was fascinating to see how they all unfolded. Some chapters came about very quickly, whilst some took over a year to come together. I have written about the experiences in an anecdotal style, but in this book what the interviewees themselves had to say is very much at the fore.

Mum's illness, and the fundraising that I have been doing since 2012, have changed me as a person. This book in particular has been hugely cathartic following Mum's death. I have made many new special friendships as a result, and the continued support that I have received from everyone has been amazing. The cancer community is very special, and I have found the people to be incredibly supportive. Patients often refer to it as the best club that no-one wants to join. Getting to become friends with just a few of these people has been one of the best things to have happened to me. I also have to mention the fans of my favourite band, The Alarm. Their support has been immense, and making so many enduring friendships as a result means everything to me.

Writing this book has been an experience like no other. Within its pages I do not shy away from the reality of cancer, especially bowel cancer. I am extremely proud of this piece of work, and I remain as passionate as ever about contributing what I can to support Bowel Cancer UK.

Kevin Sheedy

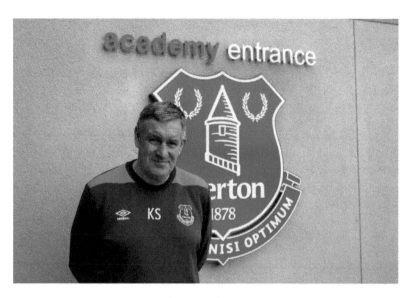

Kevin Sheedy, 3 February 2017

I met former Everton and Republic of Ireland footballer, Kevin Sheedy, at Everton's training ground in Halewood to the south of Liverpool on Merseyside. Kevin is a bowel cancer survivor, and is an Ambassador for the Beating Bowel Cancer charity.

I had never been to a Premier League training ground before, and I am not sure what the security staff thought of this man turning up in a transit van with an appointment to see Kevin Sheedy. I had managed to combine the trip with a work delivery of packaging materials, hence my manner of transport. The facilities were very impressive, a very long way from the muddy park pitches or dimly lit five-a-side courts that I used to train on in local football. How much would I have given just to kick a ball on one of the perfectly manicured training pitches! I waited in the reception area for a couple of minutes before Kevin appeared, having finished the morning training session. Kevin was in charge of the Everton Under-18 side at that time, with the aim of bringing youngsters through to the senior side. One such player who had recently broken through to the senior side was Tom Davies, who had scored his first professional goal in a 4-0 win over Manchester City.

Kevin told me that the first record that he bought was 'Rocket Man' by Elton John, which reached number 2 in the UK singles chart in 1972. We talked a little about his playing career. He won two league titles, an FA Cup and the European Cup Winners' Cup. He also represented the Republic of Ireland 46 times and scored their first-ever goal in the World Cup Finals at Italia 1990 against England in a 1-1 draw. He told me that the best player that he had ever played with was Neville Southall, Everton's legendary goalkeeper. More surprisingly, perhaps, was his choice of the best player who he played against. He told me that it was the Italian, Giuseppe Bergomi, who man-marked him in the 1990 World Cup Quarter, which the Italians won 1-0.

I have only been to Everton's Goodison Park stadium once, which was back in 1985 when I saw Arsenal beaten 2-0. Although Kevin was part of the Everton side that won the league

that season, he did not play in this match. I can vividly remember how impressive the ground was, with the high stands very close to the pitch making for a terrific atmosphere. I remember a late Andy Gray goal sealing an Everton victory, making for a long, miserable journey back to London for me and the rest of the Arsenal fans on the football special trains.

Kevin has completely recovered from bowel cancer, but still has regular check-ups. He told me that, although he is quite a private individual, he greatly values his work as an Ambassador for Beating Bowel Cancer. By talking about his cancer battle he has done a great deal to help raise awareness about bowel cancer. He said that he has been approached by people who, having heard his story, have got themselves checked out, and had bowel cancer detected and successfully treated at an early stage. The role that high-profile individuals like Kevin play in talking about bowel cancer is vital, as lives are being saved as a result. It was really nice meeting him, and an hour or so later, having done my delivery, my route rather fittingly took me past Goodison Park.

Since our meeting, Kevin has taken up a new coaching role at the Al-Shabab club in Saudi Arabia.

Eddie Gray

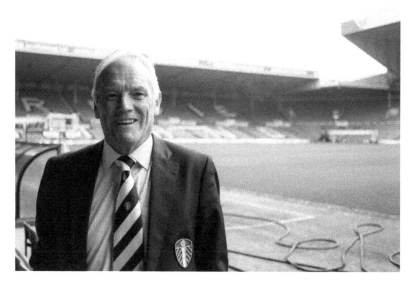

Eddie Gray, 3 March 2017

I met Eddie Gray, who was part of the legendary Leeds United team from the 1960s and 1970s, at Elland Road. He was a talented left-winger and renowned for tormenting defenders with his deft turns and changes in pace with the ball. Eddie played for Leeds throughout his whole career, from 1966 until his retirement in 1983 – playing for one club would be unheard of these days, in the modern era. He has managed the club twice, coached the Youth Team, and been Reserve Team Manager as well as Assistant First Team Manager. These days he is a Football Ambassador at the club and a co-commentator on LUTV, covering all Leeds matches home and away. We met up prior to Eddie travelling to Leeds's away match against Birmingham City that evening.

I actually saw Eddie play towards the end of his career. My brother drove me and my friend, Earle Avann, to watch Leeds play Arsenal at Elland Road in September 1981. It was my first experience of watching top-flight football, but unfortunately it was a very dull 0-0 draw. In fact the most memorable thing was the car being hit from behind on the way up on the motorway in roadworks, almost ending our trip before we had got there.

The rain was pouring as I met Eddie at the stadium, but we were able to go down next to the pitch to take some photos and stay dry under the cover of the West Stand. The stadium has a capacity approaching 40,000, and Leeds fans are notorious for creating an intimidating atmosphere for away teams. There was, however, something quite special about being there with not a soul in the ground apart from the two of us. It was nice to get a photo of Eddie with the famous Kop End in the background, which is now called the Revie Stand in memory of the team's late manager Don Revie.

Eddie told me that the first record he bought was 'Let's Dance' by Chris Montez in 1962, which got to number 2 in the singles chart. He also revealed that Elvis Presley is his great

favourite and he has virtually all of his records. One of his sons bought him a turntable a couple of years ago, so he is now enjoying listening to all his old vinyl records once again.

Eddie would certainly have benefitted from the stricter rules and protection that players get in today's game. Tackling from behind was part and parcel of the game back then, and he said that you had to expect to take a few whacks. Leeds lost the 1970 FA Cup Final 2-1 to Chelsea in a replay at Old Trafford after the first match had ended in a 2-2 draw at Wembley. In that first game Eddie had been named man of the match after giving Chelsea defender David Webb a torrid time. In the replay Chelsea put Ron "Chopper" Harris on him, and the uncompromising defender made sure Eddie's influence on the game was reduced by whatever means necessary. Eddie described how a few years later, Ron came up to him in the bar, after a golf day at St. Mellion, and asked Eddie if he could have his studs back!

When it came to answering the question of who was the best player that he played with, he said it was a tough choice between Billy Bremner and Jonny Giles. Jonny just won, as Eddie described him as a tactical genius, as well as a great footballer. Bremner, he said, was a more spontaneous player and a great inspirational character to have in your side. In fact Eddie went on to say that the team was full of great players. In Allan Clarke, Leeds had a striker as good as Eddie had ever seen. Under the management of Don Revie, Eddie said that they were taught to play to the best of their individual ability for the benefit of the side.

Eddie never got to play against the best footballers of his era, such as Pelé or Maradona, but he did say that the best British footballer he'd played against was Sir Bobby Charlton, and the best player he's ever seen live is Lionel Messi. The evening before our meeting, Eddie had been with Norman Hunter, another member of the Leeds side, and Eddie said that the greatest thing for him was to be in the dressing room before each match with the group of players they had, and thinking that there was no way that they could be beaten. This was not in any way arrogant. Eddie knew soon after joining the club, aged 15, that he was playing with a talented group of players, and the club was going places.

Don Revie was a manager who Eddie spoke very fondly about. He left the club after they won the League Title in 1974 to become manager of England. Eddie said that Revie's ambition was always to win the European Cup with Leeds, but the side was getting older, and he didn't want to have to break up the team. Eddie spoke about the four great signings Revie made as Leeds manager. The first was signing Bobby Collins from Everton, who captained the side, beginning the football revolution at Leeds, and who led them back into the First Division. Bobby's influence can't be understated. He was a winner, and ruthless at times with it. The other signings were Jonny Giles, Allan Clarke, and Mick Jones. Jonny Giles once told Eddie that one of the reasons he joined Leeds was knowing that Bobby Collins was there. The rest of the players who were to become part of the successful side came up through the ranks.

We spoke about Brian Clough's brief period at the club and the film depicting that time called *The Damned United*. Eddie said that he went to the film's premiere and enjoyed it. He also said that for some of the football action sequences they used his son Stuart's feet to play Eddie's feet to get some authenticity into those shots. He did say that film had a

lot of artistic licence… As far as Clough's short tenure as manager goes, Eddie said that maybe Brian might have done things differently, and in fact Brian himself said this to him many years later. Eddie thought that if Peter Taylor – Clough's right-hand man – had been with him, things might also have turned out differently. He said that for all the problems at Leeds, Brian Clough proved himself to be one of the greatest managers the game in England has ever had, with his success at Derby County and Nottingham Forest.

Eddie talked about his two spells as manager at the club. His biggest regret was coming back to the club as caretaker manager the season that the side was relegated from the Premiership in 2004. By the time he took over, the club was in dire straits, but being the man that he is, he still told me that he accepted full responsibility for the team being relegated. He enjoyed his first spell as manager from 1982 to 1985. During that period the club developed a lot of young players, and Eddie said that they were progressing and it was a shame he wasn't given a little more time. Eddie was to return to the club, eventually becoming assistant to manager David O'Leary. Once again Eddie said that it was a shame that this period wasn't allowed to go on longer with the great crop of young players they had developed. The club's financial dealings at the time, spending money that they didn't have, meant players had to be sold.

Eddie really enjoys his work these days for LUTV and getting to go to every Leeds game. He is such an enthusiastic man who still loves the game and, of course, Leeds United, with whom his association goes back over 50 years. As we parted ways Eddie and commentator Thom Kirwin were packing their equipment before heading off to the match against Birmingham City. Leeds won the match 3-1, which would have meant a happy late-night return to Yorkshire for Eddie and the team.

Christine Ohuruogu MBE

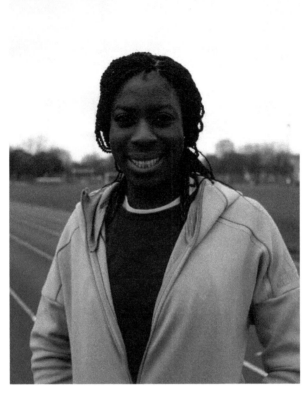

Christine Ohuruogu, 6 January 2018

Christine Ohuruogu is only the second British athlete in history to win medals at three consecutive Olympics. The 400m runner won gold in Beijing 2008, and then silver in London four years later. She also won a bronze medal in the 400m relay at Rio 2016. We met on a bitterly cold day at the Mile End Stadium in East London, which is located not far from the Olympic Stadium. I'd been in contact with Christine for a year or so, and it was a case of trying to find a convenient time to meet up, given her busy schedule. The first hurdle I encountered when I arrived was how to see Christine, as the guys on the entrance desk did not seem overly keen on allowing me inside the stadium with my camera. Thankfully Christine was able to sort things out, and we were able to go out onto the track to take some photos and have a chat.

I don't think Christine has bought many records, but her first record was a cassette single by the Spice Girls. It was the double A-side single of 'Mama' and 'Who Do You Think You Are', which was the group's fourth consecutive number 1 single when it was released in 1997. It was also the official *Comic Relief* single that year.

The amount of work and dedication Christine put into all of her track achievements meant she couldn't pick out a favourite medal from her career. The home games in London in 2012 was obviously pretty special, and Christine said that she would invariably come into

the tournaments as an outside medal hope, making her silver medal there very satisfying. She has also won Commonwealth gold, and was World Champion in 2007 and 2013.

Christine was getting used to her first full winter at home in many years. Usually she would spend part of the winter training in South Africa or Jamaica, but she's recently begun studying for a law degree at Queen Mary University in London, which she admitted would put even more pressure on her already busy schedule. Her ambition at the end of the two-year course is to become a barrister, but despite this, she couldn't see a time where she wouldn't still be out on the track running, even after her competitive athletics career comes to an end. She did say that she couldn't see herself working as a trainer in the future, as they can get a really hard time similar to that of a football manager. Although Christine has done some radio work, she said that, even when she wasn't competing, she preferred to be trackside with her teammates.

Christine told me that 2017 had not been a great year for her on the track, and so it was not surprising that she hadn't enjoyed it, which she said was not like her. She suffered a complete loss of form, and thought that one of the reasons for this was that she had perhaps over-trained, and had burnt herself out too early in the season. Such is her focus and intensity, Christine finds it hard to change and adapt her training methods over time. At our meeting Christine talked about retirement, and said that she didn't want to finish in such a disappointing way, so her desire was to continue competing and to finish on a more positive note as and when she felt that the time was right. Unfortunately a niggling injury restricted her training in the lead-up to the 2018 season, so she announced her retirement at the beginning of the British Championships.

We got to chat a little about bowel cancer. Christine wanted to know about my mother's illness, and a bit more about the disease. She hadn't realised that bowel cancer is the second biggest cancer killer in the UK. We talked about how treatable it is in the early stages, and how much more needs to be done increase awareness, and improve early detection rates.

Christine, by her own admission, loves to chat, so there was never a quiet moment during our time together. She has a great sense of humour, and a very infectious laugh. When I went to put my camera back into its bag after the photos, Christine gave me a humorous telling off, as I had left the case on the muddy ground, as opposed to on the dry and clean steps at the side of the track. It was a fantastic experience meeting one of Britain's true sporting legends. Christine was kind, extremely helpful, and a really lovely lady.

Carl Hester MBE

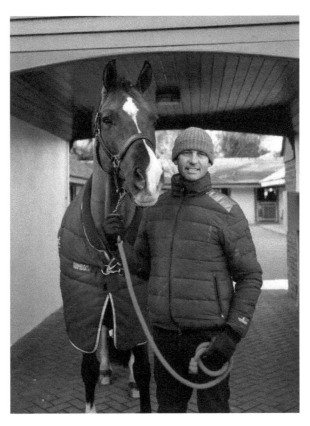

Carl Hester and Valegro, 1 December 2017

Equestrian rider Carl Hester MBE has competed at five Olympic Games, winning team gold in the dressage at London 2012, and team silver four years later in Rio. I was lucky enough to be invited to meet him at his stables in the stunning Gloucestershire countryside. It was quite the most beautiful setting. When I arrived Carl was doing some dressage coaching. It's not something that I know too much about, but I appreciated that what I was seeing was pretty special, and I thought how much my Mum would have enjoyed it. Carl told me that riding in competitions isn't particularly well paid, so the stables is a fully working outfit where he teaches and coaches. It took him 13 years to get the stables fully completed, since it had to be done in stages as finances permitted.

Carl's first record was 'Some Girls' by Racey, which reached number 2 in the UK singles chart in 1979. It's a song I can remember being all over the radio airwaves that year. Carl told me that when he arrived home after his recent 50th birthday party he was watching an old episode of *Top Of The Pops* on late-night television when the song came on, which was rather appropriate.

I was really pleased when Carl agreed to be in the book. Horses were my mother's passion all her life, and if she'd still been alive, nothing would have stopped her from coming. Throughout my time with Carl my thoughts would turn to Mum, and how much she would

have enjoyed meeting him. The other reason for asking Carl to appear in the book was that he'd had a scare with bowel cancer when he turned 40.

Carl has two of the most famous horses of recent times, Valegro and Uthopia, in livery at his yard. Valegro, who Carl has shared ownership of, was ridden by Charlotte Dujardin. Together, Carl and Charlotte are a triple gold-winning partnership, having taken home two golds in London, and one in Rio. When it came to taking the photograph, the decision was an easy one: I asked if I could take a picture of Carl with Valegro. My mother had taught me the correct way to photograph a horse, and it was no different with Carl, who used the old trick of having one of his stable hands shake a tin to get Valegro to prick his ears forward, so that I got the perfect shot. Valegro retired from competition in 2016, and Carl told me that the horse is amazing when it comes to tolerating crowds and being photographed. I thought that Valegro would be highly valuable at stud, but Carl explained it was not the same as horse racing. If Valegro went out to stud 10 times in a year, that would just about cover his costs for the year.

Carl won his gold medal at London riding Uthopia. He told me that you hope you find such a horse once in a lifetime, but to have two at once was amazing good fortune. I was interested in finding out how Charlotte had ended up riding Valegro. Carl told me that he had already committed to riding Uthopia, and Valegro was at the right age, and far too good not to be taken forward, so Charlotte began the job of developing him instead. Three Olympic gold medals later, the rest is history. It was rather special seeing these amazing horses stabled together, not forgetting Nip Tuck, who is Carl's other Olympic medal-winning horse at the yard.

Carl had a very close shave with bowel cancer after he'd turned 40. He had been in hospital a couple of times after having difficulty swallowing food. He described it as something that was annoying, but he had just got on with things. Then after a late-night meal he had another bad episode, this time with a piece of steak that he couldn't digest, and ended up in accident and emergency. The following week, on hearing what had happened, the father of one of his clients, who is a doctor, asked Carl to make an appointment to see him to get checked out. It took a few weeks, and a bit of persistence, but Carl eventually went for checks. He told me that on the way he was joking about waking up and being told he had cancer. As things turned out this was pretty much what happened. Numerous polyps were removed from his bowel, two of which showed signs of cancer. The doctor told him that without treatment he would have been dead within 12 months. Carl's family has a history of cancer on his mother's side, so he said it wasn't perhaps the biggest surprise. He now has annual checks, and since the scare Carl has made changes to his lifestyle and diet, given that junk food, late nights, drinking, and smoking are common traits among riders. As well as improving his own health, Carl has persuaded some friends and colleagues to live more healthily too. He counts himself fortunate to have survived the episode, as he had shown none of the symptoms more commonly associated with bowel cancer.

Uthopia and Nip Tuck

Carl is already looking ahead, and is hoping to compete at the next two Olympics which would make it seven competitions in total. I could not leave the stables without getting a photo of Uthopia and Nip Tick.

Meeting Carl was an incredible experience – one to remember, and Carl was friendly and supportive throughout. It was also an experience that Mum would certainly have approved of.

Anne Usher MBE

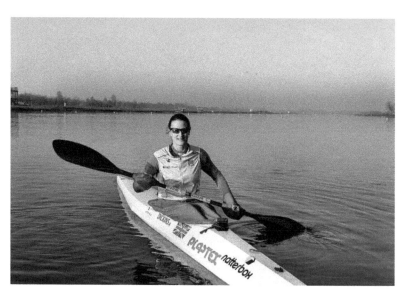

Anne Usher, 17 January 2017

I met Paralympian Anne Usher MBE at Dorney Lake. Anne won a gold medal at Rio 2016 in the KL3 200m Paracanoeing. The purpose-built racing lake at Dorney hosts rowing and canoe sprint events. It is still perhaps best remembered for hosting the rowing and canoeing events at the London 2012 Olympic and Paralympic Games. Many thousands of spectators crammed onto the banks to see those races, but the venue was virtually deserted on this sunny and crisp January morning. The lake is located between Maidenhead and Eton, and although I was born just a few minutes away at Cliveden Hospital in Taplow and brought up in Maidenhead, I had never been there before. I must admit that as soon as I entered the park and began the long drive to the car park which follows the length of the course, I was completely blown away by the stunning setting and wonderful sporting arena.

Anne was just one of three paracanoeists training on the lake. I was able to look down the entire length of the course from the jetty and see Anne slowly come into view as she finished her training session. In a break from tradition when doing these photographs, I took the photo before we properly introduced ourselves as I naturally wanted to take a photo of Anne in her canoe. You couldn't ask for better weather or indeed a better location for the photo, so I was especially pleased with how it came out.

Anne suggested that we went to the Dorney Kitchen, a short drive away, for brunch and a chat. She was incredibly generous with her time, and we ended up talking for an hour and a half. Anne told me that the first record she bought was *Graceland* by Paul Simon, although she confessed that music was not one of her major passions. We spoke about her time as a cyclist, which had really started as little more than as a hobby to get fit, and how she then finished fourth in the World Solo Mountain Bike Championships at her first attempt in 2010. It immediately became apparent that Anne is very much a glass half-full type of person, and will always seize an opportunity when it presents itself. Sadly, a

serious back injury ended her cycling career, and she admitted that it took her some time to bounce back from that.

It was at London 2012 where Anne, using her skills as a physiotherapist, was helping out as a volunteer in the cycling velodrome at the Olympic Park, that a chance encounter with Colin Radmore, a GB paracanoe coach, led her to beginning her career as a paracanoeist. He invited Anne to try out for the GB paracanoe squad. She had never been in a canoe before, but four years later she became a Paralympic Champion. During the games in London Anne slept on a friend's floor, and she told me how she stuck green crosses on top of the red crosses on all the medical clothes, because the red crosses were considered to be branding, which is not allowed at the Olympics. She comes across as someone who certainly isn't afraid to get her hands dirty when necessary.

We chatted about Anne's training regime. She has to leave her home no later than 6.15am to drive to Dorney, suffering the trials and tribulations of the M25 motorway, and her training is six days a week. On top of her training, Anne has her day job as a physiotherapist, and the small matter of being a wife and mother. It's a good job that she said she enjoys being busy! The aim of training is to improve and maintain her technique, build up her body strength, and also to increase her speed and endurance. I think just sitting in a canoe without toppling over is a feat enough in itself, let alone racing to a gold medal. Interestingly, Anne pointed out that whereas it might look like she races strongly towards the end of a race, it's actually more the case that she is able to maintain her top speed for longer. During a race everything can come down to very fine margins, so everything is analysed down to the tiniest detail to try and improve on performance. This all paid off for Anne, who won gold in Rio by the most slender of margins in an incredible final.

One thing that struck me all through our meeting was how down-to-earth Anne is. She travelled to the 2016 Olympic homecoming parade in Manchester by train. Due to a train fare anomaly it was cheaper for her to buy a first-class ticket, and so she travelled there by first class for the first time in her life. She ended up having conversations with fellow passengers, including giving advice to one passenger who had sadly let his girlfriend down at the last minute to be on the train. Anne had no idea initially that she had been handing out advice to one of the Kaiser Chiefs! I think this is typical of Anne, who is just an ordinary woman who will happily chat to anyone and for whom a "please" and "thank you" will go an awfully long way.

Anne has had to make a lot of sacrifices to get to the top of her sport. Throughout this time she prioritises her family first and foremost, and says she is lucky to have some very understanding friends. Whilst she is incredibly proud of her own achievements, she regards being a success in life as not necessarily about being first across the finishing line. Her story is certainly an inspiring one, but she was also keen to point out that we can all have achievable goals in life. As much as we talked about her life, she was also a very good listener and interested in what I did and about my mother's battle with bowel cancer. In her work as a physiotherapist Anne has come across bowel cancer, one of the symptoms being back pain. We agreed that better early detection of this awful illness is needed.

Meeting Anne was a fascinating experience, and I left our meeting with plenty of food for thought about the potential paths ahead for me.

Since our meeting, Anne has retired from paracanoeing to focus on enjoying the many different adventures that the world has to offer.

Jeanette Chippington MBE

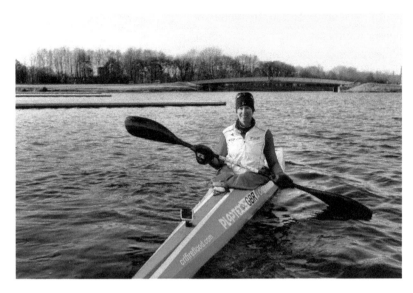

Jeanette Chippington, 7 February 2017

I returned to Dorney Lake a few weeks later to meet Jeanette Chippington MBE, who won a gold medal at Rio 2016 in the KL1 200m Paracanoeing. Jeanette lives in Maidenhead with her husband and family, and in fact went to the same secondary school that both my mother and sister did. My mum attended the Maidenhead County Girls School, which was located on Castle Hill. By the time my sister and Jeanette went there it had been renamed Newlands, and had moved to its present location in Farm Road.

The first record that Jeanette bought was 'Brass In Pocket', which was a number 1 single for The Pretenders, and in fact it was the first song to top the chart in the 1980s. By coincidence I bought their follow-up single, 'Talk Of The Town'.

Jeanette became paralysed in both legs while she was at Newlands after a virus caused damage to her spinal cord. She began swimming on the recommendation of her physiotherapist, and first competed as a Paralympic swimmer in the 1988 Seoul games where she won a silver medal. This was an amazing achievement, as just four weeks before it started, Jeanette's event was cancelled, which meant she had to race up a classification. Her Paralympic swimming career spanned five games and she won medals at each one. We spoke about the gold medal that she won at the Atlanta Games in 1996 in the 200m freestyle S6 event. It was a race that went down to the wire and Jeanette had already seen her world record broken twice in the lead-up to the final, so she was fifth fastest after the heats. Little things can sometimes make the difference in the final, and whilst Jeanette was gathering herself beforehand, she saw her long-standing rivals chatting and joking. This gave a fully-focused Jeanette that extra bit of encouragement, if it was needed, to beat her opponents. The race came down to a touch finish, and on hearing a cry of joy from her opponent, Jeanette thought she had missed out. However it was Jeanette who had taken gold in a new world record time, and such had been the effort she

had put into the race, she wasn't able to fully comprehend the result displayed on the scoreboard in the arena.

After her swimming career ended, Jeanette took up coaching. She also wanted to try another sport as a hobby, and after some persistent persuasion from a friend she took up kayaking. Her paracanoe career began in 2011, and she won the world title from 2012 to 2015. However some seeds of doubt were sown in the lead-up to Rio 2016 when she had to settle for silver in the World Championships. She conceded, that, on reflection, she had focused on her opponents rather than her own race plan. It was a tough lesson, but one she took on board, and as she lined up in the Paralympic final she knew that she had the beating of the opposition and was going to race her own race. As in Atlanta, though, the result came down to the wire. In fact it was so close that at first she thought she had finished second as her opponent was celebrating as though she had won. In spite of the scoreboard showing Jeanette as the winner, she did not believe it, and it was not until she was back in the changing room that Jeanette was finally able to let the result sink in.

Jeanette is obviously a tough competitor, and it was interesting listening to her talk about the races she didn't win. At the Barcelona Olympics in 1992 Jeanette didn't win a medal in her individual events. Although the margins of winning or not winning a medal were fractions of a second, it was an experience that she learnt from. Being so close to being placed merely spurred Jeanette on to make sure that she went one better the next time at Atlanta. To compete at Paralympic level, and win gold medals, the hard graft has to be put in. Jeanette trains twice a day. She has to fit in two sessions before picking up her children from school, which doesn't give her a great amount of time to recover between the sessions.

Jeanette has been in a wheelchair since 1982. Things were very different back then. Newlands, like many schools, had no wheelchair facilities, so Jeanette had to crawl up the stairs to get to some classes, and she would have to wait until the lunch break to go home to the toilet. While things have improved over the years, she still has to plan her trips out, as wheelchair users still face challenges every single day just getting around doing their daily business. When she goes out for a meal with friends she has to find out about access and the toilet facilities. There are occasions when she simply is unable to drink anything because of this. However, she has not let her disability stop her from achieving the great successes she has had in her life.

We spoke about my mother's illness and in fact talked at great length about bowel cancer. Jeanette revealed that her family has also been touched by cancer. She lost her auntie to cancer a couple of years previously. Jeanette's mother has dementia and Jeanette believes that this was triggered by the loss. Her sister-in-law lost her brother to a brain tumour, and one of the mums at Newlands also lost a battle with cancer. Cancer seems to have touched everyone – or maybe it's the fact these days that people are a lot more open to talking about cancer than perhaps was once the case.

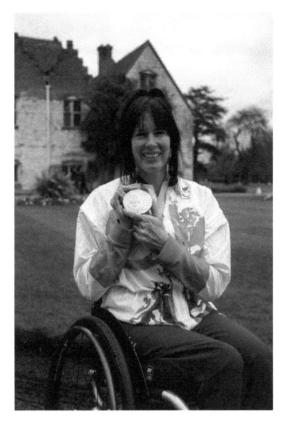

Jeanette Chippington, 14 March 2017

After our meeting at Dorney Lake, we agreed that it would be nice to get a photograph of Jeanette with her gold medal from Rio. A few weeks later we met up again, this time at the Bisham Abbey National Sports Centre outside Marlow. This is where Jeanette does her gym training, and she showed me around the state-of-the-art facilities. I had stayed in the old Abbey (behind Jeanette in the photo) on a football course back in 1976. It was all the more interesting as I remember the first foundations were being laid for the sports centre, which has developed over recent years into one of the top sporting facilities in the country.

Shortly after our second meeting Jeanette was to go to Buckingham Palace to receive her richly-deserved MBE, the prospect of which didn't seem to daunt this fearless athlete at all – in fact, she was more concerned about what to wear.

Zac Purchase-Hill MBE

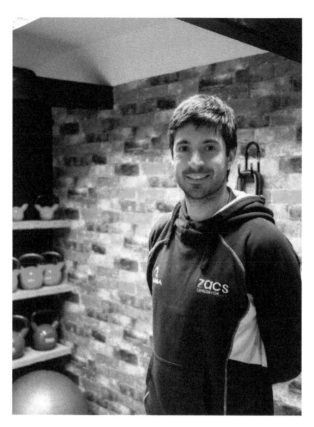

Zac Purchase-Hill, 15 December 2017

Zac Purchase-Hill won an Olympic gold medal at Beijing 2008 in the Lightweight Double Sculls with Mark Hunter, and the pair followed this up with silver at London 2012. Zac now owns a successful fitness studio in Marlow with his wife Fliss. When I made contact with Fliss to see if Zac would take part, she explained that she had lost her grandmother to bowel cancer, so they would be happy to be involved.

The family had thought Fliss's grandmother had lung cancer from smoking, and Fliss only found out shortly before she died that it was bowel cancer. It was a very rapid decline in her grandmother's case, following a late diagnosis. Fliss told me that her grandad had died four years previously, and felt that her grandmother probably didn't really want to know, and that it had been very hard to get her to go to the doctor's. By the time bowel cancer was diagnosed her grandmother had been moved into a hospice, after spending a couple of days in hospital. Sadly she died just a couple of weeks later.

I met the couple at the studio, which is in the centre of Marlow, set back in a small beautiful courtyard that I had no idea existed, in spite of its central position in the town. It's a wonderful location, and Zac said that when they were first told about it by their estate agent they weren't sure, but as soon as they went to see it they knew it was the right place for them.

Zac's first record was 'Better Off Alone' by Alice Deejay which got to number 1 in the charts in 1999, and sold more than 600,000 copies. He was in his mid-teens at the time, and confessed to not buying records any more, as these days he streams all of his music. Fliss's first record was the Dolly Parton song '9 to 5' from the film of the same name. Released in 1980, it didn't make the UK top 40, but it did get to number 1 in America.

Zac first came to Marlow when he was rowing with Dan Tipney, who was a member of Marlow Rowing Club. They rowed together for about three years, so Marlow was the obvious club for Zac to join after he left his school in Worcester. Throughout his time rowing for Team GB, Zac kept Marlow as his club, and he is now a life member there. Zac told me that he'd never been a member of the prestigious – and very successful – Leander Rowing Club in Henley, and felt that the club could be better at taking on more people who don't row. Zac said that Leander Club tend to admit successful and competent rowers, rather than teaching people to row, whereas most rowing clubs exist to teach people to row. This was certainly the case with my late father at Maidenhead Rowing Club almost 70 years ago. Zac said that at Marlow they have the facilities to support rowers all the way through from junior level to Olympic standard.

Zac retired from rowing at the relatively young age of 26. He said that at that point he had been World Champion four times, set World and Olympic records, and had won the gold and silver medals at the Olympics. He felt that it was not a bad place to draw a line under his rowing career and try something else, although Zac had no idea at that point that he and Fliss would end up running a fitness studio. The option of returning to rowing was always there, and he said that it took almost a year to decide to retire. Zac said that the burning passion required to compete at the highest level was no longer there.

Zac's original ambition in rowing was to win a gold medal at London 2012. As soon as it was announced that the games would be in London, it became the sole focus of his rowing career. In fact, the gold medal he won in Beijing was a by-product of the journey to London. Beijing was a special and magical moment in his career, but it wasn't London. Zac said that the silver medal in London was almost like an anticlimax. All he had ever dreamed of was winning the gold there, and to fall so agonisingly short was hard to take. It's something that – unless you have been there – is probably quite hard to understand. Zac had wanted to win the gold medal in London so badly that the silver medal left him sad and disappointed. I wanted to know what it was like rowing at Eton Dorney at London 2012 in terms of the amazing home support. Zac said that it was incredible, and very different to Beijing which was a relatively quiet affair. Zac said the crowd at London was the most noisy and enthusiastic crowd that he'd ever seen.

Zac did a lot of his Olympic training in Reading, but he said it was interesting training and rowing in Eton from its inception – he once rowed there with a digger in the lake during construction – to its completion and the packed crowds at London 2012. Zac also spoke about the National Watersports Centre in Nottingham, which he believes is a good thing, as it's less London-centric. It can be a stunning place to row, but also is subject to strong winds at times, which is not so good for rowing.

It was really nice meeting such a lovely couple. Zac is a man with a wonderful sporting career to look back on, but he is also very much a person who lives in the present, making the most of all the opportunities that life offers.

Rupert Moon

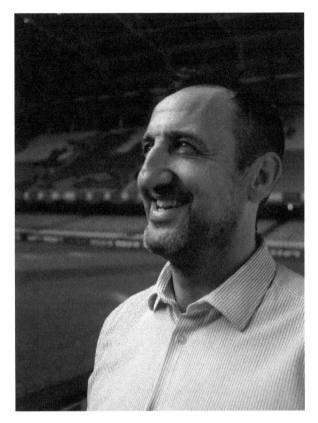

Rupert Moon, 10 October 2018

I spent an incredible afternoon at the Principality Stadium in Cardiff, when I went there to meet Rupert Moon, the former Welsh international rugby player capped 24 times by his country. I have to be honest in that I didn't get to ask many of the questions I'd planned, as it became the kind of chapter that took on a direction of its own, and it pretty much wrote itself.

The first record that Rupert bought was 'Under The Moon Of Love' by Showaddywaddy. It was a number 1 single in the UK in 1976, selling just short of a million copies. Rupert actually went to see Showaddywaddy at a small venue in Cardiff in the early 1990s, during the period when he was playing for Wales, and he got to meet the band's drummer, Romeo Challenger.

Rupert suggested that we meet in Cardiff, and the initial plan was to take a photo of him outside the stadium. I asked whether it would be possible to go inside, and Rupert managed to pull out all the stops and make that happen. It was an unseasonably hot day for the middle of October, so unusually for the time of year I was able to travel down in just a T-shirt, which drew a lot of attention during the day. Rupert is a good friend of Mike and Jules Peters from The Alarm, so I went in one of the band's T-shirts. The attention began before I arrived in Cardiff, as a gentleman at Reading Station told me that he had seen The Alarm support U2 at the Lyceum in London back in 1982. At the stadium in

Cardiff at least half a dozen people commented on the T-shirt and said what a great band they are, including a member of the Welsh FA, and a Spanish man, who was there working for Spanish television who were covering the Wales versus Spain international match that was being played there the following night.

I met Rupert at Gate 4, which is the entrance for players and officials to drive into. He drove us through the security barrier, and it was at this point, when Rupert was having a joke with security on the other end of the intercom, that I began to appreciate just how popular Rupert is, and the high regard he is held in there by everyone.

Before we headed through the players' tunnel and out onto the pitch, Rupert showed me some beautiful wooden display boards, which list the name of everyone who has played rugby for Wales. Rupert Henry St. John Barker Moon is player number 907. In 2003 Rupert was employed as the Head of Group Commercial & Business Development for the Welsh Rugby Union and Millennium Stadium (as it was then known). He told me how money was very short in those days. Alongside his normal duties, Rupert and some of his staff would spend hours after work painting the breeze blocks underneath the stands. At the end of the corridor was the players' lounge, which was a store room when Rupert began working there. We were in luck as a member of staff with the key kindly opened it up for us, and Rupert showed me round.

Rupert told me how ex-Welsh international rugby players get a seat for life at the stadium, and can a take a guest to every game there. They are able to enjoy free hospitality in the lounge, and can also enjoy a meal in the adjoining restaurant. At one end of the lounge there is a display cabinet of the famous rugby groggs. Created in Pontypridd, these are nine-inch clay caricatures of Welsh rugby players. Rupert said that you knew you had made it when you had a grogg made of yourself. In fact, he was the first non-international to have a grogg made of him before he won his first cap. The lounge hosts some amazing memorabilia, including photos and old shirts, and it must be a wonderful place for the ex-players to reminisce on match days.

We then went inside the state-of-the-art changing rooms. Rupert told me how the south dressing room was said to have been cursed, since the teams that used it failed to win, and how Welsh artist Andrew Vicari painted a dragon mural on one of the walls in an attempt to rid the room of the curse. Rupert said it seemed to have worked, and that it was a shame that it had been painted directly onto the wall, as it can't be moved. The mural is now hidden from view behind a Welsh flag.

The Press Office was the next room that we passed, and everything had been prepared for the football international the following evening. Rupert had no hesitation in telling me to sit in one of the chairs for a photo. I suspect that the actual post-match press conference would have been quite lively, as Wales ended up losing the match 4-1.

We went through the players' tunnel onto the pitch. Rupert told me it is an experience very hard to describe, walking out with a capacity crowd chanting, "Wales, Wales, Wales". I have to admit that I got goose bumps, and there was barely another soul there. We weren't allowed onto the grass playing surface, but we stood on the Astro Turf right

next to it. The Principality Stadium was opened in 1999, and cost £121 million, which is remarkably cheap compared to more recent stadium projects like Wembley.

Rupert told me about the major role he played in organising the Tsunami Relief Concert staged at the stadium in 2005. The event sold the full allocation of 60,000 tickets in just three days, and was televised to a global audience of millions, raising £1.25 million. Rupert contacted many artists and requested their participation using his full network of connections, but he said that it was only when Eric Clapton confirmed his appearance that the rest of the lineup really fell into place. During the event, Rupert described how he was sitting with a laptop linked to the scoreboard that displayed the total raised so that Lulu, who was performing on stage, could announce this to the crowd. After the concert had ended Rupert said that he, and some of the artists involved, played a game of football at 4 a.m. in the deserted arena. It was the biggest charity concert since Live Aid, and the contracts signed with the artists have prevented a subsequent commercial release of the broadcast. Rupert believes that the master tapes are still stored away in a box somewhere.

Rupert is a supporter of the Love Hope Strength Foundation, which Mike Peters from The Alarm, who has been living with leukaemia for over 20 years, co-founded in 2007. The charity's aim is to raise funds and awareness in order to benefit people with leukaemia and other forms of cancer. It is now the world's leading rock and roll cancer foundation. Rupert has taken part in many events, including the By Your Side Walk in North Wales in 2017. At The Gathering, held in Llandudno, Rupert takes on the role of barman in the VIP bar, serving drinks to the artists. He told me how, at the 2018 event, he stayed up through the night with Mike and Jules. He spoke about the pair of them with such affection that there is obviously a very close bond between them.

I spent a fascinating hour with Rupert. If the only minor downside was not getting to find out a little more about Rupert himself, the upside was being given this amazing and unique experience. He couldn't have done any more to ensure that my day was one that I will never forget. Rupert was quite simply the nicest man you could wish to meet, and a hugely popular figure, who couldn't go more than a few minutes without someone coming up to him – whether it be the groundsman or a high-ranking official – and shaking his hand and having a chat with him. He is a man who has time and a smile for everyone.

Kelly Smith

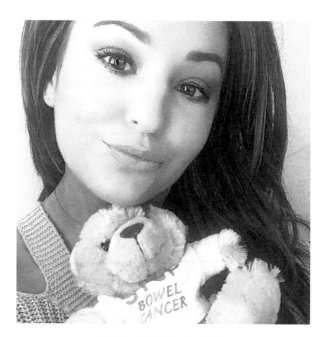

Kelly Smith, 29 October 2018

Kelly Smith has stage 4 bowel cancer. I've known her on social media for about a year, and I was delighted when she agreed to be part of the book and write the foreword. She lives in Cheshire with her young son Finn. The biggest challenge was finding a suitable time to meet up, as not only does Kelly lead a busy life, but she was also going through some pretty gruelling rounds of chemotherapy. We decided that a chat on the phone would be the best way forward, and Kelly had already sent me this wonderful photo of her with one of the Stop Bowel Cancer bears – now adopted by Finn and named Barry.

The first record that Kelly bought was 'Mama' by the Spice Girls. It was a double A-side, with 'Who Do You Think Are' on the other side. The single was released in 1997, and was the group's fourth consecutive single to go to number 1 on the UK singles chart. It was also the official Comic Relief song of that year too. Kelly is a massive music fan. She likes Sam Smith, who was also the last artist she went to see in concert, and she likes Dua Lipa too. Her main passion, though, is 1990s dance music, including artists like Robin S, Bobby Brown, Strike, and Tony di Bart.

We talked about Kelly's life before her cancer diagnosis. She'd led a life busy with a fascinating career. Kelly worked at Clinique as a make-up artist, before moving jobs and working with a company called Art Deco, who did the make-up for *Dancing On Ice*, and other shows on ITV. Kelly got the opportunity to work on the *National Television Awards*, where she did the make-up for the girls from *Coronation Street*. She also worked with actress Michelle Keegan when she came in to launch a new product. Kelly was then head-hunted by Christian Dior, where she was the colour stylist at their flagship store in Selfridges at the Trafford Centre in Manchester.

Kelly then met her partner, and Finn came along. After he was born Kelly didn't want to go back to doing the commuting to and from work, as they were living some distance away from Manchester. She had saved enough money to have an extra nine months off work after her maternity leave ended. Kelly then returned to work in a salon working as a receptionist, and did a bit of make-up work at weekends. Unfortunately Kelly was made redundant from the salon just three weeks before she was diagnosed with bowel cancer.

Kelly first noticed that something wasn't right when she returned home from Finn's first holiday abroad to Lanzarote in 2016. She had a stomach bug, but didn't think anything of it. Two weeks later she got another one, and things escalated – Kelly began experiencing tummy pains, and was being sick every couple of days. She wasn't experiencing the classic symptoms of bowel cancer like blood in her stools, as she wasn't going to the toilet that much due to the tumour being so big. Kelly was extremely tired and lost a lot of weight, but that was put down to the vomiting. The doctors told her that it might be colitis. They checked her gallbladder, and thought she might have coeliac disease as she was also anaemic. They also thought it could be appendicitis – in fact everything but bowel cancer, which was never considered a possibility by the doctors. Kelly was misdiagnosed seven times.

Kelly had been to A&E three times with the pain before it was decided to do a scan. She had an ultrasound done on her liver and gallbladder, and at that point the guy in the room doing it fell silent. He told Kelly he was sending her for a CT scan straightaway. A few hours later Kelly got a phone call at home telling her she had to go back to A&E immediately, as they had found a five-centimetre obstruction in her bowel. Even at this point Kelly was unaware it was cancer. They wanted to do a colonoscopy, but Kelly couldn't drink the prep drink as it was just too much and she vomited. She was sent home for the weekend, and came back in on the Monday for another colonoscopy. It was at this point that she saw the tumour. They took some biopsies. The next morning the consultant saw Kelly, and said he would have a chat with her about what they had found, but he wanted her to have someone there with her. In the conversation that followed the consultant told Kelly that he would be removing the tumour a week later, and after that would deal with what he described as the seedlings on her liver. Kelly, at this point, still didn't know it was bowel cancer. He then went on to tell her that she would then have a course of chemotherapy, and as soon as he said that word Kelly knew that she had bowel cancer, and the tears began to flow. Kelly was diagnosed with bowel cancer in April 2017.

Kelly went home for the week before the operation, and had meetings with Macmillan nurses and bowel cancer nurses. She also had to get everything sorted at home before the operation, and tell her other half and other family members. Kelly described the bowel resection as the most amazing operation in the world. She was up on her feet the day after surgery, and remained in hospital for about seven days. It took a few weeks for her bowel habits to return to normal, and for her to be able to eat normal food again, as she was put on a sweet and soft diet, which involved soup, jelly, and ice cream – in other words, anything that was not crunchy.

Kelly's course of chemotherapy started a couple of months later in the June, and went through until September. This involved having chemo every two weeks, and she had

seven rounds in total. The scans showed that the tumours on her liver had shrunk enough for her to have the liver surgery, which was performed on 5 November 2017. Kelly described that operation as like a smack in the face – absolutely horrendous, and said she hadn't really taken on board just how hard it was going to be. She had two drains on each side of her hips, which for her was the worst bit, and incredibly painful. She now has a scar that runs down from where the breastbone finishes, along her rib cage, and down the side of her stomach. Kelly was in hospital for eight days, and said the recovery period was a good two to three months. Six tumours had been removed – three were still active and three had died.

In January 2018 Kelly had a PET scan, and everything was clear. She was told that she wasn't out of the woods, but that there was no evidence of the disease. Kelly started a new job working for the jewellery shop Pandora in the February, and had just signed a new contract after completing her three months' probation period, when she began to feel really sick and tired again. Her three-monthly scan revealed that she had three tumours on her aorta. This is largest artery in the human body, coming out of the heart. Unfortunately the tumours there are inoperable. The scan also revealed a few new tumours on her liver. The medical team wanted to see how those tumours would grow before deciding on the course of treatment. Over the next six weeks the tumours tripled in size.

Kelly was put on a course of 12 rounds of chemotherapy, which was a different type to the previous chemo she'd been on. It was particularly hard as she was on Irinotecan, which Kelly said was a pretty sickly type of drug, and she suffered really badly. It was around at this time Kelly had agreed to be in the book, so it's not surprising that we weren't able to meet up.

At the time of writing this chapter, Kelly is in talks with her medical team about the next course of treatment. Another liver resection is under consideration, but a recent MRI scan showed that there wasn't a lot there at this stage, so they are not sure whether another resection is required. However, Kelly is under consideration for proton beam therapy, which is a new kind of radiotherapy that will target the lymph nodes on her aorta – but she can't have that until there is no evidence of the disease elsewhere in her body. This means that Kelly is experiencing a frustrating waiting game at the moment. She has been through an awful lot, and hopefully she won't have to wait too long to begin the next stage of her treatment.

Kelly decided to share her experience of cancer on social media, and help raise awareness. Her diagnosis came as a huge shock to everyone, as you don't hear about too many young people having bowel cancer – although this figure is growing. Kelly couldn't really see many people out there of a similar age talking about it. One person who was talking about bowel cancer was Deborah "Bowel Babe" James, who was helping a huge number of people, and Kelly thought that it might help her if she began talking about what was going on. She didn't want anyone else to have to go through the same experience as her, and wanted to help in any way she was able to.

There are times when Kelly doesn't feel like sharing what is going on, but she said one of the reasons why she still continues to do it is because of the amazing support she gets – knowing that everyone is rooting for her keeps her going. Kelly receives loads of

messages telling her how she has helped someone who has been diagnosed with cancer, and not just bowel cancer. It's very rewarding for Kelly to know that she has been inspiring people and helping them not to be scared. There is no doubt that Kelly, and others like her, are helping to change the image of cancer, and her posts on social media also show that it is possible to have a normal – or at least a semi-normal – life with bowel cancer. By her own admission Kelly admits to being a bit scatty, but her posts on social media paint a wonderful picture of a very selfless and kind individual. There are tears at times, but the laughter is there in abundance as she navigates her way through day-to-day life.

We spoke about Kelly's experience of appearing on the *You, Me and the Big C* podcast, and meeting its presenters Rachael Bland (who, sadly, has since died of breast cancer), Lauren Mahon, and Deborah James. She had been having a few conversations online with Rachael, and she'd already known Debs for some time. She knew Lauren through the *FFC* page on Instagram, which was created by Kelly and some other women, providing a place of support to anyone affected by cancer. Rachael asked Kelly to be a guest on the podcast, and the episode Kelly featured in was about online friends. In terms of Deborah, Kelly said that because she had been diagnosed earlier and as a result had a little more experience of bowel cancer, Debs is always the one Kelly turns to for advice. They are quite different, in that Debs does a lot of research about the disease, whereas Kelly doesn't like to know about the ins and outs of everything, and prefers to have a plan in place and to just go for it. After they finished recording the podcast, Rachael took the girls on a tour of MediaCityUK, and they posted some brilliant stories on social media doing keep-fit exercises on the BBC News set. Kelly said it was really nice to finally meet the three ladies face to face, and afterwards they were able to sit down and just have a normal chat, which was well overdue after the phone chats and conversations they'd been having on social media.

I'm extremely grateful to Kelly for her openness, and for being prepared to talk to me about living with bowel cancer. She is an amazing individual: an inspirational young lady doing so much to raise awareness about bowel cancer, and to help others in a similar situation, whilst going through such tough treatment for the disease herself. I'm also very grateful to her for writing the foreword, and hopefully I will get the opportunity in the future to meet her in person.

Deborah Alsina MBE

Deborah Alsina, 28 March 2018

I went to meet Deborah Alsina, the CEO of Bowel Cancer UK (Beating Bowel Cancer Together) at the charity's former Teddington office shortly after Beating Bowel Cancer and Bowel Cancer UK merged at the start of 2018. Deborah was someone who I was keen to get involved in the book, and she agreed as soon as I asked her. It gave me a great opportunity to find out more about the work that the charity is doing. Such is her busy schedule, this appointment had to be made weeks in advance. The late winter snow in the south of England had already put paid to one meeting that we'd arranged. It was lovely to finally meet Deborah, as we'd known each other for some years on social media, and she had always asked after my mother during her treatment.

Every day is an extremely long day for Deborah, who commutes into London from her home in the Cotswolds. She also travels all over the UK, and to other parts of the world as part of her job. Away from work, Deborah's sanctuary is her life at home with her family. She described her husband as her rock, and she has three children – two sons at university, and a daughter at home. She walks a lot with her dog, and enjoys photography.

Deborah's husband was diagnosed with chronic myeloid leukaemia about 15 years ago, just two weeks after they had got married. For a while it was very tough, and they had no idea if he would survive, but, these days, thankfully – with the help of super drugs – he is in a drug-controlled remission. If he'd had a bone marrow transplant, there was a 50%

chance that he would have died, so, as things stand, if he develops a resistance to one drug, he can move on to another drug from the same family. Four years after her husband's diagnosis, Deborah's father was diagnosed with bowel cancer, and sadly passed away just six months later. Deborah wondered how she had been living so close to cancer, and yet had never heard of bowel cancer. As a result, she decided to try and do something to help raise awareness, so she contacted Bowel Cancer UK and offered to volunteer with them. Deborah was quickly pulled into the organisation, becoming Director of Services and Strategy, and then Chief Executive a year later.

I asked Deborah about the issue of reducing the screening age for bowel cancer in England, Wales, and Northern Ireland from 60 to 50, to match what it already is in Scotland. She said that the challenge is how to achieve this within the framework of the NHS, and that this can only be done by increasing workforce capacity. Deborah explained that the current FOBT (faecal occult blood test) screening system misses high levels of cancer, and is being replaced with a FIT (faecal immunochemical test), which is a simpler test to use, and avoids many false positives because it only detects human blood. It is also a quantitative test, which means you can vary its sensitivity to suit your workforce capacity. The more sensitive the test, the more cases of bowel cancer will be detected. Not only will FIT save more lives, but by detecting bowel cancer at an earlier stage, it will also save on the very expensive costs of late treatment. It is also anticipated that the uptake of screening will be approximately 10% higher because people only need to take one stool sample rather than three, as they currently do. However, there is not sufficient diagnostic workforce in place to deal with the increased demand, and increasing capacity and training new staff takes a long time. The charity has been campaigning for investment in workforce to address this situation, but at the moment progress is slow. Deborah explained that the role of the charity is to understand the key issues, and to work in partnership with patients, clinicians, and policy makers to develop real solutions so that in the future more lives can be saved.

Deborah talked about the charity's campaign to improve the identification and screening of people with Lynch Syndrome, which is a genetic condition that can increase the risk of bowel cancer by up to 80%, and increases the risk of other forms of cancer too. As it's a genetic condition, there is a one in two chance that you might pass on the mutation to your children, and of course other family members may also be affected. However in the UK, only about 5% of the 175,000 people who have this genetic condition are currently known. Therefore, the charity has been campaigning for improvements to the identification of people with Lynch Syndrome, so that they can have the screening they need.

We talked about bowel cancer in the under-50s, and Bowel Cancer UK's 'Never Too Young' campaign. Deborah explained that there has been an increase of 47% of cases in this age group in the last 12 years. Every year in the UK, there are 2,500 people diagnosed under the age of 50, 60% in the later stages of the disease, and over 30% as an emergency. This rise in incidence is happening in many countries around the world, and is in part linked to lifestyle, as well as genetics. However, those factors alone do not completely explain the increasing numbers, and this is where research comes in. The charity is working in partnership with others and funding research to better understand the factors leading to the increase in diagnosis; for example, whether changes in an individual's microbiome (gut bacteria) could shed more light on new risk factors.

I asked Deborah about misdiagnosis, and late diagnosis, which – sadly – I seem to have come across far too often. She told me that the statistics show that this happens most in younger and older people outside of screening age. Deborah explained that with younger patients, for example, it is very difficult for GPs to decide which ones to refer through for a colonoscopy, since they will see many young people with symptoms that could be bowel cancer, but won't be (as the symptoms are more likely to be caused by a benign condition such as IBS or IBD). Currently, GPs are criticised for referring people, and also for not referring people, and so are left in a difficult situation. As a result, the charity has worked with the Universities of Exeter and Durham to develop a risk assessment tool to support GPs' decision making. Deborah told me that using a very sensitive FIT to triage people through to diagnostic tests might also help to speed up the diagnosis of younger patients too, and this was something the charity was keen to explore in light of new NICE guidance on the use of FIT in low-risk, but not no-risk, populations.

Before we finished our chat, Deborah revealed that the first record she bought was the *Discovery* album by ELO. The album topped the charts in 1979, going double platinum. She said that she still loves listening to it, and can probably still remember a lot of the lyrics. Having older brothers and a sister meant that there was a lot of music in her house when she was growing up, and she inherited a lot of records. She remembers liking songs by The Beatles when she was very young. Deborah was a teenager in the 1980s, and was very pleased to discover, more recently, that her new car had a dedicated 80s music radio station when she bought it.

Deborah is completely immersed in bowel cancer and the community, and she feels blessed to have met so many patients and their families. She knows many long-term survivors now, which is something that makes her very happy. It's not easy to put into words just what it means to Deborah, as it's so much more than being the CEO of a charity. She genuinely cares about everyone connected with bowel cancer. She might not say so herself, but I have lost count of the number of people who will talk about how she has become a friend to a patient or family member. On those occasions when things do get her a little down at work, Deborah only has to chat to a couple of patients to give herself the necessary motivation to keep going.

Deborah deals with a lot of death, grief, and suffering. Emotionally, it's very tough, but she has found that channelling those emotions back into her work, to build and grow the charity and drive it forward, is the best way of coping with it. People are dying needlessly of a disease that can be cured, and she is determined to help change that. It was a fascinating experience meeting someone so passionate about bowel cancer, and working so hard to change things and make a difference. She gives so much of herself not just to her work, but also to the many patients and families she meets. I found her to be incredibly kind, and without doubt inspirational as well. Bowel Cancer UK is in good hands with Deborah at the helm.

Since our meeting, it has been announced that the bowel cancer screening age in England and Wales will be reduced from 60 to 50. The focus now is on when this will be implemented.

Gina and Esmée Shergold

Gina and Esmée Shergold, 11 February 2017

I travelled to Bournemouth to meet with Gina Shergold, where she lives with her daughter Esmée. Gina's husband Steve tragically died from bowel cancer in November 2015, aged just 33. Although bowel cancer is widely perceived as something that affects the over-60s, more and more young people are being diagnosed with it. I had first come into contact with Gina a few years ago through the blog she was writing on the Internet about Steve's battle with bowel cancer. We chatted for a couple of hours and Gina was happy to talk about Steve and their lives together, and how she has coped since losing him. Esmée was, maybe not unsurprisingly, the star of the show throughout. She referred to me as 'Man' and I was given a display of her car driving, building with blocks, climbing on furniture, and eating uncooked jelly blocks…

Steve and Gina met at a call centre where they both worked. Steve, a talented goalkeeper, played semi-professional football with a number of local sides in the Bournemouth area. He had also worked as a personal trainer. They were just like any other young couple in love, planning for a life together, which was then so cruelly snatched away from them by bowel cancer. Gina lays a lot of the credit for the woman that she has become since meeting Steve with the man himself. He built up her confidence, and as Gina told me, if she was unsure about whether to do something or not, Steve would always tell her that if something made her happy, she should do it, and if something didn't make her happy, she

should stop doing it and find something else that did. It's something that Gina has continued since losing Steve. She is an incredibly kind individual, but someone who knows her own mind and will not be pushed into doing something she does not want to.

I asked Gina about music. The first record that she bought was 'You're Still The One' by Shania Twain. I also thought that it would be interesting to find out what the first record that Steve bought for her was. Rather than remembering the first record he bought, Gina said Steve introduced her to lots of music and the one song that sprung to mind and influenced her the most was 'Somebody That I Used To Know' by Gotye, a song that Steve and his mates would always play as they prepared for nights out. It was always accompanied by some funny dancing and laughter, which was a sign of Steve's character.

Following surgery, six months of chemotherapy, and then more surgery, Gina and Steve wanted to start a family. They both wanted Steve to be in the clear health-wise before doing so. They had been reassured more than once that Steve had beaten the cancer and there was no reason for them not to try for a family. Gina fell pregnant almost immediately, but it was just days after discovering she was pregnant that they got the devastating news that Steve's cancer had returned. She believes that fate was smiling on them, and that little Esmée was a gift – something was certainly meant to be. Esmée was just over a year old when her father passed away. Gina makes sure that Steve is still kept very much in Esmée's life, and always answers questions from Esmée about her daddy with complete honesty.

Gina spoke about Steve's final hours. He had been in a Macmillan hospice a couple of weeks previously for his palliative care, but Gina was sure that he would be much happier at home, and that she and their families would be able to care for him better there. They had been told he was in an incurable state eight weeks earlier, although they were still hoping that a trial drug might become available. She had given up her job and was able to dedicate herself to looking after him. The story of Steve's final morning was something I found incredibly moving to hear from Gina. He hadn't been himself and Gina had raised her concerns with the visiting nurse, who explained that while she couldn't be certain, she didn't think Steve's life was in imminent danger. The nurse acknowledged and admired Steve's determination not to give up. After the nurse left, things did not improve and Gina called Macmillan. They were able to get hold of the nurse, who came back as Steve's condition was deteriorating. Steve's mother and brother were already at the house visiting and they decided to call Steve's father and sister to join them there. Steve had fought long and hard and Gina believes that he kept fighting for his family. As Esmée played downstairs with her cousin, Steve passed away in Gina's arms, surrounded by his family and their love.

Gina's dad later said that "whilst we know Steve had cancer, it can never be said that cancer had Steve" – something that anybody who knew Steve throughout his illness would be sure to agree with.

So I met Gina about 15 months after Steve had died. In her own words she has been to hell and back, but she also believes that while life has been unkind to her, she considers herself incredibly lucky to have met Steve and to have their daughter Esmée, who is a wonderful legacy. Bereavement is something that is incredibly personal and different to

each and everyone of us, and we all have our own ways of dealing with it. Gina said that Steve would want her to carry on living her life as the happy young lady that he met and fell in love with. He will always be a part of her and Esmée's lives no matter what the future holds for them. I thought it was quite lovely when Gina reflected that what she had with Steve, even if only for too short a time, was the kind of love that very few people experience, and she was truly grateful for it. Gina has started an online course in childcare and does some part-time work. She, of course, has to balance that with bringing up Esmée on her own. They enjoy days out in Bournemouth and going out for walks, but Gina is also happy spending time at home with Esmée watching her grow, learn, and play.

Photographing the pair of them was somewhat challenging as Esmée was not overly happy to pose for the camera at first. Bribery was the order of the day, and after the jelly blocks, a packet of crisps finally did the trick. You can see the blue crisp bowl just in the bottom left of the photo. Gina's sound advice to me was to just keep snapping away and we'd get a decent photo. There are quite a few photos that I was happy with, and I loved watching these two girls having fun together. The close bond and love between them was obvious. I know that Gina and Steve's story, and their courage, have been an inspiration for many. I left Bournemouth knowing that no matter what direction Gina's life takes, she will continue to inspire people and ensure that Steve's memory lives on.

Deborah Louise James

Deborah James, 5 May 2017

Deborah James sadly passed away on 27 July 2017 at just 37 years old. She was a beautiful, kind, and lovely soul, so cruelly taken far too young by this awful disease. I met Debs a few months before she died, and I sent this chapter to her as soon as I'd written it shortly after our meeting. We both felt that it should be presented as at that point in time, so nothing has been changed.

I met the quite amazing Deborah James a couple of years after we first made contact on the Internet where I'd come across her blog, www.myjoyfulgut.co.uk. We met close to her home in Northampton for a coffee in the Cineworld cinema complex at Sixfields. It's an area of the country that I know reasonably well, having lived in the village of Akeley, just outside Buckingham, for four years. We did the photo on a sunny and rather blustery evening, with Northampton Town's Sixfields Stadium providing the backdrop. The conditions meant that we had to strategically place Debs to minimize the effects of the wind. That lovely smile epitomizes her positive and infectious personality.

The first record she bought was 'Take On Me' by Aha, which reached number 2 in the charts when it was released back in 1985. She remembered being under 10, and that the single came with a poster that she put up on her bedroom wall – something many of us have done in our youth. She's a big music fan, and she said that her young daughter Grace

is heavily influenced by her taste in music. She has even created a cancer fight playlist, which contains some songs that take Debs back to a certain time and place, and also songs about strong women, who she has become more and more drawn to. She was gutted when her most recent car, a Mini, did not have a CD player. Her partner Si had bought her a CD as a present, and at first she didn't have the heart to tell him that she had no way of playing it.

Debs was diagnosed with bowel cancer in 2015. She is in her thirties, which once again shows that this illness does not just affect older people. She had been getting abdominal pains as far back as 2013, so she is yet another patient whose diagnosis took far too long. She'd first been told she had Irritable Bowel Syndrome. Her Nan was a coeliac, so she was tested for that in the summer of 2014. It was confirmed that she had coeliac disease, and she was put on a gluten-free diet. Sadly at this time Debs' aunt died of lung cancer. On returning from the funeral in Ireland she had an attack of vomiting, which went on for 12 hours. At her health review soon afterwards this was put down to gluten poisoning, and a pain in her right side was put down to her being coeliac. The vomiting episodes continued and in December 2014 she went to hospital after a bad episode, but no investigations were done. After speaking with Coeliac UK who said the symptoms were not normal, she went back to her doctor, who decided Debs needed to be re-referred to the gastroenterologist. By this point she had lost a lot of weight, was anaemic, and could feel a lump in her side. The gastroenterologist thought she had a blocked bowel, and Debs needed to have a CT scan and colonoscopy. A mix-up meant this took weeks to happen, even though they had been marked as urgent. The pain had now become unbearable and Debs was sedated for the colonoscopy. Debs saw a huge bloody mass on the screen, but the consultant said it was probably a blocked bowel and she might have Crohn's disease. The results came back within three days, and Debs went to the meeting with her stepmother to be given the shattering news that she had bowel cancer. Although she was told it was curable, she now feels that the consultant shouldn't have said that, as he had no idea what state her bowel was in. This happened just before a bank holiday weekend, and by the Monday the tumour was putting a dangerous amount of pressure on her appendix. Debs had an emergency operation performed on her bowel to take out her appendix.

The operation was successful, but Debs needed to have a course of chemotherapy afterwards. It was around this time that we came into contact. She underwent 12 cycles of chemo beginning in June 2015, which took her through to January 2016, and then she had a CT scan, which showed her to be cancer-free. Three months after finishing chemo, in the April, Debs felt a lump in her neck. Her oncologist decided to remove the node, which revealed that it was a secondary cancer from her bowel. She then had a PET scan to see exactly where the cancer had spread to in her body. In July 2016 at the meeting for the results, Debs knew from the atmosphere in the room that it was not going to be good news. She in fact described this day as the worst in her life. They had found a couple of nodes in her abdomen, and further tests on her original tumour had revealed a BRAF mutation, which is very hard to treat and a very aggressive form of bowel cancer. Debs said she could not believe the scan was her own, as she felt so well. This was completely

devastating, and this point was a real game changer for Debs as the prognosis was really bad: she was told that she would not make it to her 38th birthday in November 2017.

When we met, Debs had just begun phase 1 treatment at The Royal Marsden Hospital in London, which is where new drugs are tested on patients. I was actually quite surprised to find out how competitive it is to even be accepted onto these programmes. There are only two hospitals in the country that offer this service. Debs' determination to live as long as possible is quite inspiring. She regards a prognosis as a statistic and something she can defy. She doesn't forward plan, or look too far ahead, sticking to just the next three months. She has no control over the cancer, but she is determined to keep herself well and happy, and to live as long as possible. Hopefully the treatment at The Royal Marsden will help Debs fulfil this. Having been told she would not live more than a year, Debs was on the verge on going past that milestone when we met and pushing on towards her 38th birthday. She has recently set up her own business, James HR Consultancy, which aims to educate and support employers about cancer. She experienced being cast out on her own when she was diagnosed, and feels that this is the worst thing an employer can do to a cancer patient. She puts on seminars to address how employers can help and support patients and their cancers during the cancer journey, and I found her passion for this totally inspiring. She aims to turn an awful situation into something positive, and feels that this is the reason why she was put on this planet.

What came across to me during our meeting was Debs' amazing courage and determination. She leads a very active and busy life and is intent on continuing to do as many things as possible. Her young daughter Grace is her world and they have been on some wonderful holidays, with more planned. Throughout our chat Debs would break into infectious laughter, and although she is under no illusions about her illness, she refuses to let cancer rule her life. Debs said there are days when she finds it difficult to talk about her illness, so I feel very fortunate to have had the opportunity to spend an hour or so with her, and to listen to her story.

Steve Clark

Steve Clark, 7 September 2017

Before meeting Steve Clark, I had not been to The Herb Farm at Sonning Common, just outside Reading, where – coincidentally – both Steve and I live. As well as plants, there is a café, where we sat down to chat, and a lovely gift shop. Its best surprise was the Saxon Maze, situated in the grounds where we took the photo. The maze was constructed in 1991, and its design is based on a mythical creature from Saxon times. Steve told me that it had taken him about an hour to navigate around it, so I decided that attempting it would have to be left for another day.

The first record that Steve bought was 'Billy Don't Be A Hero' by Paper Lace, which reached number 1 in 1974. He bought the song after seeing it on *Top Of The Pops*, and he was even able to tell me that the B-side was a song called 'Celia', and that the record came out on Bus Stop Records. It was interesting to discover that music has been a big part of Steve's life. He has been a DJ doing mobile discos, he's worked in nightclubs, and he's done a bit on the radio as well. He has also turned his hand to singing on occasion, and got up to sing with a band at a party to celebrate the end of his chemotherapy. Since his operation, Steve has also developed an appreciation of classical music, and finds it very relaxing, but like me he does draw the line at opera. He was unfortunate enough to see a dreadful performance of *Carmen* at the Prague Opera House.

Steve began his working career as a biochemist in the NHS, after which he went into the pharmaceutical industry as a sales person. He then fell into marketing more by chance after being seconded for a product launch, and worked on a number of successful brands aimed at helping people, mainly those affected by epilepsy. He spent time living and working in Paris and Brussels, which he described as a real education, and enjoyed their completely different cultures. His career progressed to a senior management role as a board director, before he set up as a consultant after accepting a redundancy package.

It was at that point – going back 12 or 13 years – where Steve's approach to life began to change. Having got to a professional level way higher than he ever thought he would, he no longer felt that he had to prove himself. He was able to reduce his work to four days a week, and achieve a much better work-life balance. He got into fitness, losing three stone in weight in the first year, and started running at a competitive level. Steve is still proud of running 10 kilometres in 40 minutes when he was in his forties. He also got into yoga, and then progressed into meditation. Eight years later, aged 49, Steve was diagnosed with bowel cancer. His joke amongst his friends is that he spent eight years getting ready for cancer, and he credits the way he has been able to deal with the illness to his change in lifestyle. These days Steve does some consultancy work, but regards himself as semi-retired.

Steve was diagnosed with stage 4 bowel cancer in May 2013. He first had problems with going to the toilet, and he found himself going 12 times a day. He was going more often with more urgency, and this change in bowel behaviour had come on relatively quickly. Initially, Steve looked at his diet, and wondered if he might have developed an intolerance, but when none of that helped he went to his GP. The locum GP thought that Steve probably had an infection, and actually assured him that it was not cancer, which Steve feels he should never have said to him or any patient for that matter, as there was no way he could have known that for sure. After having blood tests, Steve was sent for a colonoscopy. The scope revealed an area of ulceration which the camera had struggled to get past, so they took a biopsy of it, and brought Steve back in for a CT scan the following day. The very next day Steve was back in for the results of the biopsy and scan, and it was at this point he was told that he had cancer, and that it had spread to his liver and both lungs.

Steve's brain, not surprisingly, shut down on hearing the cancer diagnosis. He said that the gastroenterologist was very positive, and by a process of repeating the information to Steve, it began to sink in. Another positive thing he appreciated was not being regarded as a cancer patient by the team. Steve was fit and healthy, so the treatment plan was to be fast and aggressive. Steve had gone to this appointment on his own, and had to drive back home to Maidenhead from Slough. He told me that he had never had to be more focused on absolutely every aspect of driving. Once home Steve said that he broke down, and described it as pure primal wailing. Meditation then came into play as Steve was able to look at his coping strategies in two different ways. He was torn between the typical male/macho solution of trying to just pull himself together, and the more enlightened approach of just letting it all out in order to begin the healing process. In the end, he chose the latter, and continues to do so.

There was only a four-day gap between Steve's diagnosis and his surgery, as the primary tumour was in danger of causing a total blockage. He regards this as a blessing, as there was no hiding place, and he immediately had to begin the process of contacting family and friends. He decided, after speaking with his sister, that he wouldn't tell his mother about it until after he'd had the operation. Steve found the difficult process of telling people quite helpful, as not only did he have to do it straightaway, but because it also got him talking about the cancer. Also Steve realised that people wanted to help and support

him, and that he would have to let them do so, and that was a therapeutic part of the journey for both Steve and his helpers.

Following successful surgery, Steve has reached the five-year survival milestone, something that only 7% of stage 4 bowel cancer patients achieve. He is not free of the cancer, and had the first proper reoccurrence during 2017, a lung metastasis which was successfully dealt with. He leads a very full and active life. Not long before our meeting the prognosis from his oncologist was one to two years, so Steve is aiming for another five years, but budgeting for twenty, which I thought was a brilliant approach. He doesn't take anything for granted, and is not hiding from his cancer. That said, cancer does not dominate his life, it is not the first thing he thinks about when he wakes up, and it does not define who he is. He does a lot of voluntary work, including moderating the Beating Bowel Cancer charity's online forum for cancer patients and their families. He has set up the 'Strive For Five' campaign to raise funds for Beating Bowel Cancer, and also to help increase awareness, and give hope to people with advanced bowel cancer. Originally there was going to be a big party to celebrate Steve going past five years, but then he had the idea of growing his beard for a year, which – as you can see in the picture – was coming along nicely when I met up with him. Steve then thought it would be good to do a few events throughout the year, which had grown to around 30 by the time we met. As well as raising awareness about bowel cancer, the campaign also aims to show what you can achieve with the disease, and that a cancer diagnosis doesn't have to be the end of your life. Steve is now contacted by people who have discovered 'Strive For Five' on social media, and it's becoming much bigger than Steve ever imagined. There are plans for the campaign to continue past Steve's five-year mark, and to develop it into a place to support and help advanced bowel cancer patients.

I found Steve to be an exceptionally kind and warm person. He was so enthusiastic about what he is doing, and he is a fascinating man to talk to, and hugely inspiring. He admitted to not always feeling comfortable with the 'inspirational' tag, as he regards himself as a very normal person, just doing what he is doing. He finished off by saying that 'Strive For Five' simply would not be possible without the amazing support that he has had from so many people. There is a wonderful quote by Steve on his website, which I think is quite perfect, and a good way to finish: "A diagnosis of stage 4 bowel cancer doesn't have to be the end of your life. It can be the reason to start living it."

Dilek Ercos

Dilek Ercos, 19 June 2017

On a very hot summer's evening in June 2017, I met Dilek Ercos at Trafalgar Square in London. Dilek is a stage 3 bowel cancer survivor, and she was very keen to help raise awareness about this awful disease, and also to highlight the fact that you are never too young to get bowel cancer.

Dilek contacted me on social media to see if she could help with my fundraising in any way. The obvious thing was to ask her to be in the book, to which she immediately said yes. We'd been connected on social media for a couple of years, but this was the first time that we had met up. The sweltering temperatures meant that the tube journey from Paddington to Charing Cross was very hot and sweaty – not ideal for when meeting someone. Trafalgar Square was a convenient location to meet, as both our tube lines converged there, and it also gave us one of the most famous tourist attractions in the world to take advantage of with the photography. Usually on these occasions I will have a chat and get to know the person a little before taking the photograph, but we decided to take the photos straightaway, and then go and find somewhere cooler, out of the intense heat, to talk. My original idea for the photo was to get Lord Nelson on top of his column in the background. However, this proved very challenging, as to get both of them in the photo meant Dilek was too far away from the camera really, so I decided to concentrate on Dilek, and to just include a bit of Nelson's Column in the picture. As soon as I was happy

that I had enough photos, we switched into tourist mode and took some selfies before heading off around the back streets, where we found a nice quiet bar where we could sit outside and have a drink.

The first record that Dilek bought was 'Careless Whisper' by George Michael. This was a massive number 1 single back in 1984, and a worldwide hit, topping the chart in 25 other countries. Although bowel cancer was understandably the focal point of the evening, the conversation went off down many random paths, and Dilek revealed a wonderful sense of humour, especially when it came to our online dating experiences. Much fun was had comparing notes!

Dilek had been diagnosed with bowel cancer at the age of 39 in 2013. She hadn't been experiencing any of the common symptoms associated with it. Dilek suffered from a blocked bowel, but the doctors in the UK didn't diagnose it as cancer. This happened a second time when she was in Izmir, Turkey, and it was at that point that she was given the bowel cancer bombshell by the Turkish doctors. She had to have an operation on her bowel to remove the tumour. They removed 58 lymph nodes and found cancer in one of them, but fortunately the cancer hadn't spread anywhere else. Seven weeks after the operation, Dilek, now back in London, began seven months of gruelling chemotherapy at the University College Hospital. Dilek has now passed the five-year milestone of being all clear from cancer, so she no longer requires scans and follow-up appointments, and has been discharged from the hospital's care.

As with so many cancer patients, Dilek is a much changed person from how she was pre-cancer. She told me that she lives her life very much in the moment, not making long-term plans. Dilek also said that she has no fear, and with a smile she admitted that living without fear can potentially get her into trouble. These days, although based in London, Dilek spends a lot of time with her two sons at her beach house in Alaçatı, which is a town on Turkey's Çeşme Peninsula. Born in the UK, she has Turkish parents, so she has dual nationality.

Dilek's message is that bowel cancer can be cured if caught early, and that any donation or support towards cancer charities helps support cancer research for future generations. Unfortunately, no-one can really understand the impact of cancer on a person, and it does hit hard.

Lauren Backler

Lauren Backler, 16 August 2017

I met Lauren Backler at Victoria Station, and we made the short walk to Buckingham Palace, where this photo was taken. I don't always have the photos planned, but on this occasion I had a specific idea, and it came out just as I'd hoped. Lauren's mother, Fiona, was just 56 years old when she passed away in 2015. Lauren took the devastation and anger that she was feeling and turned it into the most amazing positive quest to get the bowel screening age in England, Wales, and Northern Ireland reduced from 60 to 50, matching the age that it is in Scotland, and many other countries.

Fiona Backler was diagnosed with bowel cancer in December 2014. She'd been going back and forth to her GP for a while, and it was initially thought that she might have kidney stones, so she was waiting for a referral. However her health continued to decline, and she knew that something wasn't right, so she ended up going to the Accident and Emergency department at her local hospital in Eastbourne. It was then that she was diagnosed with bowel cancer, and sadly her condition was already terminal. She was given chemotherapy, although this was just palliative treatment, and not a cure. Although the initial prognosis was 12 months, Lauren's mother passed away at the end of March 2015, just four months after diagnosis. It's difficult for anyone to comprehend just how big a shock this must have been, and the utter devastation for the family, with so little time to prepare for their loss.

Bowel cancer awareness month happens each April, and not long after losing her Mum, Lauren found out about the bowel cancer screening age difference. She was, not surprisingly, furious on discovering this. She was still in the early, very raw stages of bereavement, and her anger was exacerbated by the knowledge that if her mother had been screened, as she would have been in Scotland, then there was every chance that her cancer could have been detected at – crucially – a much earlier stage. She might well have

survived, and still been here today. The seeds had been sown, but Lauren waited for a while, to allow herself to begin to deal with the grieving process.

In December 2015, exactly a year to the day that her Mum was diagnosed, Lauren set up her petition on Change.org to get the bowel cancer screening age reduced to 50 in England, Wales and Northern Ireland. Evidence suggests that over 4,000 bowel cancer patients would benefit from an earlier diagnosis, and thereby have a much better chance of survival. Of course, cancer diagnoses affect not only the patients themselves, but also their families, and the communities where they live. Lauren's mother was heavily involved in her local community, so her death had a huge knock-on effect. Lauren has done plenty of research into bowel cancer screening, but has been unable to find a plausible reason as "why the age is 50 in Scotland but higher in the rest of the United Kingdom". She told me that as well as saving lives, the lower screening age would save money too. If a patient is diagnosed and successfully treated at an early stage, then this would massively reduce the costs of having to treat them at a later date. From my own experience with my mother's five operations over four years, and her lengthy stay in hospital during the last few months of her life, I can appreciate just how much money her treatment would have cost the NHS. The National Screening Committee had initially advised the NHS that bowel cancer screening should start at 50, but this advice wasn't taken up. Lauren has asked many people why not, including Jane Ellison, who at the time was Parliamentary Under-Secretary of State for Public Health at the Department of Health, but has not been given a proper answer. If it comes down to resources then it is the job of Government to deal with that.

When Lauren set up the petition, she had no idea of how it would go viral so quickly, getting 100,000 signatures in the first month. She thought that it might get a few hundred signatures, and maybe do a little to help raise awareness about bowel cancer. With the petition getting such large numbers, the media began to take an interest. Lauren was interviewed live on Sky News, which was quite nerve-wracking, as this was the first media appearance she had done. She has been to Parliament several times, and on one occasion she watched the debate that came about as a result of her petition. Another time she gave a speech as a special guest of Beating Bowel Cancer at their Parliamentary Reception held there at the beginning of 2017. Lauren appeared on Sky Radio and was interviewed on *Good Morning Britain*, as well as on various regional news channels. There followed an appearance on *This Morning* hosted by Phillip Schofield and Holly Willoughby. The programme also featured bowel cancer survivor Richard Haugh, whose cancer was detected by the screening process in Scotland, proving that screening at 50 saves people's lives. She then went on to appear as a panellist on *The Wright Stuff* hosted by Matthew Wright, who has since become an Ambassador for Beating Bowel Cancer. Lauren is also keen for the take-up rate to improve for the screening kits that are sent out to the over-60s, and for people to realise the importance of taking the test and returning their kit. By helping to raise awareness, she feels that if just one person was to use the kit who might not have done so otherwise, then she will have achieved something.

Lauren was soon to begin teacher training in Eastbourne, with her aim being to teach at primary school. She had been an actor, but after losing her Mum, she found it incredibly difficult to give all her energies to it. However, whilst teaching beckoned, she still hoped

that acting would play a part in her future. The first record that Lauren bought was 'Freed From Desire' by Gala. Released in 1997, it reached number 2 in the singles chart. She actually got the cassette single of the track. She loves her music, and is a more a fan of bands as opposed to DJs. Elbow is one of her favourite bands, but she described her musical tastes as being not too picky.

The two and a half years since losing her Mum have been really tough for Lauren. Her family has always been very close, and the loss of her mother has been extremely traumatic, as it would be for any daughter, and has left her feeling very alone at times, in spite of being very close to her Dad and two brothers. Lauren feels like her life has been changed forever, and one thing that particularly hurts is everything that her Mum will miss. She has, in fact, already missed so much, including her older brother having another child. Lauren wants to have a family one day, and it hurts her deeply knowing that her Mum won't see it happen.

Lauren is yet another amazing person that I have met on this incredible journey, and she is a real inspiration to a lot of people. She is very kind and caring, but also possesses a steely determination to get the bowel cancer screening age reduced to 50, and she is not going to give up until she sees this happen. As we walked back towards Victoria Station, she told me one final thing that has stayed with me. She remembered a conversation with her Mum not long before she died, where her Mum told her that things could be worse. Understandably Lauren asked how on earth could things be any worse than they were, to which her Mum replied that it could have been the other way round, and she might be watching one of her three children with terminal bowel cancer. There is nothing more I can add to that, except to say that Fiona Backler was a quite remarkable woman, with Lauren following in her footsteps.

In August 2018, the government announced that they would be lowering the screening age from 60 to 50, but Lauren will not rest until there is an implementation date. The success of the petition is staggering, and at the time of publication, it had received a remarkable 500,000 signatures.

Deborah James

Deborah James, 20 September 2017

Deborah James has stage 4 bowel cancer. Her high-profile campaign on social media using the name "bowel babe" has helped to raise awareness about bowel cancer, and to raise funds for the Bowel Cancer UK charity. We met at the White Cross pub in Richmond on one of the most picturesque sections of the River Thames. There was no mistaking Deborah when she arrived, as she was wearing a wonderful pair of red high heel shoes. The light was rapidly fading, so we took some pictures before heading inside the pub to talk about her story.

Deborah's first record that she bought was 'Relight My Fire' by Take That featuring Lulu, which was a number 1 single in 1993. The song was originally written and released by Dan Hartman in 1979. Deborah said that at the time, Take That were a group that you would not admit to liking – in fact she pretended to like East 17 who were a bit more cool back then. These days she happily admits to liking Take That, and she has seen them live on a number of occasions. Going back a little further she asked her Mum to buy her 'If You Don't Know Me By Now' by Simply Red as she used to love Mick Hucknall. I was really interested to hear Deborah talk about her love of jazz and opera. She frequently goes to the Bull's Head pub in Barnes, which is well known for its live jazz scene, and to the legendary Ronnie Scott's in Soho. Her love of jazz dates back to when she toured the west coast of America, and spent a lot of time in San Francisco's jazz bars. Deborah went

to the Glyndebourne Opera Festival in 2017, and she told me that after her cancer diagnosis at the end of 2016 she went to watch the ballet *Giselle*. The second half opens with a graveyard scene, and as beautiful as the ballet is, it sent her into tears as she was overcome with emotions about her own mortality. The same thing happened when she went to see *Madame Butterfly*, where Butterfly kills herself with a dagger. Deborah said that they were both beautiful productions, but with more than a hint of humour, she added that they were maybe not best seen immediately after a cancer diagnosis.

Deborah had been having problems with her bowel for a year before being diagnosed with bowel cancer in December 2016. She had blood in her stools, she was going to the toilet at least ten times a day, and she was losing weight. Her GP had put her symptoms down to Irritable Bowel Syndrome. Deborah is a deputy head teacher, and at the time she was under a lot of stress as she had been seconded to a school that had been placed under special measures. One regret Deborah has is putting her own health at the bottom of her priorities. She didn't want to take time off for doctor's appointments, especially with the amount of upheaval her pupils were going through with the school being in special measures. The 5.5cm tumour had probably been growing inside her for about a year, but as she said, hindsight is a wonderful thing. Deborah was convinced that something was seriously wrong, and she started taking pictures of stools which, after showing her sister, she showed to the doctors on her fourth visit. Deborah decided that she could not wait for a referral, and instead, she paid for a colonoscopy, which led to the bowel cancer being discovered.

Deborah has an aggressive form of bowel cancer. She had a mucinous tumour, which can often show up as benign, and she has a BRAF mutation. In Deborah's case her MRI scan suggested the tumour was benign, so she didn't have any chemotherapy or radiotherapy to shrink the tumour before surgery. She feared that she would need a colostomy bag after the bowel operation, which she had in January 2017, but fortunately the section of the bowel that was removed was higher up than first thought, which meant she didn't need to have a bag. One third of Deborah's bowel was taken out. The surgeons had thought that the cancer was at worst an early stage cancer, still possibly benign, but then the biopsy revealed that the cancer was in eight lymph nodes. It had an aggressive mutation, which has a way of hiding itself in normal cells, and can spread very quickly and rapidly making it very difficult to detect.

Deborah was referred to The Royal Marsden Hospital in London. This hospital specialises in trials, which Deborah is particularly interested in, and wanted to take part in too. Following the surgery, she met with her oncologist expecting to be put on a course of chemotherapy for six months, and then to be clear of the cancer. Unfortunately the oncologist had bad news, and wanted to focus on Deborah's lungs. Another scan revealed that she had seven nodules on her lungs. In April 2017 she underwent the first of three surgical procedures. Her right lung is now clear, but unfortunately her left lung collapsed during surgery, so she still has two or three tumours there. Her ongoing problems are more about her lungs rather than the cancer, and she was due to see a lung specialist in the near future. The intense chemotherapy that Deborah is having is keeping her cancer stable. The tumours are not shrinking, but they are not increasing in size. The amount of chemotherapy that she is having is probably not something that her body will be able to

tolerate for a long time, but she is hoping that the aggressive treatment she is undergoing at this stage will enable her to stay disease-free for a longer period. She admitted to feeling more and more tired, as she has had more chemotherapy than most patients. Throughout this part of our conversation Deborah's positivity and determination shone through. I don't think anyone on the outside can really fully appreciate exactly what she has had to go through.

Whilst Deborah has been having her treatment, she has also done an incredible amount of fundraising and awareness raising for the Bowel Cancer UK charity. She comes across as a human whirlwind, tearing up everything that is thrown in her path. The first thing that Deborah decided to do was to tell the children at her school that she had cancer. Too many teachers had been coming and going without explanation, so she wanted let the children know exactly what was happening, and why she would be disappearing. The response she had was amazing, not just from her own school, but as the news spread, from other schools that she had worked at over the last 15 years. Understandably Deborah found it difficult and very draining to keep repeating the same story to everyone, so it was at this point that she decided to start writing a blog about her illness.

Deborah realised that raising awareness in the UK is probably 10 years behind some other countries. She didn't think she had bowel cancer, and aged 35 she is not the stereotypical bowel cancer patient, but she has come to realise that there are many people in a similar situation to her. The number of people under 50 getting diagnosed at a late stage as Deborah did is on the rise. The blog got a great response, and it led to Deborah appearing on the *Victoria Derbyshire* programme, and on *BBC Breakfast*. Then she began to write an online column for the Sun newspaper, where she was able to express her opinions about life, with her own cancer never too far away. More recently she was working on a project with the Stand Up To Cancer charity.

Deborah admitted to living her life at one hundred miles an hour. She has refocused things more on herself and her family – the most important parts of her life. Her two children think that it is a good thing that mummy has got cancer, as it means that they have been getting to see a lot more of her. She has learnt to slow down a little, and has got a much better balance in her life, but she still finds it strange.

Deborah came across as someone with positivity and determination, but also as someone very much in touch with the reality of her situation. She talked with passion about her cancer, but also with a huge amount of common sense. She has no control over the cancer, and statistically speaking she shouldn't even have it. The statistics associated with BRAF tumours are not good. Her oncologist cannot predict what is going to happen, and it really is a case of taking things one step at a time. The doctors are doing everything they can for her, and hopefully advances being made all the time in research will mean that Deborah's chances of a positive outcome improve. We chatted for over three hours, and she was especially interested in my Mum's cancer journey. I found Deborah to be quite an amazing person. Throughout the evening she would break into laughter, and her feistiness with some wonderfully colourful language was never too far away. I cannot overstate just how important the things that she is doing are, in terms of raising awareness, raising

money, and – perhaps most importantly – letting people out there in similar situations know that they are not on their own.

Since our meeting Deborah's journey has continued apace. She co-hosted the brilliant *You, Me and the Big C* podcast with Lauren Mahon, and Rachael Bland who sadly died in September 2018. The three ladies talked about living with cancer honestly, and with an unashamedly dark humour at times. Deborah also published a best-selling book, *F*ck You Cancer*, and I met her again at the Henley Literary Festival, where she kindly signed a copy for me. Deborah also had a period of remission, which unfortunately only lasted a few months. Her cancer has metastasized to her liver, and she continues to be treated at The Royal Marsden Hospital.

Dafydd Wyn Farr-Jones

Dafydd Wyn Farr-Jones, 5 January 2019

I travelled to the Plough at Stalisfield in the heart of the Kent countryside to meet Dafydd Wyn Farr-Jones. We had lunch there with Daf's partner Russell, although things didn't go quite to plan to start with. Daf had sent me a link to the pub's website, so I got the directions and arrived there in plenty of time. Daf and Russell arrived half an hour late, as they had been sat in another pub called the Plough waiting for me! Daf said that alarm bells started to ring once the staff told him that they didn't have a booking for lunch. Once they realised their error they made the twenty-minute drive to meet me, so it made for an amusing start.

Daf was diagnosed with bowel cancer in 2009, and he has done an awful lot of fundraising and awareness raising for Beating Bowel Cancer, and now Bowel Cancer UK. I've known him since I started fundraising in 2012, and he has always been a terrific support, and has given me numerous contacts to try and get for the books. I'd met Daf and Russell for the first time in August 2017 at Kensington Gardens in London at an event called The Big Hug, which was organised by Daf to celebrate the lives of Ben Ashworth and Anne Carlin, both of whom had died that year of bowel cancer.

Daf spent years listening to Welsh music growing up, but his first record was the 'Mr Blobby' song from 1993, which got to number 1. He was a big fan of *Noel's House Party*, and the song was released at the height of the show's popularity. The single went platinum, selling over 600,000 copies, so there were plenty of people, including me, who have this in their record collections. Russell, on the other hand, bought the *Now That's What I Call Music 41* compilation album as his first record.

Daf led a busy life before getting bowel cancer at the age of 26. The diagnosis was quite late. The symptoms had begun in July 2009, but it wasn't until the October that the

diagnosis came. He kept going to his GP and being told it was Irritable Bowel Syndrome, and was given Gaviscon, which is commonly used for treating an upset stomach. Daf finally got to see a consultant after being fobbed off by the doctor four or five times. The operation on Daf's bowel took place in January 2010.

Daf met Russell in 2009 at the Pizza Express in Leadenhall Market in the City of London, and after a while they moved in together in Russell's flat in London. Daf adopted Russell's cat, Ticky, which was in fact Russell's dad's cat. This was also the first time that Daf had owned a cat. He said that Ticky proved to be a comfort when he was ill, giving him lots of affection when he needed it. Growing up, Daf was bullied at school, and said that he was always at his happiest when he was at his grandmother's with her cat. These days having cats brings back many happy memories for Daf of his time living with his grandmother, and her death had a profound effect on him as he grew up. He now has three cats (Duke, Mikey and Colin), and two rabbits (Beyoncé and Jay-Z|), which are adopted or rescued, and which keep him focused, not to mention very busy. Having animals bring great comfort to Daf, as they don't judge – they just provide unconditional love on their own terms.

Daf and Russell had only been seeing other a few months when Daf was diagnosed with bowel cancer, and it was a difficult time with a very uncertain future. They decided to get married, so planned a civil partnership in the June to give Daf time to recover from the operation. They converted the civil partnership into a marriage after the law was changed in February 2015. Russell had been made redundant from his job in IT, so was doing some volunteering with Beating Bowel Cancer, which was how Daf then began his fundraising. His first venture after getting married was to walk up Ben Nevis and Mount Snowdon in the same year to raise funds for the charity. The physical aspect to the challenge proved to be quite gruelling, coming so soon after major surgery. As a result Daf decided to switch his fundraising to eBay, and now runs regular auctions featuring items donated by celebrities and major businesses, and has raised thousands of pounds in the process. On top of the bowel surgery, Daf has also had two major operations on his back, and has also undergone two major knee operations. He has so many scars that he describes himself as like a patchwork doll.

Daf told me that the fundraising gives him something to focus his mind on, and he finds it very rewarding being able to help others going through bowel cancer. He said anything is possible, and described how he managed to arrange for a stage 4 bowel cancer patient to meet the First Minister of Wales, through sheer persistence and refusing to take no for an answer. Daf published his brilliant charity recipe book in 2016 called *Cook Along With Celebrities and Inspirational People*, which I was very happy to be part of using my mum's sausage casserole recipe. He is currently in the process of putting a second fundraising book together, which will be in memory of the late Dame Tessa Jowell.

Daf also gives talks on behalf of Bowel Cancer UK about health in the workplace. He found this particularly hard on one occasion when he spoke to an office full of people he worked with, and had to tell them about his personal story. He continues to do this each year, and although it's hard, it's also really important.

Daf suffered a personal loss in 2015 when his dad died of bowel cancer. They had been estranged for 20 years. His granddad died of lung cancer, so cancer has always been in the male side of the family. Although he didn't have a good relationship with his dad, the fact that he also went through bowel cancer affected Daf a lot. Daf believes that everything you go through in life makes you stronger, and whatever you go through, there are others going through worse. In 2013 he thought that he was going to lose his mum after she suffered a major heart attack, spending four months in hospital before making a recovery.

Russell has been a big support to Daf, who is currently learning to drive, so he is still reliant on Russell to drive him around and also to pick up his medication. Russell has gone with Daf to a number of funerals of bowel cancer patients. Daf said that they don't tend to go to as many now, because it just gets too much, and takes over your life when you get too emotionally involved. He pointed out that these people might be seriously ill, yet still manage to support him with his charity work, and this is something that I have experienced first-hand too.

It was really nice spending time with Daf and Russell. They were great fun, and Daf has been through an awful lot, but is selfless and determined in his efforts to help and support others. Bowel cancer might be perceived as an older person's illness, but more and more young people are being diagnosed. It is crucial that early detection rates improve to bring down the number of deaths that could be prevented each year. Daf said that things are now changing, and hopefully bowel cancer in younger people is being taken more seriously. He will continue to do what he does for as long as it takes.

Olivia Rowlands

Olivia Rowlands, 24 February 2018

Olivia Rowlands is a primary school teacher who lives with her husband Sam in St. Andrews, north-east of Edinburgh. Liv is recovering from bowel cancer, having been diagnosed at the young age of 29. Time and time again we are reminded that bowel cancer can affect people of any age. My original plan had been to meet Liv in Scotland, but the trip fell through after her mother booked a weekend in Dublin for them, not knowing that Liv had planned to meet me. As result we made an alternative plan, and arranged to speak on the phone instead. It's always a shame when I don't get to meet someone in person, and St. Andrews looked beautiful, so it was also a pity to miss out on going there.

Liv sent me this photo, which was taken just two weeks after her tumour was removed. She was recovering from the nine-hour operation, having had sepsis twice, and was still getting her head around having a stoma. Liv wasn't in pain any more, and she felt over the moon. The photo was taken in her family home in Crail, Scotland. She describes it as the most relaxing, calming place she knows, and as her favourite place in the world to be in.

The first record that Liv bought was *Spice*, the debut album by the Spice Girls. It was a multi-million selling album worldwide, reaching number 1 in both the UK and the USA, as well as in many other countries. In the UK, the album topped the chart for 15 consecutive weeks.

Liv and Sam have always enjoyed their music, and they occasionally post songs on social media, purely for their own enjoyment. Liv got a degree in music before doing her PGDE to become a teacher. She plays the piano, and is also trying to teach herself the guitar. She listens to a wide cross-section of music, which includes Paul Simon, Ella Fitzgerald, Gregory Porter, and Mumford and Sons.

Liv led a very happy life before bowel cancer. She had just qualified after teacher training, and had been married to Sam for three years, so they were still relative newly-weds. Liv's parents live in Dubai, and Sam's parents live in Belgium, so they enjoyed travelling to see them.

Liv had been experiencing symptoms for about two years before being diagnosed with bowel cancer. Her GPs basically weren't listening, and were putting things down to Irritable Bowel Syndrome and intolerances, so as a result Liv was on and off dairy and gluten during that time. Eventually someone realised that something was wrong, and Liv was diagnosed in December 2017 after having a colonoscopy. While she was waiting for her treatment plan Liv kept feeling really ill, but her GP's surgery kept sending her home. Things got so bad that Liv's mum, whilst over from Dubai, took her to the local hospital, and Liv was diagnosed with sepsis. Liv had emergency surgery to get rid of the infection, and was fitted with a stoma to prevent the infection coming back. Although a "poo bag" was the last thing she wanted, she was so ill that she was almost beyond caring at that point.

Sepsis is a life-threatening condition – a rare but serious complication of an infection. Without quick treatment sepsis can lead to multiple organ failure and death. Sadly, this is something that I am all too familiar with. In 2009 my father developed sepsis after coming down with pneumonia, and died just a week after falling ill.

Liv was given her treatment plan, which involved radiotherapy to shrink the tumour to enable surgery. She was also told that she that she wouldn't be able to have children as a result of the radiotherapy. Having started treatment Liv got sepsis for a second time, so the surgery was done straightaway in case the radiotherapy wasn't working, and also to remove as much of the tumour as possible. The operation was successful, and the surgeon managed to remove all of the tumour. It was decided that Liv would still have radiotherapy and chemotherapy after the operation. She had six weeks of chemo, followed by five weeks of radiotherapy, and then another six weeks of chemo. Following the treatment Liv was given the all-clear.

At the end of October 2018, Liv underwent a stoma reversal. This is not straightforward, and getting used to a new bowel, and for it to work properly, takes a long time. Liv told me that she wasn't prepared for just how hard things would be. Following the operation Liv's bowel went to sleep, which meant she was in hospital a lot longer than she was supposed to be until the bowel started to work. It's been a long, hard process, and by her own admission Liv is very impatient. At first she wondered why she had even had the reversal, but over time the improvement has been amazing, and now Liv is very pleased that she persevered through the tricky early stages.

Liv's blog and her presence on social media has helped to raise awareness about bowel cancer, and has been a source of great support for a lot of people. Following her diagnosis Liv found that she was being asked the same questions each day by lots of people, and so she decided to start writing a blog, which avoided the necessity for her to repeat the same information over and over again. The blog proved to be very popular, and Liv then began looking on Instagram, and discovered that there were a lot of people going through the same thing as she was. She began making friendships, and found that it was a nice way to normalize things, and to give and receive incredible support. However, the downside to this was that she would also have to go through the pain of losing people who died from this awful disease.

Liv had not been able to teach for just over a year while she went through the treatment. When we spoke she had just started working full-time once again after a phased reintroduction. Unsurprisingly she tires easily, and so it will take a little time for her to be fully back to her old self. Liv and Sam hope to do a lot more travelling, particularly to see their parents overseas, and they also are hoping to start a family by going through surrogacy with Liv's preserved eggs. She also said that she was quite happy with her life before cancer, and just wants a bit of normality once again.

It was really nice speaking to Liv. She is another example of just how amazing people are in the bowel cancer community. She comes across as such a happy and positive person. It was a shame that I wasn't able to meet her face to face, but it just means that I will have to visit St. Andrews another time, when hopefully I'll be able to meet both Liv and Sam together.

Greg Gilbert and Stacey Heale

Greg Gilbert and Stacey Heale, 6 November 2018

I met Greg Gilbert and Stacey Heale in their hometown of Southampton. Greg, a musician, artist, and writer, has stage 4 bowel cancer, and his wife Stacey, a former university lecturer in fashion design, and now a writer and speaker, stopped working to become Greg's carer. I'd been in contact with them for over a year, and initially Greg had decided not to take part in the book, so it was just going to be Stacey, but shortly before our meeting she told me that Greg was also happy to be involved. I'd got to know both of them fairly well on social media, so I was really looking forward to meeting them both at the Trago Lounge, which is a café in Portswood just outside the city centre. One of the reasons we met there was so I could bring my dog with me, and Prince was spoilt rotten, not just by Greg and Stacey, but also by the staff there too.

Greg was diagnosed with bowel cancer towards the end of 2016. He had been treated for his initial diagnosis of IBS (Irritable Bowel Syndrome), but his condition deteriorated and he ended up being admitted to A & E, where an x-ray detected bowel cancer. Further investigations revealed that the cancer had spread to his lungs. Treatment options on the NHS were limited to a 12-week course of chemotherapy, as surgery on the bowel had also been ruled out. The only immunotherapy drug that Greg was compatible with, Avastin, is not funded by the NHS. Immunotherapy treatment involves taking medicines that encourage the immune system to fight cancer. It was at this point that Stacey set up an online fundraising campaign to raise money to fund Greg's treatment. The couple did not have any medical insurance, and although they are both advocates of the NHS, Stacey couldn't just give up and allow Greg to die, and leave their two young daughters, Dali and Bay, to grow up without their daddy because of money. I don't think Stacey and Greg were prepared for the surge of support from fans of Greg's band, Delays, and within days over £100,000 had been raised. That figure has now risen to over £200,000.

Stacey talked about the availability of drugs, and whether in fact people with private healthcare insurance would have a better chance of getting those drugs. She spoke about a cancer world where private clinics prey on cancer patients' vulnerabilities and desperation for a cure. Greg and Stacey have been contacted by thousands of people telling them that Greg should not have chemo, and suggesting that he could be cured by eating cabbage, eating meat products, taking turmeric tablets, going to Mexico to have IV sodium bicarbonate, and numerous other so called remedies. Stacey had spoken to people who had sold their homes and bankrupted themselves in the desperate search for a successful cure. During Greg's first round of chemotherapy, which was extremely hard for him, he was contacted by people telling him that the chemo could cause more cancers and kill him. These people were so convinced about their righteousness, but it was based on no foundation at all.

I think, having asked Greg and Stacey about the first records that they both bought, the conversation then went off on a tangent for half an hour. Greg was really funny in the way he finally managed to bring the talk back onto records from a rather in-depth discussion about cancer. His first record was a compilation cassette called *American Heartbeat*, which was released in 1984. He said that it was an album full of MOR (middle-of-the-road) and AOR (album-orientated rock) music, featuring bands like Toto, REO Speedwagon, and Survivor. It was the music that Greg was heavily into at the time, and he regarded it as a soundtrack to what America was like, literally playing it until the tape wore out.

Stacey's first record was 'I Should Be Lucky' by Kylie Minogue. The song was a worldwide hit, and topped the UK singles chart for five weeks in 1988. She told me that one of her favourite Christmas presents was when her Nan bought her the top ten singles of the Christmas week's chart. They were all individually wrapped, so Stacey started unwrapping at number 10 going down to number 1. Greg pointed out that they wouldn't be able to do that for their two girls in the modern era of downloading and streaming music.

Greg's band, Delays, has released four albums so far. Until I made contact with Greg and Stacey, they were a band that I wasn't overly familiar with, but that soon changed, and in the months leading up to our meeting I was listening to their music probably more than any other band. My personal favourite album is the 2008 release *Everything's The Rush*, and Greg said that there was quite a bit of pressure surrounding it. The band had been dropped by Rough Trade, but subsequently signed to a major label, which had that extra added pressure and expectations. It's an album that Greg is really proud of, and he said it has more organic sounds on it, including an orchestra recorded at the Olympic Studios – where The Rolling Stones and Led Zeppelin also recorded – which was an amazing experience. Greg described the rather comical scene that unfolded while the orchestra was recording: Stacey appeared in the studio to take photos with her camera, to Greg's sheer horror. One of the first things that I did after the meeting was to buy all four Delay albums on CD.

The band's last release was back in 2010, which was six years before Greg's bowel cancer diagnosis. They last toured together in 2014, and their last appearance was at the Isle of

Wight Festival. Greg told me that none of the band were making any money out of it, and that three of them had started families, so they needed to find alternative careers. Stacey pointed out that the industry was changing. The times of being given a publishing deal and regular wages were over, and the band were being asked to play gigs for no fee, and to record and release music for free, in order to gain exposure, which wasn't a sustainable situation with young families and mortgages to pay. However, Greg said money was never an issue within the band, and that they remained fully focused, with their conversations revolving around how to make the best record possible.

One of Greg's favourite things about being in a band is getting together in a living room with a film playing in the background with the sound turned down, and working out new songs together. These days he enjoys the creative side of music more than the thought of performing. Greg described how his health issues were making touring difficult back in 2014, as at that stage Greg was already suffering acute pain from his – at that point, undetected – cancer, which was already having a debilitating effect on him.

The band has not split up, and remains in limbo, with Greg saying that first and foremost they are great friends. He added that one of the problems these days is that they are all spread out in their lives. His brother and fellow bandmate, Aaron, is busy working on film sets in London, but Greg has been jamming with the other members, Colin and Rowly. Greg has two albums' worth of songs written, but he pointed out that without Aaron's contribution it wouldn't really be a Delays album. The songs that Greg has been writing are very personal to his traumatic cancer journey. He said that he wasn't sure if they would work as Delays songs, so another possible option might be making a solo record. I asked Greg if he had recording equipment at home, but he said that he is hopeless with technology, so he uses his phone to record his new ideas. Greg explained that what he and Stacey had experienced with the fundraising campaign, and the support of so many fans, validated every single moment of being in a band. Greg genuinely had no idea that the band had reached so many people, and he had no perception of the band going beyond certain parameters of being just an indie band.

Greg has spent more time recently on his art and poetry, which he said has come a lot more easily than the songwriting. He is a superb artist, and very kindly agreed to allow me to use one of his pieces of work as the basis for the front cover of this book. I actually collected the stunning painting when we met. It's a wonderful memento of our meeting, and something that, as I told Greg, will be hung on my wall, and enjoyed for life. Greg said that he's learnt more about the creative aspect of his life since his diagnosis than in the five to ten years before that. He believes that, sadly, the diagnosis and everything they have been through has brought out a lot of the creative art and writing that he had always wanted to do. He described it as like having the veils torn away, and now he simply goes for it without fear of how his work might be perceived by others. In his own words, "F*ck it, I don't care." It's been a hard-won development for Greg, and one thing out of a terrible situation that he is grateful for.

Greg also loves books, and is an avid reader. He described having piles and piles of books by his bedside. I am not sure Stacey shares Greg's enthusiasm for the books, but I suspect that's more down to the fact that they are cluttering up their bedroom. Her exact words

were, "I absolutely can't talk about it." Greg has published a poetry book, *Love Makes a Mess of Dying*, inspired by his illness. He said that life had all of a sudden given him the biggest theme of all, and that the rawness of his reality was the most personal thing he had. Greg hoped that by being honest and sharing stuff, it might make other people in similar situations feel less lonely.

Greg admitted to sometimes getting into heated debates on social media. He said that it was easier to be angry about something than to be scared about what you are going through. He is passionate about the NHS, but fears for its future and what is in fact already happening to it. Greg pointed out that if the wrong words were said to him at the wrong time it could send him down a rabbit hole. One such experience was the mention of life-extending by oncologists. Greg is in no way in denial of his situation, but at the same does not want to go too far into the realities of it, as it wouldn't be helpful for him. He prefers to stay optimistic without needing to go into too much detail. Greg said he is very lucky to have Stacey and his family around him, as they act as a kind of shield, which has allowed him to indulge himself in reading, writing, and art.

The effect that Greg's cancer has had on Stacey's life has been huge. When Greg first went into hospital, and was diagnosed, Stacey was two weeks away from returning to work after maternity leave. She could remember sitting alone in the hospital thinking that she had to go back to work, so as to continue to pay the mortgage, which she could just about manage on her own. Stacey also tried to figure out who would come in to look after Greg when she returned to work, not to mention who would sort out their two girls. She said that in the end she was in such a state that she was signed off sick. Greg pointed out that Stacey's role as his carer, and how she threw herself into the fundraising campaign, was her way of coping with the situation.

Stacey has been on a real journey during the past two years. At the beginning she said that she was spurred on by sheer terror and adrenalin. When she started the fundraising campaign, Stacey had no expectation of being able to raise the money. Greg pointed out that he was not so much worried about whether the campaign would be a success, but more about the effect it might have on Stacey if it didn't succeed. Stacey admitted that when Greg first went into hospital, she didn't think that he would live more than a couple of weeks. He had lost so much weight, and looked so ill. When the diagnosis came it all finally kind of made sense to her.

Over the next four or five months Stacey threw herself into everything. The fundraising campaign had achieved its target, Greg was on chemotherapy, there was so much going on, and so many things she wanted to do that she burnt herself out. Greg pointed out that they fell out very badly over it. He said that they had both buried their noses in what they were doing. They had their backs to each other facing the world instead of each other, and didn't understand each other. Stacey said that as a result she took a step back from some things. She had been reaching out to the online community, and had felt safer and comforted there, feeling that she was helping and supporting others by giving an insight into her experience. The detrimental effect of that situation, though, was that Stacey and Greg had become like ships in the night. At the same time that Stacey decided to take a step back, she also left her job, and accepted voluntary redundancy. She was a course

leader, and had also been a lecturer for eight years, so her work had been an enormous part of her life. In spite of her colleagues trying to make it possible for Stacey to return to work, she realised that she couldn't do it anymore. Stacey said teaching is a lifestyle choice. She was responsible for a lot of students, and as well as the day-to-day teaching, it's also all about the emotional stuff that goes with it. It's a very stressful job, and with two young children and Greg on chemo, Stacey feared she would have a nervous breakdown. She admitted that she also had a lot of anger to deal with regarding cancer, and was asking herself what else it was going to take now that it taken her career.

Stacey now writes a newspaper column, and gives talks about cancer. She feels that she has transferred her teaching skills to use when putting ideas out to an audience, asking them about their own experience, and starting a dialogue about it, which she considers to be pretty similar to lecturing. She is not presenting facts, but rather ideas, and asking how everyone feels about their experience with cancer, and how they can move forward.

Greg and Stacey got married in 2018. Greg said that before they got married, he introduced Stacey to people as his wife rather than as his partner. Stacey said it was a bit weird as they had been together for 12 years, and so they were already very established, as opposed to couples who might get married after a couple of years. They both described it as lovely and beautiful day, and Stacey said that the day was great fun, and that they had such a laugh. It was a very small service for their immediate family, who were shouting out stuff during the ceremony. At the traditional moment where the question is asked, "Is there anyone here who objects to this marriage?", everyone started shouting. Greg described how, during the service, he held Bay, and they both thought it was really special having their children there with them on the big day. They both believed that having their two children was a much bigger life event than getting married.

The meeting with Greg and Stacey was every bit as good as I hoped it would be, if not better. They are two very likeable people, who are kind, warm, and outgoing, with plenty of interesting things to say. The support that they have given to others in such a time of adversity is pretty special. I liked them straightaway, and immediately felt comfortable in their company, so it was more like catching up with friends than meeting with two people I hadn't met before. I was extremely grateful for them talking so openly to me about such a difficult subject. They were also really amusing with a great sense of humour throughout, and I left them feeling like I had made a couple of good friends. Hopefully I will see them again in the not-too-distant future.

Richard and Sarah Haugh

Richard and Sarah Haugh, 25 June 2018

I met Richard and Sarah Haugh at the Crown Inn at Playhatch, which is just outside Reading on the Berkshire/Oxfordshire border. It was a perfect location to have a chat over a cold drink at the end of a scorching summer's day. The couple used to live quite locally in Sonning Common, and were down from Scotland, where they now reside, to visit Richard's parents. Richard used to work for British Gas in Reading, and Sarah worked in Henley. It was while working and living in Aberdeenshire that Richard was diagnosed with bowel cancer, and this illness changed both of their lives forever.

I'd previously met Sarah a couple of years earlier, in 2016, at Beating Bowel Cancer's Patient Day in London, where she was giving a talk. This annual event brings together patients and their families to meet and talk to others in a similar situation. I'd stayed in touch with Sarah on social media, and I was delighted when they both agreed to be in the book. The only problem was where and how to meet up. This small window of opportunity presented itself, and I ended up spending a really enjoyable couple of hours chatting to them.

Sarah felt rather embarrassed about her first record, which was 'Tie A Yellow Ribbon Round The Ole Oak Tree' by Dawn featuring Tony Orlando. The song sold a million copies in the UK, and was number 1 on both sides of the Atlantic. I actually think it's a cracking first record to have bought. Richard, on the other hand, was very proud to have bought a KTel Disco Rocket compilation album as his first record in the 1970s. These records, hugely popular in their day, have sold an astonishing half a billion units worldwide. I wonder how many other people still have one of these records in their collection.

Richard told me about his bowel cancer. He suffered an anal bleed at work, which came as a big shock. He went to the doctors, where he saw a locum, who wasn't particularly helpful. The stool sample that Richard submitted came back negative. Richard had just turned 50, so he decided to just wait for his bowel cancer screening kit to arrive. In Scotland, bowel cancer screening begins at 50, as opposed to 60 in England, Wales, and Northern Ireland. This time Richard's samples tested positive, and within a couple of weeks he had a colonoscopy, which couldn't be completed as they couldn't get the camera round the tumour. Richard was sedated for it, and the first thing he remembers is being told that they needed to find his wife before stating what had been found. Although the diagnosis was cancer, Richard and Sarah were told to wait for them to be back in touch, which left Richard in limbo, and feeling very uncomfortable, having been given what he thought at the time was a death sentence. The couple panicked, and decided to get a scan done privately, which confirmed the bowel cancer. Richard got a date for surgery to remove the tumour which was 5 November 2012.

The surgery to remove the tumour was successful, but they also discovered that Richard had diverticulitis, which is a digestive condition that affects the large intestine (colon). The surgery went from being keyhole to open, which gave rise to a big infection, and meant that Richard stayed in hospital a lot longer than planned. Richard was assessed by the tissue viability department, and had a vacuum pump put into the wound to suck out all the poisons and toxins. This was bizarre as the treatment actually left the wound open until new skin grows and you recover. During this period of recovery, Richard who was contracted in the oil industry, managed to go to the Christmas party. It was a black tie event, and Richard managed with his open wound by wearing a pair of black tracksuit trousers!

Once the wound had healed, Richard had four cycles of chemotherapy – each cycle lasting three weeks. Richard was slowly able to return to work, and have scans every six months. At one point a cyst was discovered on his liver, and this was a very worrying time. The cyst was only confirmed after a CT scan and a MRI scan. Not surprisingly the initial worry was that the cancer had returned. You can understand why patients are always so anxious about their scans.

Richard was very keen to point out that throughout everything he had the unwavering support of Sarah. She learnt everything possible about bowel cancer, and made sure Richard's treatment guidelines were strictly adhered to, and that all the scans happened when they should.

Richard isn't working at the moment, but rather than retiring he considers himself as taking a long sabbatical. He has been fundraising, which started when he took part in Decembeard 2013 supporting Beating Bowel Cancer. For this event he was sponsored to not shave during the festive month, and to grow a beard instead. He did so well that he was awarded the top-raising individual 'beardy' in the UK! Both Richard and Sarah have also campaigned tirelessly for the age of the screening test to be lowered in the rest of the UK to match that in Scotland and were featured in many newspaper articles. Richard even appeared live on *This Morning* with Phillip Schofield and Holly Willoughby. For the last three years Richard has successfully completed a 200-mile cycle ride across The Grampians each summer in support of Maggie's Cancer Centres, after having only taken up cycling after he finished chemotherapy. By his own admission Richard was

overweight, weighing 16 stone after chemotherapy, and found cycling a great way to lose weight and get fit. Since he has cycled well over 10,000 miles, his reward to himself for that was to buy a new road bike. He has also supported Friends of Anchor in Aberdeen, which is a charity set up to raise funds to make cancer care in the region the best that it can be. Sarah even managed to persuade Richard to apply to take part in a male catwalk show, which is a major yearly event in Aberdeen, organised by Friends of Anchor. Applicants had to submit their story to a selection committee, which looked at several things: how far patients had gone with their treatment, the effect that telling their story might have on the wider community, and whether they would be able to physically cope with the event. Richard was one of three people out of 24 who were chosen for the show and interviewed, sharing his inspirational story on the night with hundreds of guests.

I was interested to get Sarah's perspective on Richard's illness as she was both a wife and carer. She said that it was extremely hard, and because they were given no information at the outset, Sarah decided to go out there and find out everything that she could about bowel cancer. The stark question for her was how could she care for Richard if she didn't have the knowledge? Although others might say, "Don't look on the Internet," Sarah did, as it was the only way for her to find information. It was through the Internet that she came across Beating Bowel Cancer, which proved to be a really good support system for her. Whilst Richard was in hospital, Sarah drove over 100 miles each day on school runs as well as going to the hospital to visit him. They had no family in Scotland and Sarah had to ask for help at times, which is something she would not normally do. She also had to take Katy and Peter down to auditions and University open days in Bristol and Bath, so the situation was exhausting and extremely difficult.

Sarah had been on the Beating Bowel Cancer online forum from the start of Richard's illness, eventually becoming a moderator for the last two years. She was approached during that time and asked whether there should be a place online just for relatives. Sarah thought it was an excellent idea, as it was hard to talk openly to other relatives without upsetting the patients on the forum. She said that carers didn't want loved ones to know how worried they are, or that they couldn't cope. It can be extremely exhausting staying strong all the time. Being a founder and sole moderator of the very successful 'relative to relative support' group on the charity's forum is something that Sarah is immensely proud of. This was not an easy role, as by supporting other relatives Sarah found that she was reliving Richard's journey over and over again. However, she would be on the forum chatting to patients' relatives well into the small hours, giving a great deal of her support and knowledge to others. Sarah also helped set up the 'Wellness during and after treatment' group, another part of the forum, which invites sharing on information like cycling, yoga, and recipes for cancer patients.

Sarah felt that five years was a good time to take a step back. Richard was at five years in remission, which is an important milestone in any cancer patient's journey. They felt that it was a good point for them to move on with their lives. However, she still feels that she has a lot to give, and has an in-depth knowledge of the subject. I think when the circumstances are right, Sarah might well return to the charity in some capacity.

We spoke about bowel cancer for half an hour, but we were actually together for a couple of hours. Richard and Sarah are a wonderful couple. Laughter was never far away, and I had so much fun in their company. They are also both very modest people, and neither

liked to talk up their own achievements, leaving it to the other one to prompt them. Richard and Sarah have given up so much time to help others. Charities simply could not function without such people. Since Richard's recovery from bowel cancer they have thrown themselves into enjoying life, and have not put off doing things until another time. Richard said that having cancer is bizarrely life-enhancing, but only if you get to his stage five years on. Of course not everyone makes it to that milestone.

Nicole Cooper

Nicole Cooper, 3 April 2019 — Photo Used By Kind Permission of Sean Crank

Nicole Cooper is a working wife and mother who lives in Melbourne, Australia, with stage 4 bowel cancer. Melbourne is my favourite Australian city, and I have been fortunate enough to have been there three times. I would have loved to have made trip number four to meet Nicole in person, but sadly that wasn't possible. Instead, we were able to have a video call on WhatsApp, and then Nicole sent me the photo of her standing on Brighton Beach, not far from her home, on a very blustery and rainy (and typically Melbourne) day.

Nicole was born in Perth, the capital of Western Australia, which is a city my own family has a connection to. My mother's grandparents sailed to Australia in the early 1900s, taking my grandmother with them, who was a young child at the time. In February 1916 they took part in the building of ANZAC Cottage, which was built in one day. It was a war memorial for those soldiers who died at the Gallipoli landing, and also a home for a returned wounded soldier, Private Cuthbert John Porter, and his wife Annie. My mother, brother, and sister have all visited it, but it's a place I've still got to see.

The first record that Nicole bought was a Baz Luhrmann album, *Something For Everybody*, which was released in 1998. It contains re-recordings and remixes of songs from his films and plays, including *Romeo and Juliet*, *Strictly Ballroom*, and *La Bohème*.

Nicole said that she had studied *Romeo and Juliet* at high school. She described the album as a bit bizarre and left of centre in its premise of taking the works of a single director and putting them into an album, but it worked, and was a huge hit in Australia.

Nicole's musical tastes are very diverse and eclectic, and she said that they have been heavily influenced by her dad. She is a big fan of Robert Smith of The Cure, as well as The Rolling Stones, Spice Girls, Britney Spears, Miles Davis, and Diana Krall. In the gym she listens to a lot of heavy R&B and rap, as it encourages her to work harder, so the list is pretty endless.

We talked about Nicole's life before her bowel cancer diagnosis. She studied Journalism and Asian Studies at university, which resulted in a double degree, and she majored in Indonesian as a language. Nicole said that she had hung onto an idea that her dad suggested to her, which was working for ASIO, the Australian equivalent to MI5. She successfully applied for a job there after finishing university, and worked for five years in counter-terrorism. Whilst there she met her husband, Tim, who was also a spy. At this point in our conversation I was thinking to myself that I was having my first-ever conversation with a real-life spy!

Nicole and Tim decided to move on to new challenges. The couple were now living in Sydney where Tim worked as a merchant banker, and Nicole worked at Ernst & Young for the next five years as a management consultant. The job involved a lot of travelling, spending Monday to Thursday in Perth every week, so Nicole then went to work in her parents' business, which is a training organisation for real estate agents, and the couple moved to Melbourne. It's a job she has been doing pretty successfully for the last five years, and whilst working there she became pregnant with their son Joshua. Nicole was diagnosed with bowel cancer in March 2017, two months after she returned to work following maternity leave. Joshua was just eight months old.

Nicole does a lot of fitness work, and we talked about the benefits that had for her and her life with cancer. At the time of her diagnosis, Nicole was told by her first oncologist that her cancer was inoperable, and that her condition was terminal. This was a traumatising experience for Nicole, who was 32 years old with an eight-month-old baby. She went to see another oncologist who told her that there was a tiny window of opportunity that might work, but that she would have to exercise as part of her treatment plan. The oncologist prescribed her chemotherapy with a view to possible surgery. He told Nicole that exercise would help with the side effects of a really aggressive form of chemo he was going to put her on. He said that people often don't get to the end of this type of chemo regime due to it being so horrible, but that he needed Nicole to go through it all. Nicole took his words very seriously, and the regime gave her something to desperately cling on to and have control over during such an awful time.

In October 2017, having gone through twelve rounds of chemotherapy, Nicole had the operation she was told she would never have. Surgeons removed two segments of her liver and 25cm of her bowel. At this point all signs suggested Nicole would be, rather miraculously, free of disease; but a further scan revealed that she had some cancer on her lung. She underwent surgery on her lung in March 2018, which turned out to be a massive operation as surgeons had to saw through a rib to get the best angle in order to retain as

much of the lung as possible. I spoke to Nicole the day before she underwent more surgery on the same lung at the end of November 2018. This was an original disease site, which was good insofar as not being some form of new cancer. At the time of surgery, Nicole's cancer was stable, so she was technically in remission; but then she had to go through a similar procedure on her other lung in early 2019. Unfortunately, the cancer was missed, and so Nicole had to go through the ordeal again a few weeks later. All in all, it's been a pretty tough period for her.

Nicole said that she felt the benefits of exercising. The toxicity of the original chemo died down as exercise assisted the drugs in working through her body. She simply trusted that her combination of therapies was working, and got through every round of chemo that she needed to. Nicole also spoke about how exercise gave her a sense of purpose in what was a really difficult time for her. Through research, Nicole made contact with Associate Professor Prue Cormie, one of the leading researchers on the role of exercise in the management of cancer. They have become firm friends, and have registered EX-MED Cancer as a not-for-profit charity, which is being rolled out nationwide. The aim of the charity is to provide an effective, accessible, and fit for purpose exercise oncology programme for cancer patients, delivered by exercise physiologists. In terms of private and public healthcare in Australia, Nicole had noticed that there were massive gaps in people's access to the best quality treatments and cancer medicines. She felt that this was a situation that she could improve without needing to have a medical degree. Nicole is now a director of the charity, and she plans to make it her full-time job some time during 2019. Nicole talked about accidently becoming the living, breathing media case study for exercise with cancer, and as a result she has been heavily featured in the Australian media as the programme has been rolled out.

In the future Nicole hopes to publish a book. Anyone who reads her remarkably moving and detailed blog posts, or who follows her on social media, will know that it would make for a really fascinating read, and with her background in journalism she writes to a standard that I can only aspire to. Nicole didn't have a timescale, but she told me that that it would take her a long time, partly down to the fact that she is a real perfectionist. She is writing her cancer story, and the role that cancer plays in the broader scope of her life. For a while when Nicole didn't know if she would live or die, the cancer became absolutely everything in her life. On the hand, having cancer has opened very many doors for Nicole, and given her considerable perspective on her opportunities and relationships. As a result, there have been plenty of things that Nicole has now done, but there is also much that she still wants to do.

Nicole came across as someone with great passion and energy, and someone determined to take the positives out of a terrible life-changing situation. Her work helping others through EX-MED Cancer shows how kind she is, and that she is someone with a huge heart. Throughout our chat she would break out into laughter, and clearly possesses a terrific sense of humour. As we finished talking, I was at the start of a working day, which would involve taking delivery of a lorry-load of cardboard boxes. Nicole, the night before her operation, joked that my day would be a lot better than hers with lung surgery. Thankfully, Nicole came through the lung surgery well, and it was great to see her beginning the journey to recovery. She is yet another person from the cancer community

who it has been a pleasure to become friends with, and who is another wonderful inspiration to many.

Gillian Wood

Gillian Wood, 1 February 2019

Gillian Wood lives just outside Edinburgh, and unfortunately my original plan to travel to Scotland to meet her fell through. However, she made a last-minute decision to travel to Llandudno a few weeks later to see The Alarm play at The Gathering, so we were finally able to meet in person. I took Gillian's photo inside Venue Cymru at the small stage in the centre of the arena during the band's intimate Friday night concert.

Gillian was diagnosed with stage 2/3 bowel cancer in 2017, and on the day we spoke she had just received some really good news, as her recent scan results had come back clear. She was celebrating with a large glass of gin, apparently called a Gin Genie cocktail, which she had tried a week earlier at a David Bowie celebration gig. Gillian was also waiting on the results of blood tests, which, if clear, would give her a six-month gap before the next round of tests.

The first record that Gillian bought was 'I'm Mandy Fly Me' by 10CC. The single, released in 1976, reached number 6 in the UK, and cost her the princely sum of 79 pence. She would spend her Saturdays in the record shops in Edinburgh, gradually building up her own collection. Her family enjoyed their music, and Gillian's parents had a pretty decent record collection, which included everything from 1950's rock 'n' roll to classical symphonies. She revealed that her dad was in a skiffle band when he was younger.

Gillian's mum worked at a radio station for a few years. Although she was involved in sports, it meant that not only did Gillian get to see how the programmes were made, she also got loads of promotional records, posters, and badges.

Gillian is a massive fan of David Bowie. She was introduced to his music by her next-door neighbour, which meant that she didn't actually need to buy any of Bowie's records to begin with, since she could hear the music through the walls, as well as go round and borrow the records. Gillian was fortunate enough to see Bowie in concert on his 1983 Serious Moonlight tour.

Gillian was a fan of punk music in the 1970s, particularly bands like Buzzcocks, The Damned, Stiff Little Fingers, and The Clash. In 2009 she saw The Alarm for the first time when they supported The Damned in Edinburgh. We both know Cathi Simpson, who is a big fan of The Alarm, and Gillian said that since meeting her a few years ago she has become a little bit hooked on them herself, particularly enjoying the band's recent releases.

Life had been pretty good for Gillian before cancer. She had been working at Standard Life Assurance for 22 years when in 2013 she was made redundant. She had done a few different roles, and had ended up as a Project Manager, which was challenging, but something she enjoyed doing. As a result of the redundancy, she decided to form her own company and do short-term contract work. 2013 was also the year Gillian turned 50, and two days after her birthday the bowel screening kit arrived through her letterbox – the minimum screening age being 50 in Scotland. She liked the idea of being able to do it in the privacy of your own home, so she did it and sent it away. The results came back clear, and she would receive another one in a couple of years.

Gillian started a new short-term contract, which ended up lasting for 18 months. Things were fine, but she was getting tired, which she put down to the menopause as well as the long hours, all the travelling, and the work itself, which was hard and challenging. Gillian was working full-time, following years of working part-time whilst her daughter was growing up. Two years later Gillian received another bowel screening kit, and sent off the test. She had started a new job when the results came back asking her to do another test. These results came back showing traces of blood, and they wanted to do further investigations, with Gillian being advised to get a colonoscopy done. However, Gillian felt fine, having had some time off between work contracts, and having just started her new job didn't want to take time off work going to hospital appointments, so she decided to put it off.

A year and a half later Gillian noticed that she was going to the toilet more often, and she was getting stomach cramps. It was different to anything she had experienced before, and Gillian thought that perhaps there was something wrong after all, and that maybe she should have followed it up at the time. She went to her doctor, and explained what had been going on. Her doctor decided, in view of her age and the symptoms, to refer her

straight to the hospital as quickly as possible just to be on the safe side. Things hadn't been brilliant at work, so Gillian decided not to renew her contract. She suspected she had bowel cancer, and wouldn't be able to work, so she decided to prioritize sorting her health out.

Gillian had her tests in July 2017, and she could see on the screen that something was not right. The surgeon told her the chances were that it was bowel cancer, and Gillian said that she was quite calm and had prepared herself for the news. She had tests, scans, and a biopsy before starting chemo and radiotherapy in the September. Following more tests and scans, Gillian had surgery in January 2018. Test results also showed that the radiotherapy had successfully zapped the tumour. A few days after surgery Gillian got sepsis, so thankfully she was treated for that in hospital, and stayed there for a couple of weeks.

The doctors had to make a decision on whether to give Gillian follow-up chemotherapy after surgery. They told her that because she had responded so well to the radiotherapy, they couldn't tell if it would be of any benefit. The normal response to radiotherapy was between 50% and 80%, but no trials had been performed on patients with a 100% response. The decision was left to Gillian, but her surgeon advised her not to, because she was still recovering from the sepsis, which had weakened her immune system – more so than the surgery.

Gillian had a stoma fitted during surgery, and the reversal – which could have been three to four months after surgery – was also put back a few months due to her recovery from sepsis. The reversal eventually went ahead in October 2018, and was performed with keyhole surgery. Recovery from the reversal has not been easy. Gillian was aware that bowels do not like being handled, so this is always an issue during a stoma reversal, but she said that hers went into overdrive. Some days Gillian would be in and out of the toilet all day, whereas on other days nothing would happen at all. She said that it has been challenging, but that things had slowly been improving. Gillian tires very easily. It's not that she isn't able to get out and do things normally, but it's the fatigue that kicks in quite quickly. Gillian now has to listen to her body, and pace herself. She has also put all the weight back on that she lost during 2018.

Gillian feels that giving up the contract work was one of the easiest decisions that she has ever made. She doesn't want to go back to it, hasn't had any stress, and has felt calm and relaxed about everything that has happened. Gillian believes that you get a different perspective on things when you go through cancer treatment and has a very positive outlook. Health and happiness are the main things for her. She has shut down her company, and is going to give herself time to think about what she wants to do next, while keeping her options open. Gillian does some voluntary work sitting on the panel of The Children's Hearing System, which is Scotland's care and justice system for children and young people.

One of the worst things Gillian had to do was tell her family and friends that she had cancer. She said that fortunately her daughter had already left home, so she wasn't dependent on Gillian, which made things less stressful. In fact her daughter was remarkably strong, and Gillian said that she wouldn't have been so calm through it herself without her daughter's strength and support, and that she is incredibly proud of her. Gillian's father has found it difficult to watch her go through bowel cancer. He had prostate cancer, and has had polyps in his bowel, so he has an understanding of what Gillian has experienced, having had radiotherapy and a colonoscopy himself. Gillian's partner Andy and best friend Trish were always around for support, which included lifts to hospital appointments.

We talked about the importance of humour to get through difficult times. Gillian's mother died of a heart attack in 2005. She described how her mum would always be late for everything, and how this even continued at her funeral. There had been a mix-up at the funeral director's with some keys, and as a result she arrived 15 minutes late. Gillian was with her father at the crematorium, and he said, "I told you she'll be late for her own funeral." This put them into hysterics, and even the driver joined in the laughter.

Gillian believes that if there was a scale of how bad cancers can be, then bowel cancer has to be one of the worst. The bowel is a working organ that is taken for granted when eating, drinking, and going to the toilet every day. When that suddenly isn't working properly as you go through treatments, you realise how much it can set you back. Not only can the treatment be harrowing, but the effect it has on day-to-day life can be really difficult. Two friends of Gillian have had cancer – cervical and breast cancer. They believe that Gillian's treatment was harder, because their treatment didn't affect them doing the things we all take for granted like eating, drinking, and going to the toilet. When Gillian had her stoma there were certain things she couldn't eat or drink, and she had to completely change her diet. She also had to empty her bag six or seven times a day, and try to avoid bag leaks, and the risk of getting a hernia, which is common for ostomates.

We had talked about Gillian's life with bowel cancer on the phone a few weeks before we met in Wales, so it was really nice crossing paths with her over the weekend, enjoying the music and the many friends we have there, and getting the opportunity to know her just a little bit better. It's been a tough few years for Gillian, but she has come through it all, and is putting it all behind her as she looks forward to what lies ahead. It's been especially nice for me to get to know Gillian, and I am looking forward to seeing her again, most likely at another musical event.

Gaby Roslin

Gaby Roslin, 27 January 2019

Gaby Roslin is perhaps best known for presenting *The Big Breakfast* with Chris Evans, and *Children In Need* with the late Sir Terry Wogan. She knows bowel cancer all too well, as her father, Clive, was diagnosed with it in 1996. Thankfully Clive, a former radio announcer, survived the illness, and according to Gaby is still going strong and now talks openly about that awful time in his life.

Gaby's first record was one of the *Top of the Pops* compilations albums, which ran continuously from 1968 to 1982, with one more released in 1985. In all, 92 albums were released. The albums were made up of re-recordings of current chart hits of the day. Gaby said that she loved Donny Osmond at the time.

Gaby worked on *The Big Breakfast* from 1992 to 1996. At the height of the show's popularity in 1993 it attracted around two million viewers, which made it the highest rated breakfast television programme in the UK. Gaby also presented *Children In Need* for ten years from 1994 to 2004. She has, in other words, enjoyed a long and distinguished career in broadcasting, and said that her favourite person that she had worked with is Chris Evans, describing him as a true broadcasting genius.

Gaby's favourite guests over the years include Tom Hanks, Sean Connery, Billy Crystal, Barbara Windsor, and Julianne Moore.

I'd approached Gaby to be in the book after seeing her support an event organised by Bowel Cancer UK, and she was very happy to be involved. The photo of Gaby was taken before her regular Sunday afternoon radio show on BBC London. Unfortunately I didn't get to meet Gaby, but she has been extremely helpful and supportive to me during the writing of this book.

Nicola Bryant

Nicola Bryant, 4 December 2017

Nicola Bryant is best known for playing Dr Who's companion, Peri, during the 1980s. I met her at Worplesdon Place just outside Guildford. It was early December, so we went outside – before the light faded – to take some photos, with the picturesque lake making the perfect backdrop.

Nicola was running late, as she had been with her mother at a hospital appointment. As soon as she arrived I immediately realised that I was with an incredibly kind person. She didn't want to let me down, but obviously had to make sure her mother was alright before she could leave her. I got the sense that there were not always enough hours in Nicola's days.

The first record that Nicola bought was 'Sunny Honey Girl' by Cliff Richard, which reached number 19 in the UK charts in 1971. Nicola also told me that she developed a love of music at a very early age, and aged just three in 1963 she asked for 'Love Me Do' by The Beatles. Nicola admitted she also proposed to Paul McCartney when he was on the television, but sadly he did not accept. Music has been a big part of Nicola's life, and she is also a songwriter. I told her it was something that I also enjoy, but that I find writing lyrics especially difficult. Nicola has no such problem, saying that words just come to into her head and she 'downloads' them. If only it would happen like that for me.

We spent a great deal of the meeting talking dogs. Nicola's dog, Harvey, is a massive part of her life. She told me that when she looks at job offers, she has to work out how much the job pays, and how much a dog-sitter will cost, before she can decide whether to take the job. In the photo she is wearing her Harvey scarf, and she was especially looking forward to meeting my dog, Prince, having brought treats along for him specially.

Nicola's had Harvey since he was a puppy. She said that it took a couple of years to get him to be the perfect finished article, but that even as a young puppy he really was delightful.

Nicola had a three-year contract on *Doctor Who* from 1984 to 1986. She worked with both Peter Davidson and Colin Baker, the fifth and sixth doctors respectively. She is especially close to Colin, who she still sees regularly, saying that she was like his fifth daughter. She also said that there was definitely a feeling of family on the programme. In 1985, while *Doctor Who* was on hiatus, Nicola and Colin appeared in *The Two Doctors*, which also featured the late Patrick Troughton, the second doctor, and his companion, played by Frazer Hines. Nicola told me that there were barely enough funds to make the programme, and that there was a lot of goodwill from the actors, who loved the show, to make sure that it happened. Nicola also told me that it was agreed that she would leave at the end of her contract. She said that she had been in the show longer than some of the doctors, so the time was right, and also as a young actress she wanted to try new things. She was slightly sad that the 50th anniversary celebrations of the programme did not make enough of the ex-cast members, many of whom had been brought to London for the occasion. She believes that it was probably the last chance to interview so many of them, but the opportunity was not really taken.

Overall, Nicola regards *Doctor Who* as both a blessing and a curse. She is still best known for a role that she stopped playing over 30 years ago, but at the same time that role has taken her to places all over the world that she would never otherwise have got to see. She still regularly goes to fan conventions across the globe.

We talked about bowel cancer, and I hadn't realised that Nicola's family has also been touched by the disease. Her partner Nev's family have a hereditary history of bowel cancer. Nev's mother died aged 58. Sadly, since I met Nicola, Nev's father has died whilst undergoing treatment for bowel cancer. Nev has had genetic testing himself, but thankfully the results proved to be negative, so he does not have the inherited gene.

Life in still very busy for Nicola. Before we met, she had been filming for *Star Trek Continues* in America, as well writing and recording. Christmas preparations were also well under way, and she wouldn't entertain the idea of any of her extended family being on their own at that time of year. As we left, Nicola made a big fuss of Prince, so she definitely got herself a new friend there. She was great fun, fascinating to talk to, and a genuinely kind person.

Victoria Derbyshire

Victoria Derbyshire, 17 July 2017

Like many people, I was familiar with Victoria Derbyshire's work as a radio presenter on BBC 5 Live, where she worked for 16 years before making the switch to television. In fact her breast cancer diagnosis came just four months after her *Victoria Derbyshire* weekday morning programme began on BBC 2. I was keen to get Victoria involved in the book, after her well-publicised illness.

An early afternoon meeting for most people would be halfway through their day, but for Victoria, whose alarm goes off at 4.00am, it is more like at the end of a long day. Having presented her morning current affairs programme from Broadcasting House in Central London, she met me in a coffee shop in Middlesex on a very hot July afternoon. We'd originally arranged to meet up in May, but the small matter of a General Election scuppered that plan. However Victoria, who was enthusiastic to help from the outset, immediately came up with an alternative date, so I didn't have to wait too long for our meeting.

Victoria grew up in Rochdale in the 1970s/80s, and like many people of her generation, she would listen to the chart show on Radio 1 every Sunday afternoon at teatime. The first record that she bought was the brilliant 'Ghost Town' by The Specials. The song reached number 1 in 1981, and was the band's final single before they split up. It is also a song that I still have in my record collection, as I was a massive fan of the band during my

teenage years. Victoria claimed that buying the record was nothing to do with being cool, more the fact that she liked the song, and of course there's nothing wrong with that.

The rawness of Victoria's cancer battle was, understandably, still very close to the surface. It was still too difficult for her to talk about it. She said she was glad to still be here, which spoke volumes, and she also talked about just how amazing the cancer community are, which is something that I have also experienced first-hand. Victoria's cancer battle is documented in her book, *Dear Cancer, Love Victoria*, which was published in September, 2017. The book is based on Victoria's personal diaries beginning on Monday 27 July 2015 when she googled "inverted nipples", and saw among the answers, breast cancer. What follows is a very heart-warming and moving account of Victoria's journey from diagnosis through treatment. She had a mastectomy, six gruelling sessions of chemotherapy, and thirty doses of radiotherapy. She lost two thirds of her hair during her treatment, which she admitted to finding harder to deal with than the loss of her right breast. Victoria kept working as much as the treatment and its side effects would allow, and the book ends after her final dose of radiotherapy on Wednesday 25 May 2016. Alongside the book Victoria filmed video diaries at some of the key stages of her illness, which, to date, have been viewed more than 17 million times.

Victoria has been very open about her disease. Cancer has a reputation for being talked about in hushed tones, and one of the aims of her book is to change this timid approach, since we don't deal with other illnesses, such as Parkinson's or dementia, in this way. She does not feel that cancer has changed her very much as a person, as she has always regarded herself as someone who lives life to the full. However, she has a little more perspective, and does not allow herself to get stressed over things in the way that, previously, she might have. The way that Victoria approached diagnosis and treatment might not be for everyone, but it worked for her, and her story gives love, hope, and strength to anyone touched by cancer.

We chatted for some time about bowel cancer, and the need to raise awareness about this awful illness. More specifically, Victoria was keen to hear about my mother and her long illness. I'd taken a copy of my previous book, *Lives & Times*, to give to Victoria, and she immediately went straight to the chapter about Mum. She was interested to hear me speak about Mum's strength, and how she became the rock of the family after my father passed away in 2009. She also wanted to know how me and my brother and sister were coping with the loss of Mum, as the first anniversary of losing her was approaching.

Victoria spoke with great affection about her time at 5 Live, and how she covered the major news issues of the day, including 9/11. She also talked about how the job had taken her to some amazing sporting events, such as the Olympic Games and World Cups. However, after 16 years she was ready for a new challenge, and her morning television programme proved to be just that, with new skills to learn too. I wondered how she managed to cover some of the more tragic events, as we met not long after the awful Grenfell Tower fire in London. At such times, she listens to what people have to say, and lets them tell the story. She is no different to any of us in feeling desperate sadness at such tragedies.

The time raced by, and Victoria was on a tight schedule, as with her "mum" hat on, she also had to do a school pickup. I have to admit that so engrossed was I in the conversation, that, for a moment, I almost forgot that we had to do the photo for the book. We simply walked to the side of the road and took the photo under a tree. Her only request was that I didn't take a photo showing a tree growing out of her head! I actually think that it's a great picture, as it captures her kindness and warmth, which I took with me from the meeting.

A couple of months later I went to see Victoria at the Henley Literary Festival, where she was talking about the book, and answering questions from an audience that included some women who had also had breast cancer. It was a special evening, and quite emotional at times. She very kindly signed my copy of her book: the short inscription she wrote was just perfect, and very much something that I will carry with me.

Jim Rosenthal

Jim Rosenthal, 7 August 2018

I met sports television presenter Jim Rosenthal at The Shire Horse public house located on the outskirts of Maidenhead. Our family has a very strong connection with this place. My grandparents took over the tenancy in 1938 when Mum was two. In those days the pub was called the Coach And Horses, and Mum lived there until she and Dad built our family home less than a mile away in Altwood Road in 1963. Mum and Dad are buried at Littlewick Green Church, which is a few hundred yards from the pub.

When it comes to music, Jim said he was very much the black sheep of his family. His dad was the lead violinist of the Oxford University Orchestra for over 30 years, and came from a very academic background. Jim, however, started listening to rock music very early on. The first record that Jim bought was 'Rock Island Line' by Lonnie Donegan in the old 78rpm format. Released in 1955, the song went gold in the UK, and got to number 8 in the US. Lonnie Donegan is credited for the revival in the UK of skiffle music, which saw three-piece bands use an acoustic guitar, accompanied by a washboard and tea chest rhythm section. Jim described Lonnie Donegan as his pop idol, and such was his influence on the British scene, it has been suggested that without him we might never have had The Beatles or The Rolling Stones.

Jim has been supporting Bowel Cancer UK (Beating Bowel Cancer Together) for a couple of years. His 91-year-old father-in-law has bowel cancer and had just celebrated 71 years of married life. Jim's very happy to support the charity and keep raising awareness. The other charity that he supports is ex-Arsenal goalkeeper Bob Wilson's Willow Foundation. The charity organises special days for terminally ill young adults. These days give a huge boost not just to the patients, but also to all those around them.

Jim began his career in journalism at the Oxford Mail. He went there straight from school, not going to university. This was where Jim got his journalistic training, and with it being a nightly newspaper he learned the importance of deadlines very quickly. A sub-editor told me that he could submit the best piece of prose ever written, but if he handed it in at 10.31 and the deadline was 10.30 it would go straight in the bin. He said that while he was there a lot of graduates from Oxford would also work there, and would not be able to make the transition from their student days, where they had been able to spend all day writing a piece, to the reality of meeting a newspaper's strict deadlines.

After four years Jim moved to Birmingham where he worked for Clive Everton, the BBC snooker commentator, for a few months. Clive had two magazines, Hockey Scene and Snooker Scene. Jim then moved into the media, working for BBC Radio Birmingham. He said he covered the Birmingham pub bombings, which were pretty harrowing. He then transferred into sports news, and he said that the West Midlands was a great place to cover sport, with all the football teams there, and Warwickshire cricket at Edgbaston. He was feeding stories down to London, which enhanced his growing reputation. Jim's big break came in 1976 when he covered the Montreal Olympics, and after that he began working for Sports on Radio 2 (later to become 5 Live). I remember listening to Jim as a teenager when he hosted the big European football nights. He covered the boxing too and was a regular host of the Saturday afternoon sports show, which included the legendary Sports Report at 5.00.

Jim moved to ITV in 1980 when they won the rights to Saturday night football, and he told me that the deal was done in a football changing room at his Sunday morning football side with Jeff Fousler from ITV. Jim worked there for 32 very happy years: he said it was very good for him, and he wouldn't say a word against ITV. During those years he did lots of football, including eight World Cups, and also Boxing, Athletics, Formula 1, and Rugby World Cups, including England's dramatic last-ditch victory in the 2003 World Cup in Australia, which Jim regards as the highlight of his broadcasting career.

Since leaving ITV in 2012, Jim has worked on European football for Channel 5, and he has done a lot of work for a company called OSN in Dubai covering cricket and rugby. He also works for MUTV (Manchester United's football channel). Jim has a great love for sport, and continues to enjoy what he does. He did say that a lot of broadcasters have gone on too long, and don't know when to put the microphone down since sports broadcasting is, according to him, a "very seductive gig". He doesn't want that to happen to him.

Jim's favourite person he met was the legendary Mohammed Ali. It was a meeting that almost didn't happen. Shortly before his move to ITV, the BBC sent Jim to cover three fights in America featuring British boxers Alan Minter, Dave 'Boy' Green, and John Conteh. Jim decided not to tell his bosses about his impending move, as he knew they would pull him off the trip. Jim had the number of Mohammed Ali, so in between the fights, he decided to ring him up, and to his surprise the phone was answered by Ali himself. Jim told him that he was in the United States with some boxing writers, and asked whether it would be possible to see him. Ali answered "yes", and when Jim asked when, Ali said "now". Jim hastily gathered the other boxing writers together, who having been

out the night before were in various states of disrepair, and off they went to see Mohammed Ali.

Photo Used By Kind Permission of Jim Rosenthal

Jim and the other writers turned up at Ali's house in two yellow taxis, and ended up spending three hours with him. Ali gave them a tour of the house, and on standing outside one of the bedrooms, Jim heard Ali say to his wife, "Get your fat ass out of bed, the British media are here". Ali did all his legendary conjuring tricks, and it was a fantastic and memorable experience for Jim.

Jim spoke with huge pride about his son Tom, who has achieved great success as a comedian off his own bat without any help from his father. In fact, the only way Jim helped was during Tom's early days when Jim told him he could say anything about him that he liked, which resulted in Tom ripping him to shreds during his early stand-up routines. Jim described how when Tom got his A-Level results, he forged a document to give awful grades, which Jim and his wife Chrissy completely fell for. Tom and his mate Mike Dowling had spent the night before on the computer creating their masterpiece.

We ended up talking for an hour and a half, and a nicer man than Jim you simply couldn't meet. It was a fascinating and entertaining experience. He spoke with knowledge and insight, and humour was always close by. I could have spent all day talking to Jim.

Nick Robinson

Nick Robinson, 27 November 2018

I thought that my alarm going off at 5.40 each morning was early enough, but that is nothing compared to broadcaster and journalist Nick Robinson, whose alarm call is at the brutal time of 3.30 in order for him to present *Today* on BBC Radio 4. By the time we met for a coffee and chat at the top of Tottenham Court Road in central London, Nick had already presented the three-hour show, been to the gym, and was heading off to Westminster to continue working after seeing me.

I hadn't realised before meeting Nick that his father had suffered from bowel cancer, and had sadly died after the cancer spread to his lung. Before I asked Nick about his life and career in the media, he was keen to hear about my mother's illness, and how it had led me into fundraising and writing books. I had to explain to Nick that as much as I would enjoy being an author, this wasn't my full-time occupation.

Nick told me that the first record he bought was 'Hold Your Head Up' by the English rock band Argent. The single was released in 1972, and reached number 5 in both the UK and US singles charts. Nick believes that, these days, the beauty of music streaming services is that you can easily listen to the old records from your record collection. He still has his old records stored in a box somewhere at home.

Nick began his career at Piccadilly Radio in Manchester. He worked as trainee producer at the BBC, and became Deputy Editor on *Panorama*. He then made the move to working in front of the microphone, and became the BBC's Chief Political Correspondent. He spent three years as Political Editor at ITV, before returning to the BBC in 2005 in the same role. He began working on *Today* in 2015.

Nick told me about the most rewarding people that he had met in terms of them making good television: for him it was his repeated clashes with George W Bush at news conferences. He said that, although the ex-president might come across as stupid, he was in fact very sharp. These clashes ended on one particularly hot day when they were doing a news conference in the garden of Camp David. The journalists had not been forewarned about it taking place outside, so Nick had not brought a hat with him, and was sweating with rather a red head. The President told him that next time he should bring something with him to cover up his bald head, which became a bit of a talking point. For news journalists, Nick told me that Bush was a gift, as he would always deliver, and that the same could be said for Donald Trump. Barack Obama, on the other hand, might be an admirable man, but he didn't make for good television, as he delivered long paragraphs as speeches when answering questions.

Nick believes that sometimes the most interesting people he meets are not necessarily the most famous, and tend to be people who have had extraordinary lives. For example, on the morning of our meeting, Nick had spoken to the wife of Matthew Hedges, and broken the news on air that he had been released from prison in the United Arab Emirates, where he had been sentenced to life imprisonment on spying charges.

I asked Nick about the best news story that he had covered, which for Nick was the formation of the coalition government in 2010. He said that it was one of those rare moments when the country held its breath, and no-one knew what was going to happen. Over a period of five days, the country did not know who was going to end up in government. There was a whole series of different scenarios that could have played out. Nick spoke of the human drama of the situation, as nobody knew if Gordon Brown would leave Downing Street, whether David Cameron would move in, or which side Nick Clegg would choose to form a coalition with. He told me that that it had been the only time in his career that he would be stopped every hundred yards, when walking to the underground from his North London home, and be asked what he thought was going to happen.

I wondered whether the role of Political Editor was as high a position as you could go in television, but he said that there isn't really a hierarchy. The role meant that you would get more airtime on television, and during that time he expected to be on the television news most nights of the week. However, he said it was kind of daft to compare that to someone risking their life in a war zone. Nick went on to say that the big change with moving from television into radio was going from being a reporter to becoming a presenter.

Nick believes that one major plus side to now being a presenter is that he covers a whole host of subjects, not just politics, which means he gets to interview a much wider range of guests. The focus on *Today* remains on the big live interview. Nick's view is that in the

UK, radio dominates television in the morning, and has always been the big brother in that relationship. It has a bigger audience, has traditionally carried much more influence, and is listened to by the establishment. Nick still does work on television, including a recent interview with Theresa May on *Panorama*, and he said that he would continue to be part of the television coverage of future general elections.

Nick is recovering from cancer, which was diagnosed in 2015. He had a rather unusual tumour in the lung called a neuroendocrine (NET). Nick's particular type of NET is more commonly associated with the gut, but can occur in the lung. This is why Nick describes his cancer as being in the lung, rather than as lung cancer. The chemotherapy and steroids that Nick was on played havoc with his immune system, which is a common side effect, and three years on this is still an issue with Nick's health.

We talked about new treatments in the cancer world. Nick feels the developments in immunology, which is the role of the immune system in the progression and development of cancer, will, in our lifetime, quite possibly make chemotherapy seem as brutal and archaic as leeches do to us now. He also spoke about the fact that as more people are living with cancer than are dying from it, it's important to look at how they are adjusting to living with cancer in everyday life. A few months earlier, Nick had spoken at the NCRI Cancer Conference, which is the UK's largest forum for showcasing advances in cancer research, bringing together researchers, clinicians, industry representatives, and people affected by cancer. He had been invited to speak on what life is like for a patient with cancer. One of the side effects with Nick's treatment was that he lost his voice, and he was there to explain that the attitude of "What are you complaining about? We have saved your life!" is no longer good enough. These days a lot more thought needs to be given as to how people live with the consequences of their treatment. In addition some people may choose not to have treatment, which might shorten their life, but Nick believes that this is a reasonable conversation that people should be allowed to have.

In his spare time Nick and his family enjoy spending time at their holiday cottage in Suffolk, and he told me that, although not a very good sailor, he enjoys getting out on the water in his dinghy. He says that it is an activity that makes you think just enough, insofar as where the wind is, and what line you are taking. The benefits for Nick are that it clears his mind of everything else, and he is able to enjoy amazing views at the same time. Nick is a life-long Manchester United fan, and gets to watch them around five or six times each season. These days Nick's enthusiasm for the game has somewhat been rekindled by his two sons, aged 18 and 21, who are utterly obsessed by it. He said that probably the highlight of his career outside politics was interviewing Sir Alex Ferguson for a documentary on leadership skills, and when and how to apply them.

Before Nick headed off to Warren Street Underground Station and back to work, we went outside onto Tottenham Court Road to take some photos. I really enjoyed our meeting. Nick was fascinating to talk to, and has without doubt had a highly rewarding career in the media, which is by no means over. We met just a couple of weeks before a key vote in Parliament on Theresa May's Brexit deal, so Nick, as ever, was in the midst of huge political debate and decision-making.

Bill Turnbull

Bill Turnbull, 13 September 2017

I met Bill Turnbull outside Classic FM's headquarters in Leicester Square, where he presents his weekend radio shows, as well as occasionally filling in for other presenters during the week. Photographing Bill was a very relaxed affair, and he made me feel very comfortable the whole time. After we had taken the photos we moved back inside the building, and chatted for about 20 minutes in the canteen, which had great views of Leicester Square.

Bill spent 15 years working on *BBC Breakfast*, and it was an interview that he did with Mike Peters from The Alarm which prompted me to make contact with him. In 2004 the band duped the music industry by releasing the '45 RPM' single under the name of The Poppyfields, and got a young band, The Wayriders, to appear in the video in their place. The song went into the UK Top 40, before Mike revealed the truth. This led to huge coverage in the media, including an interview with Bill on *BBC Breakfast*. It turned out that he was a fan of The Alarm, and knew some of their material. When we spoke about it, he told me that his favourite song by the band was 'Rain In The Summertime', and he recited a couple of lines from the song, describing them as some of the best lyrics he'd heard.

The first record that Bill bought was the number 1 single 'I Want To Hold Your Hand' by The Beatles in 1963. It turns out that he is a Beatles fan, and regards *The Revolver*

album from 1966 as their finest record. It was also the first album that, as a 10-year-old, he saved up and bought, costing 29 shillings and sixpence (29/6) in old money. He transferred it to a small tape recorder using a microphone, which meant that he could take it with him everywhere, and he knew the words to every song. Even today, over 50 years on, he still loves tracks from the album, especially 'Tomorrow Never Knows', which Bill thinks is possibly their greatest song.

Bill's passion for classical music goes back about 20 years, from when he returned to the UK after having worked as the Washington correspondent for the BBC. He made the decision to listen to classical music in the car as he was doing a lot of driving into London. This is where he first discovered Classic FM, which he found to be warm and friendly, and – importantly – not patronising or elitist.

After getting up at half past three for 15 years to present *BBC Breakfast*, Bill knew that it was time for a change. He had turned 60, the programme had relocated to Manchester, and as a result, he'd lost two wonderful colleagues, Sian Williams and Susanna Reid. He admits that towards the end he was counting down the days. He interviewed thousands of people over the years, and would not always remember if he had met people before, so Susanna would sometimes have to remind him. Aside from Mike Peters, some of Bill's favourite interviews were also with musicians that he liked. These included David Burns, Bryan Ferry, Steve Winwood, and Eric Burden. Also, one very special moment was when he got to hold one of Jimi Hendrix's guitars.

Bill's most memorable news stories included general elections and US presidential elections, as well as certain other events such as the day after the 7/7 bombings in London, and the Queen Mother's death – although this coverage was criticized, quite unfairly in Bill's opinion. Another memorable event was Hurricane Katrina, as Bill went to New Orleans, which had been completely evacuated in its aftermath. Bill does miss the journalism, and said that, typically, as soon as he left the BBC, so many more interesting stories happened, including the Brexit referendum, a change of Prime Minister with Theresa May replacing David Cameron, Jeremy Corbyn becoming the new leader of the Labour Party, and Donald Trump being elected US President. However Bill has not hankered to be back doing it.

The idea that Bill's presenting at Classic FM would see him somehow winding down hasn't quite worked out like that. He had worked 40 more days already in 2017, and he was still doing some television work, including a programme for the BBC called *Holding Back The Years*, which is all about the challenges of getting older.

Bill also spoke about his love of Wycombe Wanderers FC. In more recent times he has moved to Suffolk, so he doesn't get to see them as much as he would like. He still occasionally does the radio commentary for some of their matches when the opportunity arises.

Bill had a lunchtime meeting before presenting the 5.00 – 7.00 Drive show, filling in for John Brunning, so our time had come to an end. It was a thoroughly enjoyable experience, and although it had taken a year to make the meeting happen, it was well worth the wait. Bill couldn't have been nicer, and his kindness and support have been terrific.

Since our meeting Bill has been diagnosed with prostate cancer.

Siân Lloyd

Siân Lloyd, 13 September 2018

I met television presenter Siân Lloyd at Dartmouth House in Mayfair. The stunning building dates back to the 18th century, and was used as a family residence for Baron Revelstoke and Lord Dartmouth amongst others before being converted into a military hospital during the First World War. In 1926 the building was bought by the English-Speaking Union, and they have resided there ever since. It's a wonderful piece of architecture, and has the most beautiful courtyard, where we took the photo. It was a glorious mid-September day, so rather than make my way there from Paddington Station on the hot and sweaty underground, I decided to walk, take in the views of Hyde Park, and enjoy some of London's finest architecture on the way.

I first contacted Siân after seeing a photo of her wearing jeans with the Beating Bowel Cancer logo on them. She explained that this had been taken when she became the oldest winner of the Rear Of The Year competition in 2007, as the organisers always help to promote and raise awareness of a charitable cause each year. Siân has also been touched by bowel cancer. Her late Uncle John had the disease, and more recently one of her closest friends, someone she has worked with and admires very much, has been diagnosed. Siân was very interested to know more about my mother's cancer journey and the fundraising that I have been doing. I was able to tell her just how cathartic putting this book together has been since Mum's death. We also chatted about the late Rachael Bland and the *You,*

Me and the Big C podcast, and how devastating Rachael's death from breast cancer aged just 40 was. Siân also told me a little about her mother, who sadly has stage 5 Alzheimer's, and how she does a lot of charity work to raise funds for research into the disease, to hopefully, one day, find a cure.

The first record that Siân bought was 'The Jean Genie' by David Bowie. Released in 1972, it reached number 2 in the UK singles chart, and was taken from his *Aladdin Sane* album that came out in 1973. 'Heroes' is another song of Bowie's that Siân considers to be a classic. She listens to music all the time and has a very eclectic taste. Siân listens to classical music, and enjoys contemporary artists ranging from Tom Waits and The Pretenders through to Amy Wadge, who did the music for the acclaimed television drama *Keeping Faith*. She told me quite a bit about Amy, who lives in Cardiff and was born in Bristol, and who (I didn't realise) also writes for Ed Sheeran. Siân would love to appear on Desert Island Discs, although she would find it almost impossible to whittle down her list to just ten songs. She did a similar programme on BBC Radio Wales, and found it quite angsty making her choices. Siân also said that song choices tend to change to reflect what is going on in your life.

Siân is huge rugby fan, and coming from Neath, which she described as being rugby central, she had no choice in the matter, as her father is a rugby blue for Oxford University, and her brother was captain of the school team. During that time she said that the girls would only date the rugby boys. She regularly goes to watch the Wales rugby internationals at the Principality Stadium in Cardiff, and she also told me that she does charity curry nights all over the UK where she interviews rugby players, both present and past. One of her favourites is the former Wales and British Lions captain, Sam Warburton.

Cricket is another sport that Siân enjoys, and we spoke about the beautiful walk to Sophia Gardens in Cardiff from the railway station along the River Taff. Her brother is a member of Glamorgan County Cricket, so Siân goes along to watch the cricket whenever she can. She knows some of the ex-cricketers including Phil Tufnell, who she appeared with on *I'm A Celebrity Get Me Out Of Here!* with in 2003 when he won the show. Siân was the first celebrity voted off, and she said she was absolutely fine with that, as it meant she got to enjoy the luxurious Versace hotel and the use of a soft top Audi TT. She credits the programme with her love of the Antipodes and has been back to Australia almost every year since, visiting virtually every sight. One of her favourite experiences was doing The Ghan train journey from Adelaide to Darwin, covering over 1800 miles.

Siân began her career doing research for the BBC regional news programme *Wales Today*. She regards herself as fortunate to have come from the generation where getting a good Arts or Humanities degree was virtually an automatic route into a career in the media, which Siân told me is no longer the case. Siân got a BBC graduate traineeship, which she said is the best training anyone could have, and that she regards herself as lucky to have had. Siân also had interesting views on how newspapers no longer carry the weight of influence that they once did, and that the balance has shifted much more to social media. It was interesting to hear her talk about how social media at least gives people the right to reply, which is not always the case with the national press.

Siân presented the national and regional weather forecast on ITV from 1990 to 2014, and is one of the longest-serving presenters, if not the longest-serving, although she did say that Carol Kirkwood might well break her record if she carries on the way she is going. Siân decided to leave the weather presenting to try other things. Life is too short, and she didn't want to end her career just doing the weather. Siân now has a great job with CNN travelling the world making programmes on climate change, and in fact probably wouldn't have got that job without Twitter and social media. She loves travelling, and said she could quite happily spend the whole of her time visiting nice hotels, although not necessarily expensive ones, and enjoying good food. Just before we met Siân had also featured in the *Shirley Valentine* television series on ITV, which she thoroughly enjoyed doing, and has had more responses to it than any programme she has ever done.

We spent almost two hours chatting, and this meant we almost missed out on using the courtyard for the photo opportunity as a private function was due to begin, and the staff were setting up and asking everyone to leave. Thankfully Siân was brilliant, and able to persuade the staff to give us a few extra minutes so we could take some photos. Siân was very easy to photograph, but she wanted to make sure I got the best photos possible, and came up with the great idea of getting one member of staff to take a photo of us doing the photo session. We looked at all the photos as we went along, and Siân was lovely in making sure we got the best photos possible.

Siân is the nicest person you could possibly wish to meet. It was a very memorable experience, and she was great fun and full of laughter. She was very generous with her time, and the two hours just flew by. I think that the photo of the two of us together really captures just how much we enjoyed the afternoon.

Matt Allwright

Matt Allwright, 7 December 2018

I met Matt Allwright, broadcaster and investigative journalist, at the St George & Dragon pub in Wargrave on the banks of the River Thames, which by coincidence was also the place where my parents had their wedding reception in 1960. I'd been in touch with him for over a year, and just before Christmas Matt found a gap in his busy schedule to make the trip out of London to meet me. We had both attended the Reading Blue Coat School, which is located only a few miles from Wargrave, at around the same time. I was slightly older than Matt, and our lives have taken very different paths. At school Matt had a real passion for English and Drama. He said he was incredibly lucky that there were a couple of teachers who made time for him, and who, as well as being kind and understanding, also pushed Matt and challenged him to achieve things. He added that he loved poetry and books, and enjoyed studying there.

Matt told me how he got his break in television during the late 1990s. His mother was trying to buy a new tumble dryer, and she used a fabric conditioner called Bounce which came on a sheet. She went to John Lewis, and was told that none of the manufacturers recommended using Bounce, because it gummed up the sensors. The machine would carry on working even once the clothes were dry, and as a result there was a potential fire risk. Matt was working at the BBC, and his mother kept telling him that there was a story there. He said that although it was painful to admit, she was right. Matt wrote to *The Really Useful Show*, believing that he had more chance of getting the story covered on a daytime show. However, after not receiving a response, he wrote to *Watchdog*. He actually sent a fax, and fortunately for Matt, the only person in the office at the time was the editor, who replied and asked him to write it up in a script. He liked it so much that he asked Matt if he would like to do the story on the show with his mum. The rest, as they say, is history.

Matt is not entirely sure he ever saw himself as a consumer journalist, since he was more interested in making radio documentaries. But the more he did it, the more it made sense to him. He liked covering stories where you could see a result at the end. On *Rogue Traders* Matt believes the stories are actually talking about social justice, decency, and doing the right thing. I wondered how Matt felt about confronting people, and he said that confrontation was something he did enjoy. Matt likes an intellectual challenge and thinking on his feet and told me that he has always enjoyed a good argument and discussion. On *Rogue Traders* he sits down and talks with victims, who tell him why they are upset, and who don't have anyone else to turn to. They wouldn't be prepared to go on television if they didn't believe what was happening was completely wrong. Matt told me that it was a bit like a contract, because if these people are prepared to open themselves up to potential ridicule on television for being had, then the least he can do in return is see the story through for them.

As well as being a well-known face on our television screens, Matt is also an accomplished musician, but I wasn't prepared for his first record, which was 'The Funky Gibbon' by The Goodies. The novelty track reached number 4 in the UK singles chart in 1975. Matt bought the single from a shop in Woodley, where they had a box of records on the meat counter. He now realises that they were old juke box records, as they had the middle punched out. The B-side was a song called 'Sick Man Blues'. Matt spoke to Bill Oddie about this song when they met while filming for *Rogue Traders*, and Bill told him that he really went for it with the vocals on this crazy blues number. Matt has always been a huge fan of Laurel and Hardy, and said he was obsessed by their version of 'The Trail of the Lonesome Pine' as well, which was also a big hit in 1975.

Matt said these days he would listen to pretty much any kind of music, but the big band for him in his teens was The Smiths. He described listening to their song, 'What Difference Does It Make?', on the *Now That's What I Call Music 2* compilation album, and how he just kept returning to that one song over and over again, unable to believe how good it was. He wondered how somebody had done that, and how somebody made that noise. The song was totally different to any other track on that album. As a teenager he felt that the band were speaking both to him, and for him. By this time Matt was also playing the guitar, and he said he spent a year not going out and doing anything much, other than working out how Johnny Marr from The Smiths had put the chord shapes and progressions together.

Matt has been playing the guitar since he was 12. He is rather modest about his ability, and said that he knows the bits that he can do, and sticks to that without being terribly adventurous. In the last few years, he has become better at putting a lot more time into practising, and said that his playing has benefitted from that. More recently, Matt has begun playing the pedal steel guitar, since he said that everyone wants a pedal steel player, but only for a couple of tracks on an album. He said that even after only playing the instrument for a couple of weeks there was already quite a bit of interest from people, and within six weeks he was recording tracks in the studio.

Matt plays in a couple of bands. He performs and sings in an acoustic band, The Walnuts, which can swell and shrink in size. The band play gigs to raise money for Alzheimer's

research. The other band he is in is called Band of Hope, which is headed by singer-songwriter Tom, who Matt first met when he was 17 after he joined their band having been dumped by Tom's sister. Matt now plays pedal steel with them, and the band has performed at the Latitude Festival. He loves playing with them as it's all original material written by Tom, and so he says there are no arguments because Tom is the leader of the band, writes the songs, and knows how wants them played. One of the things that Matt enjoys about playing with Band of Hope is that there is no requirement for him to be the television presenter on stage: he simply plays pedal steel, concentrating on what he is doing, and playing to the best of his ability.

Matt began his fundraising for Alzheimer's research when he first met David, the singer and guitarist from The Walnuts, on a radio show he was hosting. The guests on the show had to play a song with Matt, and afterwards David talked about the Seven Songs charity that he had set up, where he would go to people's houses, and play seven songs armed with a cake tin for donations to Alzheimer's research. Matt found him to be such a talented and kind man that he wanted to get involved too. They went on tour in Europe travelling to Barcelona and Norway in a camper van with a couple of other guys, and just played wherever they stopped at.

Matt has been blessed with good health and a happy and stable family life, and enjoys a successful career in broadcasting. The Launchpad charity, which helps the homeless turn things around, is very important to Matt. It's a charity that does a lot of amazing things, and has gone from being a soup kitchen to building houses for people. This has been achieved with not very much money. He also said that the *Housing Enforcers* programme, which he presents, also taught him how much things are about luck. Matt feels that this is something we have lost sight of, and that people are usually in tough situations as a result of bad luck. He believes that society has slipped into a general sense that if people are in tough situations, they probably deserve it, and have done something wrong, whereas in times gone by Matt feels that these people would have been regarded as unfortunate and in need of help.

Matt also supports and is a patron of SANDS (Stillbirth and Neonatal Death Society), which supports people affected by the loss of a baby. He became involved with the charity after friends lost twins six months into a pregnancy. Matt believes that losing a baby is something that should not be a taboo, and needs to be talked about, investigated, and understood.

It was fascinating talking with Matt. I found him to be really interesting, and he has a great sense of humour. We enjoyed talking about mutual friends from our school days. He finished by saying that he had been incredibly lucky with his career, but that television was changing, so the future is impossible to predict. Hopefully he will be on our television screens, fighting our corner, for many more years to come.

Gail Porter

Gail Porter, 10 January 2019

I first met Gail Porter, the broadcaster and writer, for the *Lives & Times* book in 2014. That meeting at Winter Wonderland in Hyde Park was a real highlight, so I was keen to involve her in this book as well. We've remained in touch over the last few years, and Gail was especially kind and supportive when Mum died, having lost her own mother to cancer some years earlier.

We arranged to meet for a coffee at one of Gail's favourite restaurants in Soho. It was a bitterly cold January afternoon, and I was glad that it was only a short walk from Piccadilly Circus Underground Station. It had already been a very busy day for Gail, as she had started the day with a three-hour gym session, and then had been a guest on *The Matthew Wright Show* on Talk Radio, where she had also met double Olympic gold medallist Dame Kelly Holmes, and Michelin-starred chef Tom Kerridge. She was proudly carrying a couple of signed books by them. I was able to finally add a copy of *Lives & Times* to her collection, as we'd being trying to organise a get-together for ages without success.

Gail's first record was 'Cool For Cats' by Squeeze, which reached number 2 in the UK in 1979. She bought it for £0.50 from a shop in Portobello High Street in Edinburgh, which was the sum total of her pocket money she got at the time. She described the record's sleeve as having footprints on it, and when I checked this afterwards she was absolutely

correct. As a student, Gail listened to The Smiths, amusingly describing herself as a tortured soul, as all students were at the time who listened to them. Her brief Morrissey mimic was brilliant. She was also a big fan of Prince, and used to collect picture discs by him. Gail also liked Nik Kershaw, which she said might have been because he was the same height as her. The other artist she mentioned was Debbie Harry of Blondie.

These days Gail tends to listen to whatever her daughter listens to, such as bands like The Killers and Arctic Monkeys: in fact, she had even bought her daughter tickets as a Christmas present to see Florence and the Machine. She described how her daughter told her not to sing or dance when they went to see Bruno Mars, so that is of course exactly what Gail did in spite of not knowing any of the words. She also said that she doesn't listen to much music these days, and prefers to have Netflix on her phone when she is on the tube. At the gym she doesn't wear headphones, as she prefers to chat to people. Gail is one of life's great talkers, and is always striking up conversations everywhere she goes.

Gail told me how she got started in the entertainment business. She studied film and photography at college, and decided that she wanted to work behind the scenes, so she applied for a job as runner. She must have sent off about 300 applications, from which she got two offers. Gail ended up working for a production company in Edinburgh in an editing facility, where she would make the teas and coffees, do a little offline editing, look after the library, do the cleaning, and take people's washing to the laundrette: so pretty much everything.

She then wrote to the Comic Strip in London, as she was a big comedy fan, and they asked Gail to go down to London for a couple weeks to be a runner. In London she began to meet people. She went to The Groucho Club with someone she was babysitting for, and discovered that it was a club wholly for people who worked in the media. Gail said that the more people drank the more they took your number, and of course Gail was taking their numbers too, and following up every lead, that being the type of person that she is. Eventually she got asked to audition for a new children's television show, *The Totally Interactive Game Show*. There were hundreds auditioning for it, and Gail didn't think she stood a chance, but she got the job. She said that it was a live show, nothing worked, and something went wrong every week. It was a good learning curve, and things then took off from there. My main memory of Gail on television is her presenting *Top of the Pops*.

Gail has experienced some highs and lows since we first met. She lost her flat, was homeless, and slept rough for a couple of nights. She appeared on *Celebrity Big Brother*, and hoped to get an early exit, but ended up being kept in until the final week, as people kept voting for her. Gail works with and is an Ambassador for Creditfix in Scotland, and is able to share her own experiences of financial difficulties with other people in order to prevent the same things happening to them. She has also finished writing her book, which she was working on back in 2014. Gail said she lost about six months' work on a computer when she became homeless, and also lost her mojo, giving up on the idea for a while. The book is pretty much finished, and is with her new agent, so hopefully it will soon be published. Gail said that life is looking pretty rosy at the moment. One of the main reasons for this is her very special relationship with her 16-year-old daughter, Honey. Her face lit up as soon as she mentioned her, and she said that they are best friends. They enjoy going to the cinema, and mother and daughter are alike in their hate of people eating noisily during films. Honey has seen Gail perform at the Edinburgh Festival doing a stand-up

routine, and Gail had also been pleasantly surprised by her more recently when Honey asked if she could go to the gym with her. It was obvious just how proud Gail is of Honey.

It wasn't really a day for outside photography, so I decided to take the pictures where we were seated. The lighting wasn't great, which made it a bit more challenging, but Gail was very patient, and happy for me to try out a few different ideas. It was only when I came to edit the photos using a low-key effect that I came up with the dramatic portrait photo I have used.

We walked back together to Piccadilly Circus, and Gail took us through the back streets, steering clear of the normal touristy-type routes. She showed me the road where she had her first flat in Soho over twenty years previously when she was starting out in television, and pointed out some of the places where she liked to go to. At this point, albeit far too late in the day, I realised that this was really where we should have been doing the photography, and I could have kicked myself.

I have been incredibly fortunate to have met some amazing people on my book-writing travels, and made some great new friends along the way, of which Gail is one. My life is definitely richer for it. In 2014, at Winter Wonderland, we ended up on a 360-degree rollercoaster, and it was one of those truly unforgettable experiences. This time was equally as special, but for different reasons. The subject of cancer is a sad one for both of us, as the two of us have lost our mothers to this cruel illness. As soon as we touched on the subject I could see the pain in Gail's eyes, and how she had to fight back tears. I am incredibly grateful to Gail for being wonderfully supportive during the last few years. She is one of life's genuinely kind and generously-spirited persons, and my hope is that we do not have to wait for another four years until we meet again.

Sean Fletcher

Sean Fletcher, 14 September 2017

Sean Fletcher is a television presenter and journalist, best known for working on *Good Morning Britain*, *Countryfile* and *Inside Out*. He has recently become freelance, so he has reduced the number of ridiculously early alarm calls to do the sports news on *Good Morning Britain* on ITV, which has made a big difference to his health and energy levels. He is also an Ambassador for Beating Bowel Cancer, having lost his mother to the disease in 2006. We met outside City Lit in London close to Holborn tube station, where Sean was attending a mental health event. We walked to Lincoln's Inn Fields where I took the photograph. It was perhaps fitting that we did the photo shoot there, as Beating Bowel Cancer has regularly held its annual Patient Day at the Royal College of Surgeons on the square, which is the largest public square in London.

The first record that Sean bought was 'Word Up' by Cameo, which reached number 3 in the UK singles chart in 1986. He said it was a song that didn't sound like anything else at the time, a ground-breaking record that has stood the test of time well. Back then it was just a song he heard on the radio, and went out and bought. It's very different now, as his children listen to everything on their mobile phones. Sean was quite modest about the list of skills that he has. He is an accomplished musician, and is fluent in Welsh, having married a Welsh lady, and lived in Wales for 10 years.

He did not know that his mother had bowel cancer until shortly before she died. Sean had a young family, and was living in Essex whilst his mother was living in Cardiff. She was able to keep the illness a secret from him for two years, while she was receiving treatment, and had possibly had cancer for two years before she was diagnosed. She was able to plan visits with Sean around her treatment, keeping it from him. It was not until three and a half weeks before her death that Sean found out about the true nature of her illness when he visited her in hospital. The doctors would not disclose the details, so Sean eventually got his mother to tell him, and after an initial feeling that everything would be alright, it became apparent that she did not have too long to live. He was able to spend some quality time with his Mum, and he looks back on that as a crucial period, where he could say all the things that he wanted to say to her.

After his Mum passed away, Sean felt very angry that she hadn't told him sooner, although having children of his own he wondered if he would done the same thing in her position to protect them. It was something that Sean felt incredibly hurt by at the time. He feels that his mother came from a generation that wouldn't talk about bowel cancer, and of course that is now changing, but an awful lot more still needs to be done to raise awareness, improve early diagnosis, and reduce the number of people dying who could be saved.

Sean has run the London Marathon to support Beating Bowel Cancer. It was interesting to hear him talk about how the charity is very much a little boy in the list of cancer charities, whereas it ought to be one of the big boys, with bowel cancer being the second highest cancer killer in the UK.

We walked back to Holborn, which gave us a quick opportunity to talk about football before going our separate ways. We come from opposite sides of the North London football divide. Sean has a season ticket to watch Spurs, whilst these days I enjoy watching Arsenal from the comfort of my armchair. Sean was a really nice man, and the photo shoot was a thoroughly enjoyable experience.

Jacquie Beltrao

Jacquie Beltrao, 11 June 2018

I went to the headquarters of Sky Television in Hounslow to meet Jacquie Beltrao. The former Olympic gymnast-turned-television presenter works on *Sunrise*, the breakfast show on Sky News. I had never been to the Sky campus before, and I found it a very impressive place. On arrival, entry is only accessed through airport-style security, but everything was very friendly and efficient. There are various studios on each side of the road, but it's the state-of-the-art 'Sky Central' that takes centre stage. The three-storey building contains not just television studios, but a 4K cinema, a cashless supermarket, and five restaurants, as well as office space for 3,500 employees. I met Jacquie there in the main reception, as she had just come from the gym on the campus.

Jacquie is in remission from breast cancer, and Christmas 2018 marked her being five years clear. She still has regular scans, and like so many patients finds having those scans a nervous and stressful time, with the worry of whether the cancer might return. Cancer has given Jacquie a completely different outlook on life, and has made her braver in going after things, more ambitious, and better able to stand up for herself. Jacquie feels that it has made her a better person. She doesn't take anything for granted with it, and at least three women diagnosed at the same time as she was have sadly passed away. Jacquie is always happy to talk about breast cancer, and to help more women check themselves, or

get checked at the doctor's, and not to bury it. She works at different times with most of the UK breast cancer charities, and that's something that she is very happy to do.

Jacquie's first record was *Regatta De Blanc*, the 1979 number 1 album by The Police. She remembers playing the album to death, until it literally fell apart. One of Jacquie's regrets is never getting to see the band live in concert. At the time her gymnastic training meant that she never really was able to go out, and in fact Jacquie's social life didn't really start until she went to university.

Jacquie first started gymnastics one night a week at the age of seven. She absolutely loved it, and gradually started going every weeknight apart from Thursdays. At weekends she would go away training with the national squad. Jacquie was 19 when she competed at the Los Angeles Olympics in 1984. Reaching the Olympic Games had been Jacquie's goal in life since a very young age. She said that everything had been going really well until a year before Los Angeles when her mother died. Jacquie's mum was her friend, her driver, and her part-time coach, and not surprisingly this loss knocked the stuffing out of her. Jacquie said that she ploughed on with competitions, and even represented Great Britain the day after the funeral. However, she said she never really got going at the Olympics, and it wasn't her finest performance. Despite that, it was still an amazing experience, the like of which she has never been involved with since.

Looking back, Jacquie is very proud of qualifying for the Olympics. Qualification is tough, and you have to be one of the top 50 gymnasts in the world. Jacquie qualified straight after her mum died. She retired at the age of 22, having achieved and done everything that she'd set out to do. Niggling injuries and losing a bit of drive, especially when it came to training every day, meant Jacquie knew that she wouldn't make it to the next Olympics in Seoul. Gymnastics was a fantastic time of her life: Jacquie was travelling the world from the age of 11, and had a very different upbringing to her other school friends. Her training schedule and focus meant that she missed out on things like teenage parties when she was growing up, but she didn't mind at all, and absolutely loved what she was doing.

When we met, Jacquie had been working at Sky for 26 years. After leaving university she got her first job selling advertising space for a publishing house, and while she was there got a job in sports marketing, which was the area she really wanted to work in. She then got an interview for the job of publicist for Sky Sports. Jacquie got the job, and by that time had also started commentating on the Eurosport channel whenever they were covering rhythmic gymnastics. Eurosport were owned by BSB, who had just been taken over by Sky, so they all worked in the same building. Jacquie said that during the summer, as soon as the football season ended, lots of staff at Sky went on holiday, meaning that they would be very short of reporters for other events, so she would be asked to step in. A career in front of the camera wasn't something that Jacquie had ever considered, and for about a year she continued with her job in the press office during the week, and working as a reporter at weekends, meaning she had no days off.

Jacquie learned the trade of being a television reporter on the job. She said that she wasn't very good at the start, but that you had to learn fast at Sky, and in those days they didn't give you any training. She began to really like it, and when Sky found out that Jacquie

had had a couple of job offers elsewhere, they found her a slot as a reporter on Sky Sports. From there she went to work as a presenter on Sky News, and has remained there for 18 years. Jacquie prefers the very early mornings to working nine to five hours. She said that as well as having the day to herself after the breakfast show, they get to set the news agenda at the beginning of each day for others to follow.

Jacquie told me about the most interesting people she had interviewed. She said tennis player Andy Murray might come across sometimes as uninteresting, but what he actually has to say is very interesting. Jacquie said that he listens to the questions and gives thoughtful answers, so she always enjoys interviewing him. She also really enjoyed interviewing Martine Wright, who lost both her legs in the 7/7 London bombings in 2005. Martine managed to turn such adversity around by competing in the Paralympics in 2012 in the volleyball. Jacquie said that Martine was great fun, and that she had never laughed so much doing an interview.

Like myself, Jacquie is an Arsenal fan. Jacquie's Irish father moved to England when he was 18, and lived with her Uncle Barney on the Holloway Road, working on the London buses running out of the Holloway Bus Garage. When Jacquie was growing up in Ireland, they would spend Easter holidays visiting Uncle Barney and going to watch Arsenal at Highbury just round the corner.

The 2018 World Cup was only a few weeks away when we met, but Sky don't televise it. Jacquie said that it produces some great stuff for her sports bulletins on Sky News. They are able to show the goals, but only up to a maximum of two minutes. In fact, what was really interesting is that the Sky Sports channel can't show a single frame from the World Cup. Jacquie proved to have a much better idea about England's chances than I had. Whereas I had more or less written them off before the tournament, Jacquie came at it from a much more positive angle, and said the young squad had a lot less scar tissue than previous squads, and you never know how far they might progress. She was a fan of the England manager, Gareth Southgate, and thought he was the right man to take the team into the tournament. Getting to the semi-finals proved Jacquie completely right.

Jacquie's favourite sport to cover is tennis and, in particular, Wimbledon, which she has covered for 14 years for Sky News. It's close to where she lives, and her children learned to play tennis there, so the club has played quite a big part in Jacquie's life. Jacquie loves the tournament, the matches, the way it's done. The BBC have the UK television rights to Wimbledon. Jacquie told me how Sky's live position is just across the road, but that she has full access to the matches during the tournament, and then returns outside to do her live reports.

Jacquie is very settled in her career with SKY – in fact, she made me laugh when she said she was probably institutionalised there. She did say that if she could think of something really good to do, or a business to start, then she would consider doing it. Most importantly she enjoys her work, and feels very lucky in that respect. Jacquie said that she will stay at Sky for as long as they will have her, and hopefully that will be for many more years. It was another wonderful experience for me, and I really enjoyed meeting such a warm and kind person.

David Baddiel

David Baddiel, 24 March 2017

My meeting with comedian and writer David Baddiel came together within 24 hours of making contact with him on Twitter. I'd found out that he was previewing his one-man show, *My Family Not The Sitcom*, at the Norden Farm Arts Centre in Maidenhead. It was too late for me to get a ticket, as the show was a sell-out, but David suggested that I come along to meet him there after the performance. Norden Farm is located in Altwood Road, where my parents lived until they died. They got married in 1960 and moved into the house there, which they'd built during the cold winter of 1963. It was perhaps fitting that – as the sale of their house neared completion – the road and its connection to my family would play one final part in my fundraising journey. By this time the house was completely empty, but I was able to leave my dogs there for an hour while I walked down the road to meet David. It did bring back a few sad memories. The last time I had been to the arts centre was to meet cricket commentator, Henry Blofeld, for the *Lives & Times* book, and I had stayed over with Mum that evening. This was a rather different experience, and the house had a completely different feel to it.

David has been part of some of the most successful comedy programmes on British television in the last 30 years. Whilst preparing for our meeting, I watched some old footage of David from his *Newman and Baddiel in Pieces* sketch show. The 'History Today' sketches remain pure comedy gold, and back in the day I even owned the T-shirt.

His partnership with Frank Skinner brought the highly successful *Fantasy Football* and *Baddiel and Skinner Unplanned* to our television screens. He is also an acclaimed writer, and the author of novels and children's books as well as television and radio shows.

The only other time I had been in the same place as David, before now, was back in 1996 at Euro 96 at Wembley Stadium. The 'Three Lions' song by Baddiel and Skinner had grabbed the country by storm, going to the top of the charts, and England almost achieved the unthinkable of actually winning a tournament until they lost on penalties in the semi-final to Germany again, with Gareth Southgate joining the list of players forever to be remembered for missing their spot kick for England in a penalty shoot-out. David and Frank were at all the England games, as was I, which were all played at Wembley. At the end of each match there were 80,000 fans singing along to their song.

Our meeting at Norden Farm was quite short. It was late, and David had to go back to London that night. After the show had ended I was taken into a now empty theatre. David was very happy to pose for a few photos, and to tell me that the first record he bought was 'Devil Woman' by Cliff Richard, which reached number 9 in the charts in 1976. He was very interested in what I was doing, and at the end of our chat he invited me to go and see the show during its run in London, which was a lovely gesture.

So I did. The Playhouse Theatre is a beautiful auditorium on The Embankment, and this was the first time I had been there. The show is quite brilliant: it focuses on David's late mother Sarah, who passed away in 2015, and his father Colin, who suffers from dementia. During the first half of the performance, David talks about his mother's sex life, and the 20-year affair she had with a golfer. In the second half he turns his attention towards his father's aggressive form of dementia. The whole performance is both thought-provoking and challenging, but it had me and the whole audience laughing all the way through. David described it as a massively disrespectful celebration of his parents, which is very apt.

Since losing my own parents I have always found humour to be a great way of getting through some of the darker times, and this was almost exactly what David said about the aftermath of losing his mother.

Lucy Porter

Lucy Porter, 23 March 2018

I returned to Norden Farm to meet comedian, actor, and writer Lucy Porter, who was touring her *Choose Your Battles* show. I'd first heard Lucy interviewed on Radio 6 Music, and I made contact with her when I found out she was performing in Maidenhead. This was one of the easier photos to sort out, as Lucy immediately said yes to my request, and then very kindly arranged for me to see the show.

It felt a little strange driving to the venue, which is located in a road with so many memories for me – by this point it had been almost a year since the family home in Altwood Road had been sold. Whereas I used to have a sense of belonging to and being part of the road, living and breathing it for over half my life, it now feels completely different. I have a sense of no longer belonging there, and, instead, I feel a little like an outsider. However, the memories will always be there, and can't be taken away.

On arrival I was told to wait for Lucy in the bar area. It was a Friday night, so I knew the traffic might delay her, but as the time moved closer to the start of her performance, I did begin to wonder if there would be time for her to see me. Thankfully before I could worry too much about that, I was called through to meet Lucy in her dressing room. In fact, I was a little surprised – considering what a lovely theatre it is – how basic the dressing room was, but Lucy told me it was pretty normal, and she had been in a lot worse.

Lucy was very down to earth, and while we chatted she went about getting ready and putting her make-up on. She told me that her first record was 'Baggy Trousers' by Madness. It reached number 3 in the UK Top 40 in 1980, spending five months on the chart, and as a result was one of the biggest-selling singles of that year. It's a record that I still have in my collection, and while we were talking about how it seemed to stay in the

charts forever, Lucy checked its details on her phone. She also told that me that Elvis Costello was one of her favourite artists as she grew up.

We chatted about losing our parents, as sadly that is something we have in common. When Lucy's mum passed away, she was given the option of having a complete break from work for six months, but she decided to carry on working, and felt that her mum would have approved. I told Lucy how I kept working after my dad died in 2009, and how I even took an order at the funeral director's while we were sorting out the arrangements. Dad would have loved this, and my brother even mentioned the episode in the eulogy.

If you look at the photo you might be able to work out that the time was 7:40 p.m. on Lucy's watch. I thought it best to leave her to finish her preparations for the show, which was due to start at 8:00 p.m. Photographing her was very easy as she was just so relaxed, and as the dressing room was so basic, Lucy hopped onto the table for the photos, but not before removing her packet of Doritos!

The show, in two halves, was hilarious, and Lucy kept the audience entertained throughout. In terms of 'choosing your battles', she revealed that she hates confrontation, and had never really had an argument in all the years she had been with her husband, Justin. I should point out that Justin figured very prominently during the first half of the evening. Lucy had everyone in fits of laughter as she spoke about her relationship with Justin, how they got together, their very different family backgrounds, and the various things about him that annoyed her. Her story about his pronunciation of the word 'duvet' was priceless. However, it came as no surprise that at the end of the night, Lucy conceded that their marriage was very happy, and that she would spend the rest of her life with him.

During the second half of the show, Lucy moved on to other aspects of her life where she tries to avoid confrontation, and it was full of funny anecdotes including a road rage driver who almost ran over Lucy and her children, the school mums, and a lady at yoga who managed to keep digging herself into a huge hole. The lovely story that finished the show was about Lucy's parents. After her dad died, Lucy's mum moved in with them. During their marriage, her parents had watched *Coronation Street* religiously for 40 years, so Lucy was a little surprised when her mum said she wasn't overly fussed about watching it. She explained that she had only put up with it for her dad's sake as he enjoyed watching it so much. Sadly Lucy's mum passed away quite suddenly, and at the funeral the vicar read out a note left by her dad, who revealed that he had never much cared for *Coronation Street*, and only watched it because Lucy's mum liked to watch it.

It was a lovely ending to a brilliant and very funny evening, and almost a year to the day after our meeting, I went to see Lucy perform again, this time at the South Street Arts Centre in Reading.

Basil Brush

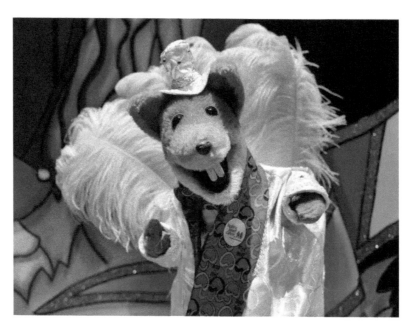

Basil Brush, 19 December 2017

Basil Brush, the nation's favourite fox, has been on our television screen for over 50 years, and like many people of my generation I grew up watching the *Basil Brush Show* on Saturday evenings on BBC One in the 1970s. I met up with him during his pantomime stint at the Theatre Royal, Windsor, where he was playing Lord Chamberlain in *Sleeping Beauty*. Going to the theatre brought back some happy childhood memories of when my parents would take us to the pantomime there. Windsor was a place we went to all the time as young children with Dad, mostly to watch the changing of the guard. We used to race the military brass band through the cobbled back streets, as it left the castle and headed back towards the barracks.

When I arrived, I was met by Basil in his changing room, and we were able to go onto the deserted stage to take some photos. It was fascinating to be backstage. It's pretty cramped for the actors and staff, as opposed to the elegant grandeur front of house. Even though the auditorium was empty apart from ourselves, it still had a special aura about it. It's a wonderful old theatre, and although the present building was built in the early twentieth century, theatrical history in Windsor can be traced back to the early 1700s.

The first record that Basil bought was 'Gudbuy T'Jane' by Slade, which was released in 1972, and got to number 2 in the singles chart. He still remembers the picture cover with all the band members on it. He actually gave me a short rendition of the chorus, and I don't suppose many people can lay claim to having had that experience! At that time Basil's favourite artists were Slade and The Sweet. He fondly remembers the record-buying experience of having to go to the shop to buy 7" singles, and then saving up to buy the album. He said it's a far cry from today when buying music is instantaneous.

Basil has appeared with various 'Misters'. I grew up with 'Mr Derek', played by Derek Fowlds, followed by Roy North as 'Mr Roy'. Basil could not pick a favourite, describing all his assistants over the years as wonderful, and without whom there would be no Basil. He also added that many of the 'Misters' went on to do great things, and he naturally claimed to have taught them everything they know. He wondered whether now might be the time to work with a 'Miss'!

Basil has been doing panto for five years. He loves it, in spite of performing as many as three shows a day. During 2017 he appeared at a number of festivals with 'Mr Kevin', who is Kevin Cruise from *Britain's Got Talent*. Basil has always been a favourite with all the family, and he regards himself as a family entertainer. His jokes appeal to children, but he also has a more sophisticated sense of humour which appeals to grown-ups on a completely different level. He appeared on an episode of *The Chase* which he actually won, and he also revealed to me that he had appeared on a forthcoming episode of *The Generation Game* (which will already have aired by the time I come to print this book). Basil's appearance went down so well that he was asked to come back and do cameo appearances in the other three episodes that were filmed. He'd love to be back on Saturday night television on BBC One, just like in the old days.

I remembered Basil's appearance on *Fantasy Football* in the 1990s. He does not support Leicester City, nicknamed "The Foxes", but instead always prefers to support the side that wins – when we met towards the end of 2017, for instance, he was very keen on Manchester City.

Basil has always enjoyed singing songs, and he told me about some of his favourite guests he got to perform with on TV, including Cilla Black, Demis Roussos, and Abba. The words in the song were modified so that Basil would upstage the star. He'd love to do more of this, and added that he would like to perform with a rap star – apparently some people have said his singing is rap, but he thinks that might be a spelling mistake! He'd also like to perform with Ed Sheeran as "two gingers together".

The theatre is opposite Windsor Castle, and Basil is a big fan of the Royal Family – he thinks it would be a great shame if we ever lost them. Being a fox he said that they have great bins at the Castle, and he'd had a good rummage through them. Basil turned his attention towards the Royal Wedding of Prince Harry and Meghan Markle. He was hoping to be invited, and said that with his talent for singing he could be the choirmaster, or one of Prince Harry's ushers, "ushing and shushing people", or he could perhaps do a reading at the service. He did say that having entertained Harry at the age of four, the least he could do would be to invite him to the wedding – after all fellow gingers needed to stick together! This led him to believe that he might perhaps be able to take Prince Harry's place and marry Meghan himself! His final message was, of course, "Boom boom!"

Sadly bowel cancer has also touched Basil's life too. He lost his very good friend Ivan Owen to bowel cancer in 2000, which was one of the reasons why he agreed to be in this book and to help raise awareness of this horrible illness. Ivan was the original voice behind Basil, and I am very grateful to Ivan's son Jonathan, and the rest of the family, for helping to make this chapter possible. I must also thank the wonderful Mike Winsor, the

voice of Basil Brush since 2000, who gave up his time during the very busy pantomime schedule to meet me, bring Basil to life, and make it so much fun to do.

Janet Ellis

Janet Ellis, 31 August 2017

I spent a quite fascinating hour in the company of Janet Ellis in her West London home. She is perhaps best known to people of my generation as a presenter on *Blue Peter*. During her time on the show in the 1980s, she co-presented with Simon Groom, Peter Duncan, Michael Sundin, Caron Keating, and Mark Curry. Janet loved her time on the programme, and said it was as much fun to do as it looked. Janet's background is in acting, and after spending five years at drama school she was working on *Jigsaw*.as an actor when her agent suggested she audition for the presenting role on *Blue Peter* to replace Sarah Greene who was leaving the show. She said that she was fortunate enough to have become great friends with all the people she worked with.

Janet was especially close to the late Caron Keating, who sadly passed away from breast cancer in 2004. She said that Caron dealt beautifully both with cancer and with the reaction of her friends, and was an amazing person. I wondered if this loss had been a factor in Janet's charity work with Maggie's, the cancer charity, but Janet told me that she had lost her mother to breast cancer aged only 57, and said that if anything this work had found her. Maggie's is a charity Janet is very passionate about. She told me that they are not specific to any particular cancer. The charity is a drop-in centre, and offers emotional, practical, and social support for anyone affected by a cancer diagnosis, which includes families and friends as well as patients. They offer loads of practical advice, but

it can also be a place where people can just go and sit quietly and have a cup of tea. There are no appointments, and there is no reception. The centres are always in the grounds of hospitals, and Janet's local one is in Charing Cross Hospital. Janet told me that the charity's founder, Maggie Keswick, who sadly passed away from cancer, insisted that all the centres were beautiful. She achieved this with the help of her husband's architecture friends, who had to create these places within limited time constraints and the physical constraints of working hospitals. Janet said that she went to see the centre in Charing Cross while it was under construction, and she was amazed to see just how spacious and lovely the finished building actually was. She added that both her Mum and Caron would have loved these centres.

Janet does workshops with Maggie's, and had recently done one about the power of words – how people are told things, and how they react afterwards. It was interesting talking to her about the use of the words "fight" and "battle" in a patient's cancer journey. These are words that I have often used when talking about my Mum's cancer journey. Janet's thoughts are that the doctors are doing the fighting on the battleground. She doesn't like the idea of a patient "losing" the battle, as this can infer some kind of failure on their part, which of course is the last thing that it is. Janet revealed that her husband, John, had been diagnosed with cancer in the tonsils in 2016, and was thankfully clear now. His experience was like that of walking through a tunnel from which there was no way of making a detour, and to keep moving forwards – not a battle or a fight. On reflection this is very similar to how my Mum dealt with her cancer. Whenever the cancer came back and she faced a course of treatment, she would grit her teeth, get on with it, and look forward to the time she could ride her horse and drive her car again. It is of course something that is very personal for everyone, and as Janet said, there are some cancer patients who do regard what they are going through as a battle. I have to admit that it certainly got me thinking about these words, and also how fascinating the workshop must have been.

The first record that Janet bought was 'Dizzy' by Tommy Roe, which reached number 1 on both sides of The Atlantic in 1969. Music has always played a huge part in Janet's life, and she told me that her husband used to write questions for the *Pop Quiz* programme, which was presented by Mike Reid. Janet still goes to see live bands, and she was looking forward to seeing a band called The Magnetic Fields at The Barbican on two consecutive nights a week or two after our meeting. Of course her daughter, Sophie Ellis-Bextor, has enjoyed huge success in the music industry, and Janet is a very proud mother of her three children. As well as loving them, she told me that they are all very nice people. Her son is a professional drummer, who is working with the singer John Newman, and her other daughter works in a successful art dealership. Janet is also a grandmother, describing Sophie as a wonderful mother to her four children.

In more recent times Janet has become a successful author. I thoroughly enjoyed reading her debut novel *The Butcher's Hook*, and she very kindly signed my copy, which I had taken with me. She revealed that she was working on her second book. Janet remains very busy, and is used to working freelance. Her work has been a lovely mix, and she has never had a plan. She never thought she would end up presenting on television, and luckily she has never regretted doing anything.

To end our meeting we went out into the back garden to take some photos. It was a perfect late summer's day, so it was really nice to be able to get outside to do the photograph. It was a fantastic experience, and Janet was really lovely. She couldn't have been more helpful and supportive of what I was doing.

Gregg Wallace

Gregg Wallace, 22 September 2018

I met television presenter Gregg Wallace before his one-man show at the Norden Farm Arts Centre in Maidenhead. Gregg is best known for presenting *Masterchef* on the BBC, and his story from working on the markets in Covent Garden to becoming a television celebrity is fascinating.

Autumn had most definitely arrived on a pretty wet and miserable afternoon. Gregg had been held up in traffic, so I had a little time to wait. Upon his arrival, the venue management suggested that I accompany Gregg on his tour of the building, and then go straight to his dressing room to do the interview. This was an interesting experience, as I got to see Gregg discuss his requirements for the evening with the staff, including his choice of meal, which was Hungarian goulash.

The first record that Gregg bought was 'Block Buster' by The Sweet, which was a number 1 single in 1973, and stayed at the top of the charts for five weeks as the band's only chart-topping release. Gregg, who had a poster of them on his bedroom wall, is still a fan of glam rock music, and plays it a lot. His wife, 22 years his junior, who had no idea of what glam rock was before meeting Gregg, now really loves T-Rex. Another single that he bought at the time was 'Part Of The Union' by The Strawbs, which reached number 2 in the singles chart. Gregg is also a massive fan of Squeeze, who, like him, are also south-east Londoners. He likes the way that they tell stories in their songs, and when we talked about their chart success from back in the 1970s and 1980s, I realized I'd forgotten just how many hits they had.

Gregg's football team is Millwall, and to my surprise he showed me the Millwall lion that he has tattooed on his chest. He rarely missed a home match from the age of five through to his early twenties, and it was only when Gregg started playing rugby that he stopped

going. Rugby is now Gregg's main sporting passion. He is a mad Wasps fan, has coaching qualifications, and is an ambassador for a couple of rugby charities. Gregg watches as many Wasps and England international matches as he can. It has become the thing that Gregg and his son, who is now 24, do together. His son started playing rugby at five, and Gregg said it was the best thing he ever did as far as their father-son relationship goes. Gregg's daughter had recently graduated with a first-class degree in Contemporary Theatre from Manchester Metropolitan University, and she had already been a great help for Gregg with preparing for this one-man show. Gregg is very proud of his children, and of bringing them up as a single parent.

Gregg is involved with the two biggest programmes on BBC 2, *Professional Masterchef*, and *Inside The Factory*. He told me that he is never scripted on television, apart from when he does pieces for camera, which he explained was linking different parts of a programme.

Gregg spoke about the one-man show and said that it was very different to his work on television, since he felt a sense of control, which he doesn't have on TV. The show not only gives him a career outside television, but also is the first creative thing that he has been allowed to do. On TV shows like *Masterchef*, Gregg just chats to the contestants, which he described as a "free-for-all". Gregg also said that nobody comes out of the show looking bad, and even if things go badly in the kitchen, Gregg, and fellow presenter John Torode, will only ever laugh if the contestants are laughing as well.

Gregg began his career working at Covent Garden Market, and I wanted to know how he got from there to being a hugely successful television presenter. He told me that this story would actually form the first half of his theatre show. He explained that everybody who is on television never intended to be there, and that there is no route that you can take. It's very much about getting that lucky break. Gregg said that he never actually sold fruit and veg on a market stall, but started off as a warehouseman, became a salesman, and then began going to France to bring back the food that the chefs in London wanted. Once he had enough customers, Gregg set up his own company, which grew into a business with a multi-million pound turnover. His work with trying to use British produce led to a magazine article on Gregg in *Hotel and Catering*. The freelance journalist who did the piece also did freelance work on Radio Four's *Food Programme*, and it was at that point that a completely different adventure began for Gregg.

I wanted to know how Gregg accumulated his knowledge of food. In his own words he is a greengrocer, not a chef. However, he was supplying the best hotels and restaurants in London, and he ended up spending all his time with the chefs. That included eating out four or five times a week in the smart London restaurants for 10 years.

I asked him how easy it was to identify flavours when eating, and what is either too much, or too little, and he said that anyone could do that if you were doing it all the time. He told me about an Irish lady who he met at Waterloo Station. She appeared to be drunk, and told Gregg that she could tell when he liked a dish, because he leaves a fork or spoon in his mouth longer. He thought that couldn't be right, but on looking back at old episodes she was correct. The reason for this is when food is beautifully delicious, Gregg is holding it in his mouth, listing what he is tasting, so that he can explain why he is so ecstatic. After

explaining this to me, he said that he would include the anecdote in the show, which he did indeed do that evening. I never thought a chat with me about food and a drunk Irish lady would end up as part of his performance.

We finished by talking about the episode of *Who Do You Think You Are?* on Gregg, which I remembered being quite a sad and emotional programme. Gregg said that it wasn't what he had expected at all and told me that at one point he got angry at the production company, because they knew what was coming. He didn't feel it was fair that they put him through so much sadness and emotion. In the episode Gregg discovered that his grandfather's baby sister died in a fire in Plymouth, and that his grandfather's grandmother was in a Victorian mental institution. He said that was really awful, and very sad. Gregg, who is very interested in history, said that it wasn't until the making of the programme did he realise the impact that Charles Darwin had had, not just on science and how we view the world, but on how mentally ill people were treated. Gregg explained that before Darwin, patients were treated kindly, and it was felt that the pace of the industrial revolution was too fast for them, so they were put back into a rural setting. After Darwin's *Origin Of Species*, it was decided that they were defects, and should be treated as such. Instead of living in the healing countryside, patients were locked away in institutions that became very much like prisons. Gregg believes that his great-great-grandmother would have been very scared and unhappy, especially having experienced both types of care.

The evening performance was very entertaining. Gregg went into a lot more depth, and the humorous anecdotes kept the audience laughing throughout. I am sure that Gregg will make a great success of the one-man shows. It was a really enjoyable experience meeting him, and although much of what we talked about was included in his performance, I felt that I also got a bit of an insight into the man away from the television cameras.

Colin Murray

Colin Murray, 7 November 2017

I met Colin Murray, the radio and television presenter, at the Sister Ray Record Store which is situated in Berwick Street in the heart of Soho. Colin spent 10 years at Radio One, so we thought that the shop would be a perfect location. When you enter you are directed downstairs to the basement which is full of thousands of vinyl records. I felt like I was being transported back in time to my teenage years when I spent all my pocket money on buying records. I can still remember my trips to London in the 1980s to pick up vinyls that you couldn't get in the local record shops.

Colin arrived not long after me, and the first thing I had to do was give him the present that I had brought along with me. Colin does a podcast series, *At Home With Colin Murray*, where he is in conversation with famous people from the world of sport. He always takes along a gift for his guests, so I thought that it would be a nice touch to get something for him. I gave him a copy of the first record I bought, which was 'Back Of My Hand' by The Jags. Colin revealed that his first record was 'Agadoo' by Black Lace which reached number 2 in the singles chart, a wonderfully dreadful song with an accompanying dance that swept the nation by storm. Colin's mum has a large record collection, as does his stepdad, so he rarely bought records when he was younger. He grew up in Northern Ireland listening to The Beatles, Neil Young, Van Morrison, Pink Floyd, Jim Croce, Bruce Springsteen, T-Rex, and Jimi Hendrix, and he absolutely loved Elton John. He described the *Comes A Time* album by Neil Young as playing a huge part in his young life. Colin is very thankful that his mother has such good taste in music.

We then had the most bizarre scene where customers browsing records were revealing to Colin what their first record was. One gentleman proudly announced that his was by Showaddywaddy, and suddenly they were being played on the in-store sound system. The manager of one of the coolest and hip record stores in London then came across, and announced that his was by The Wombles. Colin revealed that he was given a Wombles

record one Christmas when he was about two, and I also have their *Greatest Hits*, so it seems that everyone must own a Wombles record. It was almost like a badge of honour thing, and I am sure the shop has never hosted a musical debate quite like it.

Colin was very enthusiastic with the photos, and he made sure I got as many as I wanted. After every few shots he would eagerly stand with me looking at what I'd just taken, and come up with new ideas. The photo with Colin holding the record worked really well with its interesting change of focus.

Colin told me that after leaving Radio One, he moved away from listening to new music, which he'd had to do for 10 years. He discovered jazz , and he has membership at Ronnie Scott's. Colin moved into sports presenting, his other great passion. He currently hosts *Fighting Talk,* the popular Saturday morning quiz show on Five Live, and he had just started presenting the Saturday night Football League highlights show on Channel Five.

Colin is a massive Liverpool fan. He famously left the Talk Sport radio station when they were taken over by Rupert Murdoch's News Corp, who also own The Sun newspaper. Their notorious coverage of the Hillsborough disaster, where 96 people lost their lives, will never be forgiven by Liverpool fans. You have to respect and admire Colin for sticking to his principles.

When we parted, Colin left to prepare himself to work on Northern Ireland's World Cup play-off against Switzerland, which they sadly lost 1-0 on aggregate over the two games due to a controversial penalty. It was one of the worst refereeing decisions I've seen, and broke the hearts of the Northern Irish. Throughout the meeting I found Colin's enthusiasm catching. He is warm and funny, but at the same time cares very much about the world around him. He fears for the future of independent retailers in Soho, with so many already lost and gone forever. Hopefully Sister Ray will continue to flourish, and be around for many more years to come.

Laura Boyd

Laura Boyd, 4 March 2017

Laura Boyd is the entertainment reporter for STV News in Glasgow. Previously, at the time of our meeting in 2017, she reported for the *Live at Five* daily magazine show, while on Friday nights she hosted the weekly entertainment show, *E...on* STV, with her television husband Gerry Cassidy. Laura has leukaemia, having been diagnosed in 2009. To meet and photograph her meant making a trip to Glasgow, a place that I had not been to for 40 years. I'd actually approached her to be in my previous book, *Lives & Times*, but unfortunately we hadn't been able to make that happen.

Before our meeting I made a quick visit to Loch Lomond. In fact, Laura recommended that I went to Balloch Castle, which would give me great views of the loch. This was sound advice, and it was a stunning location in spite of the weather. Thankfully the rain had stopped by the time we met up outside the Kelvingrove Art Gallery & Museum in Glasgow, which gave us access to the picturesque Kelvingrove Park to take some photos. Sometimes when photographing people it can be the picture you least expect that ends up being the best one. The idea behind shooting Laura with the Beating Bowel Cancer tie was to use it to help promote the *Follow The Bowel Cancer Tie* page on Facebook. However, as much as I liked all of the photos we shot with the River Kelvin in the background, this photo, for me, captures the real essence of Laura, a fun and happy person with a zest for life.

As we walked, we talked about Laura's cancer. Her leukaemia is something that she describes as managed. It is a condition that she lives with every day. The medication that she takes keeps things as stable as possible and manages her condition, but there is always a possibility that her body might react adversely, or become too accustomed to a particular drug. If this happens a new drug needs to be prescribed. Laura undergoes regular scans to monitor the cancer. She went on to say that a last-resort treatment and potential cure is a bone marrow transplant. However, there are risks involved with that, and it also extremely

difficult to find an exact match. Laura has a positive approach to her life and the leukaemia. Since being diagnosed with cancer her life has been very different, and for all the inherent difficulties in dealing with it, her illness has taken her on a special journey. It has had a profound effect on her and she believes in living life to the full and making the most of every single day.

Laura does a lot of work with and fundraising for cancer charities. One in particular is Rainbow Valley, for which Laura is a trustee. It's a cancer charity raising funds to build an alternative cancer therapy centre on the banks of Loch Lomond, a centre to assist with the holistic and relaxation side of recovery. It will make a massive difference to both the patients and those closest to them. Laura said it will be an amazing place, which will work alongside normal medical treatment and complement it.

Music has played a big part in Laura's life. She is a very accomplished singer, having been in a band called Pooch. Laura famously duetted with Susan Boyle singing *River Deep Mountain High*. In fact over the years she has interviewed Susan a number of times and has built up a good rapport with her. She revealed to me that the first record she ever bought was an album by Five Star, although she couldn't remember which one. I believe it must have been either their debut album *Let It Loose*, or the multiplatinum-selling *Silk and Steel* which followed. This came across almost like a confession, but I don't think there's too much wrong with that.

I found it really interesting that Laura and her team at STV use social media to approach people to appear on the television programmes. It's a similar approach to the one I use, so if I was hoping to discover some tricks of the trade or the magic secret, I was to be disappointed.

All too soon our time was up and we went our separate ways – Laura to prepare for a swanky press ball that evening, and me to embark on a gruelling seven-hour drive home. She is undoubtedly a lovely lady with a passion for life, and another one of life's amazing cancer warriors.

Gareth Jones

Gareth Jones, 26 May 2018

These days Gareth Jones, aka Gaz Top, is best known for his work as a television presenter, but going back 35 years or so, he worked as a roadie for five years with The Alarm. Gareth was very happy to be involved in the book. We spent a year trying to find a date that worked, so when The Alarm announced a London concert date at the O2 Forum in Kentish Town, it seemed the perfect opportunity to meet up.

The day did not get off to the best start, as the Northern Line on the Underground was closed for the bank holiday weekend. This meant a change of travel plans, and I ended up having to get a bus from Regent Street to Kentish Town. Although the journey was longer as a result, I have to admit that it made for a pleasant change seeing the sights of London from the red double-decker bus, as opposed to the rather dreary darkness of the Tube.

We arranged to meet at the Bull & Gate pub just along from the venue, and whilst waiting for Gareth I had the opportunity to meet and catch up with friends and fans of The Alarm before the gig. Gareth arrived wearing his kilt, which seems to be a tradition for him at Alarm concerts, and as you can see in the photo his Slade T-shirt reveals a little about his musical tastes. London gigs are always busy affairs for any artist, and Gareth, having had such a long and close relationship with the band, was in high demand, with many people wanting to say hello. He was brilliant, because as soon as we had taken a few photos

outside the pub, we retired to a quiet corner inside where we sat down and had a fascinating chat.

Gareth told me about his first record – in fact, he bought three records at the same time in 1971. Unsurprisingly one of them was by Slade. 'Cos I Luv You' was a number 1 single for the band in the UK. 'Ernie' by Benny Hill was the Christmas number 1 single of 1971, and the other record was 'Something Tells Me' by Cilla Black which got to number 3 in the singles chart. Gareth was 10 years old at the time, and bought the records with WH Smith vouchers he had been given for Christmas. He still loves Slade, and not long after our meeting, Gareth got the chance to perform with them on stage in June 2018 at the Zip World Rocks concert in Snowdonia.

Gareth has a connection with bowel cancer, as his grandfather, or *taid* in Welsh, died of bowel cancer back in the 1980s. He remembers Llewelyn Ffoulkes as a lovely man, who was responsible for Gareth being a fluent Welsh speaker before he was four years old. Llewelyn fought at the Battle of the Somme in World War One, and Gareth said he owes him a great deal.

Gareth grew up in North Wales, and was part of the punk scene there, which formed the foundations of what was to become The Alarm. I wondered why Gareth ended up as a roadie for the band, and not a member. He was honest enough to admit that he simply was not a good enough musician. The Alarm had previously been known as Seventeen, and had toured with The Stray Cats. However, it just didn't quite happen for the band, and in the period before Seventeen became The Alarm, Gareth was part of a skiffle-based band, with Dave Sharp and Nigel Twist, called The Screaming Demons. The band never recorded or performed live, but Gareth told me that the band did rehearse 'Across The Border', and 'Up For Murder', two songs which would become Alarm songs.

Gareth turned from roadie to television presenter when a bandmate, Peter Picton, who used to be in the group Backseat with him, heard in late December 1984 that a new 24-hour satellite TV music channel was looking for presenter/video jockeys. Peter knew Gareth had spent five years on the road with Seventeen/The Alarm, and so thought he might be suitable for the job. When Gareth was in London in January 1985 setting up The Alarm to write and rehearse the *Strength* album, he contacted Music Box (as the channel was called). They invited Gareth in for an interview, and offered him a screen test a couple of days later. Another few days passed by, and Gareth was offered the job. The timing was perfect because Gareth wouldn't have been paid by the Alarm during their non-touring period, so he accepted a three-month contract from Music Box, expecting to return to his 'proper job' with The Alarm after that. However, Music Box just kept extending his contract, so Gareth never went back to being on The Alarm's payroll, but still remained close to them on a daily basis.

Gareth said that his time with The Alarm was like being in a gang. Everyone associated with the band was part of the gang, but at the nucleus of that cell was the band, and only some of the gang were in the band. In fact, we were chatting in the pub with another member of the gang present. Tony Evans, from Flint in North Wales, is a great mate of Gareth and The Alarm's, and was effectively Seventeen's and later The Alarm's security during the early days. Whenever the band was gigging Tony went along in the van with

them, and while he didn't have the music or technology skills needed to be a guitar tech or drum roadie or sound man, Gareth described him as an essential part of the gang, hilariously funny, and the person responsible for giving the band their nicknames.

They all had nicknames: Gareth was known as *Footsie*, on account of having very large flat feet. Nigel had the nickname *ET*, apparently because of his boggle-eyed similarity to the loveable alien. Eddie was called *Dodsworth* due to his Ken Dodd-like teeth. Dave was called *Stan Sted*, because when he took his hat off his hair would be as flat as the runway at Stansted Airport. Mike was known as *The Craft Christian*.

While I was telling Gareth a little more about my mum's bowel cancer, and talking about the book, and my fundraising, Tony revealed that he had recently been treated for bowel cancer himself. He was doing well post surgery, but his disclosure was yet another unexpected connection to this horrible illness that writing this book revealed.

I was very grateful to Gareth for sparing me so much time, when it was so busy before the gig. He is a really nice man, who couldn't have been more helpful, and made sure I got everything that I needed from him. The Alarm played a blinding two-hour set, and the only challenge that remained at the end of the night was getting back to Regent Street on the bus accompanied by a lightning storm, and a spectacular downpour. It was great evening that will live long in the memory.

Daniel Norcross

Daniel Norcross, 2 December 2016

Daniel Norcross is one of the up-and-coming cricket commentators on BBC Radio's *Test Match Special*. He was part of the commentary team covering England's 2016 tour of Bangladesh, and it was while he was there that I initially made contact with him. He was very happy to support the book and we arranged to meet up close to his home in Tooting Bec a few weeks later.

Daniel came from a household of older brothers, so he inherited a lot of their music when they moved out. He would have loved to have been able to have listed a record by The Stranglers as the first record that he bought, but of course I had to disqualify records that he hadn't purchased himself. As a result he had to rather sheepishly admit to having bought 'Moonlight Shadow' by Mike Oldfield featuring Maggie Reilly, released in 1983.

Tooting Bec is not an area of London that I know too well. I seem to remember delivering some packaging materials to the St. George's Hospital in what must have been the late 1980s, but my work travels have never really taken me into that part of London. Of course many people will remember the classic BBC sitcom, *Citizen Smith*, from the late 1970s, which featured Robert Lindsay as Wolfie Smith. His famous salute and catchphrase, "Power to the People!", remain popular to this day. Daniel thought we could get away with recreating the salute outside Tooting Bec tube station, although the famous television

scenes were filmed just down the road from where we were, at Tooting Broadway tube station.

We met at The Wheatsheaf public house just across the road from the tube station. Daniel proved to be extremely generous with his time and we ended up chatting for two hours. I was keen to find out more about how Daniel got the job on *Test Match Special*. He decided to leave his job working in the City after he sadly had lost both of his parents. He then was one of the co-founders of *Test Match Sofa*, which initially broadcast out of his flat in Tooting. The show provided an alternative commentary to *Test Match Special*, and Daniel explained that one of the reasons for setting up the station was to broadcast commentary on England matches to listeners outside the UK, who at the time were unable to get *Test Match Special*. The programme was a great success, but it caused friction with the English Cricket Board and the BBC. Daniel eventually left the programme after it had been bought by *The Cricketer*, feeling that he had taken the show as far as it could go. He then started commentating for the BBC, first at the Oval, commentating on Surrey matches, and then joined the *Test Match Special* team in 2015. Having been given the opportunity by producer Adam Mountford, Daniel has not looked back. He was keen to point out the great support he received from Jonathan Agnew, who had not been a fan of *Test Match Sofa*.

Daniel went on to talk about how he now has access to the players and how relationships and trust are built with them. He pointed out that this could sometimes be a very fine line, as you could enjoy their company off the pitch and then have to commentate on their performance on the pitch. As well as commentating on the men's game, Daniel spends a lot of time covering the England women's team. It was interesting to hear Daniel talk about his co-commentators with genuine affection. The commentary box is full of ex-cricketers, and Daniel had to win them over in his early days. When he was commentating with one former test player for the first time – no names, no pack drill – the ex-cricketer spent the entire 20-minute stint staring at him. A baptism of fire...

Throughout our meeting Daniel's enthusiasm for life shone through. He also took a great interest in what I was doing, and he was more than happy to listen to my own cricketing stories. As our meeting drew to a close, Daniel was very keen to point out that he had never been happier, and he was doing something that he absolutely loves.

Since our meeting, Daniel has become a mainstay and a popular member of the *Test Match Special* commentary team. He continues to travel the world commentating on England matches.

George Dobell

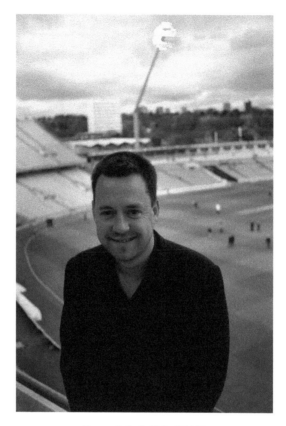

George Dobell, 14 April 2017

George Dobell is a cricket writer and journalist, and he is also a senior correspondent at ESPNcricinfo. He spends most of the year reporting on the England cricket team, so he gets to travel all over the world. The obvious downside to that is the amount of time George has to spend away from his family. We met on a very cold day at the beginning of the English 2017 cricket season at George's home town ground, Edgbaston, in Birmingham, where Warwickshire were playing Yorkshire. It didn't feel very summery at all. On arriving at the ground I was immediately given a sense of how well liked George is there by the car park attendant, who referred to him as "our George".

George came to meet me in reception, and took me up to the press box. The views of the playing area were amazing: you really are in the box seat to report on cricket. We went outside during the lunch interval to take the photo, and I think the "E" floodlight is a great touch in the ground's modern design. Conditions were not easy for batting, but I got to watch former England players Ian Bell and Jonathan Trott batting together, although neither lasted for too long. Interestingly the last time I had seen these two play live was when I was in Australia watching the 2010/11 Ashes series in Melbourne and Sydney.

George's route to where he is now has been a long one. He played cricket with a passion growing up, even to the extent of clearing snow in winter just to get a game going. Unfortunately, he was involved in a bad car accident in 1991, which means he can barely

play these days, and is unable to bowl. Cricket journalism is a dying industry, and George told me that more sensible people would have given up long before and got a "proper job". He has no idea how long it will last, but is very much enjoying it while he can. He has been a journalist for 15 years, and for at least half of that it has been a real struggle. George started work at the Birmingham Post and Mail, and his time there was really happy, making him feel part of the community. George said that if you like cricket then there is nowhere better to work than at Cricinfo, because it is unashamedly cricket-based, and if you love your cricket it's the best resource for your cricket information.

George's first record is a little different to everyone else's in this book, as he actually bought three whole albums together from a second-hand record shop in Malvern where he went to school. The first was *Pin Ups* by David Bowie, released in 1973, which got to number 1 in the album charts. George admitted that he had already taped several of Bowie's albums off friends, but he had to buy this one, as no-one else had it. Next was *Mott The Hoople's Greatest Hits* which was released in 1976, but did not chart. Over the years George has got to meet several members of the band, including Ian Hunter and Mick Ronson. The third album, which he bought on cassette, was *Transformer* by Lou Reed, a record that inspired George to start a band himself, and which peaked at number 13 in the UK. He told me that he bought all the records because of the links to David Bowie. George said of himself that he was an unsuccessful musician before becoming an unsuccessful journalist, and he once made a record with Geoff Haslam, who produced *Loaded* by The Velvet Underground. I suspect that there is a little more to George's musical ability than he let on.

We continued talking about music and it turned out that George also liked my favourite band, The Alarm. He describes lead singer Mike Peters as an unsung genius and particularly loves their song, 'Spirit of 76'. George was interested in what the band were doing these days, and had no idea why he had stopped listening to them. So perhaps I have managed to reintroduce George to their music!

George is very positive about the future of cricket, and believes that it's still a great game in all its formats, although he sees the one-day white ball format continuing its rise in popularity. He is keen for more cricket to be shown on free-to-view television, as by bringing the game to a lot more people, the game's popularity would increase. He has come a long way from the days of working on *Test Match Sofa* with Daniel Norcross to now travelling the world with the England cricket side.

Natalie Germanos

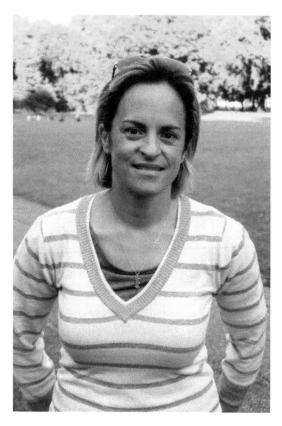

Natalie Germanos, 25 July 2017

South African sports broadcaster, Natalie Germanos, came to England during the summer of 2017 to cover the Women's Cricket World Cup as part of the BBC Test Match Special commentary team. This was in fact her first time commentating overseas, so the month-long trip was a very special time for her. The challenge we had was trying to find the opportunity to meet up, due to Natalie's extremely busy schedule during the tournament, which seemed to have her permanently on the move between the different venues. Fortunately Natalie had an extra week in London after the World Cup, so we arranged to meet up in Central London a couple of days after the final.

It was a beautiful summer's evening, so the capital city was looking its magnificent best. We tried to find a bench in one of those lovely garden squares, but the ones that we came across were all locked up. We did think about recreating the Hugh Grant / Julia Roberts scene from the film *Notting Hill* and climbing over the iron railings, but common sense won the day. We ended up walking, in a rather roundabout way, to Green Park. However, this part of the evening gave me the opportunity to ask Natalie about the first record that she bought, which was the album *Joyride* by the Swedish group Roxette. It was a huge worldwide hit in 1991, and it reached number 2 in the UK, selling over 600,000 copies, and spending almost a year in the album chart. Natalie also told me that her mother has twice been successfully treated for breast cancer. She said that on both occasions her

mother benefitted from an early diagnosis, which greatly improved her chances of survival.

I felt under a little bit of pressure when taking Natalie's picture, as she is a very keen photographer in her spare time, specialising in wildlife photography. I'd had a look at some of her photos before we met, and they were very impressive indeed.

Natalie developed her love of cricket at a young age, influenced by her father, and also by playing cricket in the back yard with her sister and two brothers. The 1992 Cricket World Cup held in Australia was also a landmark moment for Natalie, as it was for the whole of South Africa, being the first time that the country had been included in the tournament after the end of apartheid. She would watch as many games as possible on television, and even went as far as to listen to the matches on a small transistor radio at school by using an earpiece fed through her jersey. She was able to play cricket at secondary school, but when she left there was no decent women's club cricket at that time. Instead she went to Argentina to play and coach cricket for six months. I think that this is a slight regret for Natalie, as in today's game, she would have had the opportunity for a playing career.

It was when she returned to South Africa from Argentina that Natalie decided she wanted to get into commentating, and could trace it back to one particular day. She was doing a sports management course, and her lecturer was the fitness trainer at Fountain Cricket in Johannesburg. He took the class on a tour of the Wanderers ground. When they got to the commentary box Natalie had the feeling that she knew this was what she wanted to do. She stayed there for a while longer once everyone else had left, imagining what it would be like to commentate on a cricket match. After completing a BA in sports communication, Natalie contacted a producer at the South African Broadcasting Corporation. As luck would have it, they were looking for a female commentator, and asked Natalie to send in a demo tape. Before she could finish getting the tape together, Natalie got a call from them saying that the contract was ready for her to sign. Her first radio commentary was the Women's World Cup Semi-Final at Potchefstroom in 2005, and she hasn't looked back since. Natalie was part of a fantastic commentary team that the BBC put together for the Women's World Cup. She was full of praise for her colleagues, and I really enjoyed listening to the matches on the radio. The female-dominated commentary box made a refreshing change, and the expertise, not forgetting the banter, was terrific. It was obvious that Natalie had thoroughly enjoyed her time in the UK.

In South Africa, as well as the cricket, Natalie also commentates on football, netball, swimming, athletics, tennis, and beach volleyball. She has also commentated on the Olympics, although this was from a studio in South Africa, as opposed to actually commentating from the Games themselves. I asked Natalie if she did any writing as far as journalism goes, and although it is something that definitely interests her, she much prefers talking about the game, as opposed to discussing the hard news side of things, which she doesn't enjoy so much. In an era when women are making more and more inroads into the previously male-dominated world of sports commentating, Natalie's

future looks bright, and hopefully we will get many more opportunities in the UK to hear her commentate.

With our meeting over, we headed back to Victoria Station, where we would go our separate ways. The walk back took us past the front of Buckingham Palace. In fact I hadn't realised just how close to the palace we were when we sat down for our chat. Natalie had been there earlier in the day whilst sightseeing in the capital, and I must admit it brought back very vague memories of my Dad taking the family to see the palace when we were very young, some 45 years earlier.

Mike Selvey

Mike Selvey, 13 April 2018

I met former cricketer Mike Selvey at the Alban Hill Nurseries located not too far from Milton Keynes. Mike played cricket for England in the 1970s, and spent over 30 years writing for the Guardian, as well as working as a summariser on *Test Match Special* for the BBC for 20 years.

The first record that Mike bought was 'Apache' by The Shadows, which spent five weeks at number 1 in the UK charts in 1960. The song was a worldwide success, giving the band their biggest hit in a career that spanned over 50 years. Mike loves his music, and in recent times has got all his vinyl records out after being given a new turntable and music system by his children. He has seen many famous bands live, and has been to a good number of concerts including The Rolling Stones and The Who.

Before we got onto the subject of cricket, we spoke about bowel cancer. Mike is in the age group that is screened for bowel cancer every two years, and he, like me, thinks that the age should be lowered to at least 50. Mike's wife suffers from IBS (Irritable Bowel Syndrome), and she worries about the risk of getting bowel cancer, so it's a subject that they take an interest in. While having such fears is totally understandable, patients with IBS are at no greater risk of developing bowel cancer.

Mike began playing professional cricket career for Surrey after initially playing for Cambridge University. However, he spent the majority of his career with Middlesex, where he won his three Test caps against the dominant West Indies side in 1976, before moving over to Glamorgan. During his first test match he took the wickets of Roy Fredricks, Viv Richards, and Alvin Kallicharran in the space of 20 balls. I am always surprised that his England career was so short, as I always remembered seeing him regularly on television when I was a child. Back then cricket was televised on the BBC, and as ten-year-old I was an avid viewer. Mike pointed out that in those days the John Player Sunday League was televised live on BBC Two, which gave the players plenty of exposure on television.

After I left school I began listening to *Test Match Special*, and Mike was a regular summariser on there for over 20 years. However, it was to be journalism that Mike would devote his post-playing career to, with 30 years at the Guardian. He told me that it wasn't something that he had really planned or thought about doing. At the start of his career he even financed his first overseas tour in order to help give himself a step up the ladder.

Mike talked about the way journalism has changed since he started. When he began, it was a flourishing industry with plenty of newspapers employing journalists to cover cricket. However, these days it's a very different story, and it's a very tough world for the cricketing journalist. He talked about how different the job was before the age of the Internet. These days a journalist can file his copy back to the newspaper from his keyboard, with the click of a button, from anywhere in the world with an Internet connection. Before the current era of modern technology, Mike, and his colleagues, would have to compete for the limited international phone lines, and dictate their copy back to the newspapers in the UK. He told me how he learnt to become quite inventive when difficulties threatened important deadlines. On one occasion Mike ended up speaking to a lady at the Guardian who had no idea who he was. She was supposed to be on a totally different call, but such was the urgency of getting his copy to print, that Mike persuaded her to stay on the line and take his dictation, and pass it on.

We talked about the challenges that the modern game faces on the back of another very disappointing England Ashes tour of Australia, which must have been the first one that Mike had covered in 30 years. With the rise in popularity of the 20/20 short game format, Mike said that the longer form of five-day Test matches has to adapt to the changing times, and look at ways of increasing their popularity. I asked Mike whether he thought that the England and Wales Cricket Board had missed a trick after the 2005 Ashes series when the television rights were sold to Sky. Mike put forward the view that football, for example, has not suffered from its live matches mainly being broadcast on pay-per-view television – in fact it is more popular than ever. In cricket, another development is that the players are actually playing more cricket these days, with the season starting earlier and finishing later than was the case in Mike's time. We spoke about the cost of going to watch Test cricket, and how much cheaper it is overseas. Mike was able to take his family to see the Ashes in Australia where the ticket prices are much lower than they are in the UK.

We met just a few days before Mike celebrated his 70th birthday. Life remains very busy for him, and it was a fascinating experience to meet him. As we parted, Mike was kind enough to point me in the direction of a nice path, where I could take Prince, my dog, who comes with me to so many of these meetings.

Andrew White

Andrew White, 6 November 2017

Andrew White is a writer, film-maker, and broadcaster. I spent a fascinating time with him on a stunning autumn lunchtime at Cusworth Hall Museum, which is situated just outside Doncaster. In fact the sunlight made taking the photograph quite challenging. The original idea had been to meet at Conisborough Castle, but I got a message from Andrew en route to tell me that the castle was closed. During the winter months the castle is closed on weekdays, and – typically – if we had met a week earlier, it would still have been open. However, Cusworth Hall is a magnificent Grade I Georgian stately house, which has stunning views over Doncaster, and was a worthy alternative. It's situated not far from the A1(M), so it was pretty easy to find. I used to drive quite regularly for work to Hull, so the route was familiar. I must admit that once I'd met up with Andrew, and we walked to the back of the house, I was totally unprepared for the breathtaking views that awaited us. There can't have been too many more attractive settings to sit down and talk to someone whilst putting the book together.

Andrews's first record was 'Total Eclipse Of The Heart' by Bonnie Tyler, which was a number 1 single for her in 1983. The epic single, written by Jim Steinman, also topped the American charts, and sold six million copies worldwide.

Andrew was able to give me a tour of the town from this vantage point, describing the buildings we could see: the Doncaster Royal Infirmary, where Andrew's wife once worked, and the Minster Church of St. George, designed by architect Sir George Gilbert Scott in 1853. His son, Sir Giles Gilbert Scott, designed the iconic red telephone box. Andrew told me he thought it would be a nice idea to have a red telephone box outside the Minster Church to mark the Scott family's connection with the town. Also, and most

poignantly, Andrew pointed out the high-rise flats, which had recently had their cladding removed in the aftermath of the tragic Grenfell fire in London.

Andrew produces and presents *Walks Around Britain*. The popular programme is broadcast on over 20 channels around the UK, and is also shown in many other countries. It was interesting to hear Andrew speak of how he originally developed his passion for the countryside. He lived in Italy for a while, doing shift work. During his time off he would go on excursions, and he got to see and appreciate the country. The advent of the Internet meant challenging times for Andrew, and he quickly had to adapt to it. He soon realised its potential and that of social media, so he has a wealth of experience in this field. He is an accomplished writer – when we met he had three books on the go. He spoke about working on travel guides, and I was interested in the detail required just to update one, let alone produce one from scratch. He obviously really enjoys this side of his work, even if sometimes the deadlines cause him the occasional nightmare.

Andrew has a huge interest in and passion for short walks. He pointed out that long walks were not always possible for certain people, especially for families with young children, whereas he believes that short walks are achievable for everyone. Even in the centre of large towns and cities there are always interesting walks that people can find. The health benefits – both physically and mentally – are huge, and Andrew is doing a huge amount to try and bring this message home to people.

Doncaster also has its famous racecourse. It is home to the St. Ledger Stakes, which is the final classic Group 1 race of the English flat season, and the world's oldest classic horse race. Andrew also spoke about Doncaster's proud tradition with railways, and how it had the very first locomotive works during the 1850s. Two of the most famous steam locomotives the world has ever known, 'The Flying Scotsman' and 'Mallard', were constructed there.

I spent an hour chatting with Andrew, and he spoke with great enthusiasm and passion. He cares very deeply for the world he lives in, and for his home town and its surrounding area. Sadly cancer has also touched Andrew's family, and he talked at length about the impact that it was having on them. We spoke about our experiences with the illness, and although no two cancer journeys are ever the same, it is always good to talk to someone about both the similarities and the differences they have experienced.

Ian McMillan

Ian McMillan, 6 November 2017

Ian McMillan is a writer, poet, and broadcaster. He lives in Darfield, a small village just outside Barnsley in Yorkshire, and while he supports Barnsley FC, he is not simply just a fan: he is their poet-in-residence. I'd heard Ian interviewed by Mark Radcliffe and Stuart Maconie on BBC 6 Music some months earlier, and I was captivated by his enthusiasm and passion for words, and his wonderful observations on the world around him. I made contact with him not long after, and I was delighted when he agreed to meet me.

Ian's first record was 'In The Year 2525' by the American duo Zager and Paste. It was number 1 both in the UK and USA in 1969. When Ian told me about the record, I couldn't at first remember it, but then he sang a line from the chorus, and I knew it instantly. Ian remembered buying it while on a family holiday in Weston-super-Mare. Zager and Paste unfortunately fall into the one-hit wonder category as they never charted again.

I'd arranged to meet Ian at the Maurice Dobson Museum and Heritage Centre in the middle of the village. I arrived there in good time, so I took the opportunity to have a walk round the churchyard, and Ian met me as I was walking back towards the museum. It was such a lovely autumn afternoon that we decided the churchyard would be a good place to take the photo. However, Ian first gave me a quick tour of the museum which had been opened up especially for our meeting. It's on the site of the old corner shop run by Maurice Dobson and his partner Fred Halliday. They also lived there, and after his death in 1990,

Maurice left the shop and its contents, which included antiques and art, to the Darfield Amenities Society in order to set up the Darfield Museum. Ian does some volunteering at the museum, so he was able to tell me all about Maurice and Fred. He told me, as I think he tells all visitors to the museum, that it is the only museum in the world named after a cross-dressing ex-Scots Guard. Ian is a wonderful storyteller. I love reading his books, as you can really hear his voice coming across. To get an opportunity to listen to him speak about Darfield was brilliant.

The church couldn't have been closer, and we entered the churchyard, where Ian seemed to know the history of just about every grave. The first one we stopped at was that of a poor young man, Robert Millthorp, an apprentice stonemason, who had literally been crushed to death by a slab that was then turned into his headstone. Ian was keen to read out the inscription on his grave, 'the mortal remains of Robert Millthorp who died September 13 1826 aged 19 years. He lost his life by inadvertently throwing this stone upon himself whilst in the service of James Raywood, who erected it in his memory.' Ian also took me to the final resting place of Darfield's other poet, Ebenezer Elliot, whose grave is surrounded by railings. Ian told me that Ebenezer was best known for his poems in protest against the injustice of the Corn Laws, which caused so much hardship and starvation amongst the poor. He became known as 'the Corn Law Rhymer'. Ian also showed me the beautiful monument in the churchyard which is a memorial to the 189 men and boys who died in the Lundhill Collery explosion in 1857, many of whom are buried near the monument.

Much of the churchyard is on a steep incline, and in recent years volunteers have done an amazing job restoring the graveyard. Ian was particularly proud of the hand railings that he had recently helped to erect on one of the paths, which would make it much safer for visitors when the path freezes over. So perhaps it is fitting that I chose to use the photo that I took of Ian by 'his' railings. He happily admitted to enjoying having his photograph taken, so I did have plenty of photos to choose from. As well as the very busy life Ian leads with his work on radio and television, he told me that me he had also written the text for *The Arsonists*, which is the world's first opera written in a South Yorkshire dialect.

As we left the churchyard we walked past the church hall, which Ian told me had been the cinema in the village until 1956. I could have easily just carried on talking to Ian, and listening to his wonderful anecdotes, but sadly our time had come to an end. It was a brilliant experience, and Ian really was an engaging and interesting person to meet.

Noel Darvell

Noel Darvell, 29 August 2017 — Photo Used By Kind Permission of Jarryd Salem

This photograph of my brother Noel is probably the most spectacular picture included in the book. It was taken in Peru, in the Andes, on the road from Puerto Maldonado to Cusco, on what turned out to be his last-ever drive for Dragoman. Coincidentally on this trip Noel was returning to where he first drove for them in 2007.

Noel didn't get his first record player until he was 17, and before he got one he was keen for either me or Mum to buy the *Twelve Gold Bars* album by Status Quo. The first record that Noel bought was the four-track *The Golden Years* EP by Motörhead. Released in 1980, it reached number 8 in the UK singles chart, and was recorded during the band's European tour of the same year. This record also gives an insight into my brother's taste in music, which is very much rock 'n' roll-based. His favourite band is Status Quo, who he has seen play live more than 50 times all over the world, including, on one occasion, a concert in Sydney.

For many years Noel's favourite gig was Dave Lee Roth on his first major tour, post his time as part of Van Halen. He remembers that the gig was at a sold-out and wild Wembley Arena, and featured brilliant guitar work by Steve Vai, and pantomime-like special effects around a brilliant vocal and frontman performance from Dave himself. Status Quo have never failed to entertain, but the best gig Noel saw was when the classic *Frantic Four* lineup reunited, and played the iconic Hammersmith Odeon (now called the Apollo) in 2014. However, in 2016, Noel saw Bruce Springsteen play at New York Madison Square Garden, and that show transcended anything he'd ever seen before. All the hype and reputation Springsteen has for amazing live performances was epitomised in four hours of magic on a winter's night in New York.

Noel has spent much of the last 20 years travelling the world, and being in the fortunate position of getting paid to do it. He is not sure where the travel bug came from, but perhaps it stems from his trainspotting days, which saw Noel travel the length and breadth of the

UK whilst still a teenager. His first trip to Australia in 1993 certainly gave him a real taste for long-distance travel. Noel discovered overlanding on a three-week trip to Africa in 1999, and couldn't believe how much fun it was. Overlanding is all about getting to see the real country as well as the highlights, and getting away from the tourist trail. It's as much about the journey as the destination. Noel went on to spend over a year on two long trips through Africa, and then travelled overland from London to Australia, and realised that he could do it for a living. I travelled Down Under around that time with my great friends Lewis and Adam, and we met up with Noel in Melbourne towards the end of his journey to Australia. We spent 10 days watching the Ashes there, and enjoyed the holiday of a lifetime.

Noel worked as a driver for Dragoman for a fraction over 10 years, and went to so many incredible places that he finds it hard to name a favourite. He reckons the best trip was in West Africa from Senegal through Mali to Ghana. His favourite countries that he's visited include Brazil, Nigeria, Turkey, and Kyrgyzstan. I never got to go on any of the trips – the closest I got was visiting the truck parked on the outskirts of Melbourne. Mum fancied the idea of doing a trip, and she was quite the traveller herself with her Greek island-hopping holidays with Anne Manson. She did at least get to go to Dragoman's base in Suffolk, when we drove Noel there prior to one of his trips, after we all had been to our cousin David's wedding to Joanne in Banbury.

Noel grew up supporting Leeds United and watching the great Don Revie side of the early 1970s. His earliest memories are the 1972 FA Cup Final when an Alan Clarke diving header saw them beat Arsenal 1-0, and also the famous 7-0 thrashing of Southampton in that same season. The first Leeds game Noel went to was away at Norwich City in 1980. He found the raucous and humorous nature of the Leeds fans intoxicating, and soon became a fanatical supporter, attending most games, both home and away. Between 1982 and 1985 Noel only missed four competitive fixtures, and he saw every single game of the 1984/1985 season. Fortunately Noel was still going regularly when Leeds won the league title in 1992.

Noel is a member of The Maidenhead Whites – a group of Leeds fans living in Maidenhead – which effectively came into being when Noel and Steve Ogriz (Andrew Ogierman) travelled from Maidenhead to watch Leeds play for that first time at Norwich. The travelling fans used to sing the names of the places they had come from, and these were many and varied. The two teenagers joined in, thus starting the name Maidenhead Whites. Boggy (Dave Howes) soon got dragged in too, and then in May 1982 there was a crucial relegation game at West Brom on a school night. George (Paul Jordan) got wind at Desborough School that someone was driving up, and that there was space in the car for him and his mate Drain (Mark Gillet), so the five travelled together to what was a fairly infamous match where Leeds lost, and the huge away following rioted and tore up one end of the ground. For the next few years Noel regularly drove up from Maidenhead to Leeds matches, and the group's numbers increased with various old school friends, and friends of friends. The Maidenhead Whites now have a busy WhatsApp chat group, and still attend games together when opportunity and ticket availability allow. Noel's recent move back to Leeds does seem to have coincided with a more hopeful era for the team, and he suspects that he will be going to more games now that his long-term travelling has come to an end.

Noel has always enjoyed playing sport as well as watching it. The Red Lion football team was formed in 1989 when the landlord of Noel's regular drinking pub expressed a desire to sponsor the team, which had formed two years earlier, and were at that point sponsored by Servicised, an engineering company based in Slough. The team was being increasingly taken over by the Maidenhead Whites and their friends, rather than employees of Servicised, so it was a natural move. The Red Lion became quite competent in the Thames Valley Sunday League, achieving promotions on several occasions to peak at division two of eight by 1998. The side's greatest triumph was the lifting of the Mary Wells Memorial Trophy in 1997, on a memorable evening at Windsor's Stag Meadow Stadium, which was witnessed by many family and friends including me. The team continued playing into the new millennium, with Noel playing his last game for them in 2001 at the age of 37.

Noel's other sporting career has been with Knowl Hill Cricket Club. He had heard that they were looking for players through our parents, who were regular visitors to the Bird In Hand pub in the village. Noel joined in 1995, when they were seriously struggling for players. However, the introduction of a new chairman, and the creation of a more active committee including Noel as fixtures secretary, heralded the beginning of a new era for the club. Several players were recruited from the Red Lion football team, who brought with them a much-needed boost to team spirit. The club's most successful period came under Noel's captaincy between 1998 and 2002, including a promotion in 1999 followed by a thrilling league triumph in 2000. From 2003 onwards Noel's travels have seriously limited his opportunities to play, but as of summer 2018 he was still turning out occasionally, and hasn't officially retired yet. I joined the club in 2009, and it was a great feeling to finally play cricket with my brother.

A year after mum died, in late 2017, Noel also was diagnosed with cancer when he had what was presumed to be a sebaceous cyst removed from his chin. The surgeon was suspicious of what he'd found, and the biopsy revealed a DFSP (Dermatofibrosarcoma Protuberans) – a very rare form of skin cancer. Fortunately it was not malignant, but Noel had to have a further operation to remove all the affected tissue. This left a relatively large hole in his chin, as expected, so he then had to have reconstructive plastic surgery to repair the damage. As a result Noel now has a slightly deformed lower lip and associated scar, but that should be an end to the treatment. Interestingly the condition was not caused by excessive exposure to sunlight, but was in fact a completely random piece of bad luck.

I've always enjoyed a great relationship with Noel. When we were young I was that annoying little brother always desperate to be involved in the more grown-up activities of Noel and his friends. We worked together in the family packaging materials business for many years, and I think it's fair to say that the older we've got, the closer we've become. In my eyes he has never been afraid to take the big decision. When the business was in danger of going under in 2000, Noel began driving for Thames Line Couriers in Slough. He was still employed by our company, and was sub-contracted out. This arrangement meant that his wages were paid for by the driving, as well as bringing in some additional much-needed income for the business. This was a huge sacrifice, and one that I've never forgotten.

In 2009 Noel was enjoying his career as an overland driver travelling the world. As fate would have it, he was actually in between trips when Dad died after a very short illness. Noel put his driving on hold for a while, and lived with Mum until the dust had settled.

Once again Noel was home when Mum's cancer took a devastating turn for the worst at the end of November 2015. He stayed with Mum, putting the driving on hold once again, throughout the remaining months of her life. This commitment to the family has been greatly appreciated, and gave me and our sister Ali a huge amount of support during some very difficult times.

Following the sale of the family home in Maidenhead, Noel lived with me in Reading for a year, whilst he completed his final overseas driving contract and decided what to do next. I discovered that he enjoys cooking, and has a bit of a talent for it too. He moved to Leeds in the autumn of 2018, so we now make regular visits to each other. Noel is especially fond of my dog, Prince, who has wasted no time in making himself at home at Noel's on our trips to Leeds. No matter what the future brings, we will always be there for each other.

Billy Ocean

Billy Ocean, 18 April 2017

Billy Ocean has sold over 30 million records during a career spanning almost 50 years, making him Britain's biggest-selling black recording artist. During the 1970s and 1980s he had number 1 singles on both sides of the Atlantic. My pursuit of him started by sending a message on Facebook, after seeing the announcement of his 2017 UK tour promoting his *Here You Are* album. I received a positive response from his team, and I was offered the opportunity to go and meet him after his concert in at the New Theatre, Oxford, in April 2017.

I wasn't sure what I would make of the gig, as Billy's music is not usually the type of music I would listen to. I also had the usual delights of trying to find somewhere to park, but having experienced problems parking before, I had allowed myself plenty of time. At the age of 67 Billy's voice is as good as it ever was, and, with a great band behind him, he knew exactly how to work the audience throughout the evening. The highlight of the show for me was his performance of 'Red Light Spells Danger', which reached number 2 in the UK charts in 1977. In my opinion this is just about the perfect pop song, and I might well have paid my entrance just to see him perform this one song on its own. It's easy to forget just how many hits Billy has had, and he played them all during the evening, including 'Love Really Hurts Without You', 'Suddenly', 'When The Going Gets Tough,

The Tough Get Going', and ending the evening with the wonderful 'Caribbean Queen', which left the audience shouting for more.

Initially, things didn't go quite to plan after the concert. I'd checked with the staff at the theatre where I should go, and was told to go round the back to the stage door. Having been there a while I had a feeling that it was not the right the place, and fortunately the security staff made a call, and I was redirected back to the front foyer, where I was shown back into the theatre to wait for Billy. I was part of the 'meet-and-greet' package of a dozen or so people. I'd been told beforehand that I would get a short chat, so I made sure I was fully prepared. In spite of giving his all on stage and the late hour. Billy couldn't have been nicer. He was a true gentleman and was more than happy to pose for a few photos and talk about my book.

Billy told me that the first record he bought was 'Everyone's Gone To The Moon' by Jonathan King back in 1965, which got to number 4 in the singles chart. He said that he loved the imagery of the song, and it was a massive hit around the world, selling 4 million copies. Sadly all too quickly my time with Billy was over – but a nicer man, who always has time and a smile for everyone, you couldn't wish to meet.

Kim Wilde

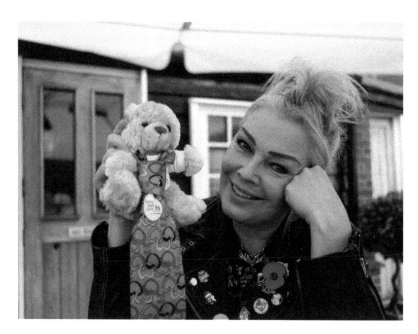

Kim Wilde, 5 November 2018

I went to meet pop star and gardening expert, Kim Wilde, at the beautiful and picturesque setting of Tewin Farm Hotel located just outside Welwyn Garden City in Hertfordshire. My journey there involved travelling on the M25 during the Monday morning rush hour, so I left very early leaving nothing to chance. I had an excellent trip, which meant I got there with two hours to spare, so I was able to explore the grounds of the hotel, which I discovered has a nature reserve.

I'd made contact with Kim, who was Britain's most successful recording artist during the 1980s, 18 months earlier on her Twitter account. At that point she was about to take six months off for the first time in ages, so she suggested I stayed in touch and that we would sort things out at a later date. What I hadn't realised is that Kim had stopped using direct messaging on Twitter, so all my messages were unanswered, and I thought that perhaps the opportunity had gone. However, when I sent an email to her manager, Sean, I got an immediate response, and our meeting was arranged during a gap in Kim's European tour.

I have to admit that Kim's first record was a song I hadn't heard of. 'Big Seven' by Judge Dread was released in 1972 and reached number 8 on the UK singles chart. Judge Dread was an English ska and reggae musician, and was the first white recording artist to have a reggae hit in Jamaica. Kim said that the song was very politically incorrect, and it would most likely have been banned today. What she liked was that it had an air of anarchy and unruliness about it, which are traits in music that she has always been attracted to.

One of the things that I could never understand about Kim's career was how some of her singles fared a lot better than others. One song in particular, 'It's Here', was released in 1990 as the first single after the phenomenal success of Kim's 1988 album, *Close*, but failed to make an impact on the charts. So I asked Kim if there was any rhyme or reason

to this, and she told me that if someone could put the magic ingredient to making a hit single into a bottle then it would be priceless. She did say that the song would make for a great acoustic track in her set, and had been played on her Dutch tour the previous year. Kim said that she still finds that elusive quality about what makes a hit very exciting.

In more recent times, the 'Pop Don't Stop' track from her 2018 album *Here Come The Aliens* was picked up by national radio, and given masses of airplay, providing a great platform for the album launch. The album has very many potential hit singles. Kim was brought up on the concept of the three-minute pop single in the 1960s, which continued through the 1970s. By the time the 1980s arrived she was releasing hit singles herself. Kim and Ricky love the pop format and the challenge of coming up with a melody in order to make the song the most exciting three minutes that anyone has ever heard. Kim revealed that she and Ricky had been trying out some ideas in making a concept album, and that it would be something really interesting and totally unexpected from her.

Kim grew up with a father, Marty Wilde, who was a huge star in the music business. I wondered if this meant that Kim was always going to go down the same route. She told me it was more down to her dad's love and passion for music, and as children they were bought up in a very musical environment. Marty was always writing songs, and he'd always be strumming a guitar, and picking out melodies and harmonies. He would play anything from Tchaikovsky to Elvis Presley, and would regularly go out and buy vinyl, and allow Kim to play it as well. Kim learnt a lot from her dad, which was more down to him being a performer. She would go out on the road with him, and watch from backstage through the curtain. It was there that Kim fell in love with the idea of being a performer herself. However, when Kim's music career was launched, she said that it was as a recording artist rather than as a performer. It has only been in the last 10 to 15 years that Kim has developed her craft as a live artist. When she was having hit singles in the early 1980s she said that did not really have those skills in her armoury.

I've always thought that Kim's early singles were not too far removed from the post-punk new wave sound, as opposed to being classic pop songs. Kim agreed that the songs certainly had a rock element to them, which is something that she has come back to on the current album. Kim has tried many different styles over the years, and she said that when you love music that is what you do. Some missed the mark with the public, and she said that perhaps the world wasn't quite ready for her R&B influenced *Now And Forever* album, but Kim said that she and the band have always enjoyed what they are doing, and still regards that album as one of her favourites.

Kim told me that the band has always had a healthy amount of independence from the main music industry, which has allowed them to do their own thing. She regards what they do as like a satellite going round the music industry, tapping into it at different points. They have their own studio, and Kim releases records on her own record label. She has complete control over the whole thing, and as a result regards this as probably the most exciting time of her career. At the same time Kim said that the *Here Come The Aliens* album was self-financed, and was a significant investment of both time and money, which has paid off with the album being a great success. She is not surrounded by A&R people trying to tell her which direction she should be going in, and forcing writers and producers

on her, which is something that happened a lot during the 1980s. At the time, that made for some confusing and difficult periods, which she managed to tough it through.

In December 2012 Kim and Ricky were filmed on the London Underground doing an impromptu festive version of her classic hit, 'Kids In America', having had rather a lot to drink. Kim said that the video appeared on YouTube and had over 3 million views, and that there was no such thing as bad publicity. She told me that she no longer drinks, so there is unlikely to be a repeat performance. One upshot of the episode was that it inspired Kim to record her 2013 Christmas album, and she is a massive fan of the festive season. Kim said that Christmas songs have a little window of beauty like a tree in autumn, where it has that brilliant moment of orange and red before turning bare. Of course, Christmas tunes are timeless, and can come back and be enjoyed every year.

Kim had always been interested in gardening, but it wasn't until she'd had her two children that her interest really took hold. She didn't really have a garden, and had previously lived on her own in the house for seven years. Kim had concentrated her time and money on the house itself, but once the children came along, she wanted them to have a garden to play in. At the same time Kim had always had a strong connection with nature since childhood, so she was reconnecting with nature.

Kim went on to win a gold medal at the 2005 Chelsea Flower Show, and said that it was one of the most incredible days of her life. She said that there were lots of funny stories to be told about it, which she has written down, and that it would make a great film one day. These days Kim and her husband are part of a big local community horticultural and gardening project called Waste Not Want Not, which is to do with mental health. She is not designing gardens anymore; this is more hands-on gardening, hands-on planting, and hands-on growing, working with both people and plants.

I couldn't pass up the opportunity to get a bit of gardening advice from Kim. Hydrangeas were one of Mum's favourite plants, and as quite a few of them were in pots in her garden, we were able to take some with us when the house was sold. Mum always told me that the best time to prune them was early in the year when the new shoots began to appear. Kim confirmed that was correct, and said that pruning similar late-flowering plants like them after the frosts had finished was also a good time. Kim has an oak-leaved *Hydrangea quercifolia* in her garden, which has long panicles rather than the more common blowsy flowers associated with the plant. She said that she had been told that Madonna hates hydrangeas, which she finds bizarre as, in her opinion, they are one of the most beautiful flowers.

Before we went outside to do the photography, I asked her what her favourite Kim Wilde song was if she was forced to pick one. She said 'You Came' was a very special song not just for her, but for many of her fans too. The song was written by Kim and Marty about the birth of his first son. Kim has a keen eye for design, and she made my job of taking her photo very easy. She was also great fun, and happy to be photographed with the bowel cancer bear and tie.

Meeting Kim was a fantastic experience. She was absolutely lovely, and couldn't have been more helpful in ensuring I got everything for the chapter that I needed. She is clearly

enjoying performing and making music as much as ever, and her enthusiasm shone through for what she is doing now, and hopefully will continue to do in the future.

Frank Turner

Frank Turner, 30 November 2016

Frank Turner is a highly successful singer-songwriter, who now travels all over the world playing to large crowds. My introduction to his music was gradual. Having heard songs by him on the radio, it was really the rave reviews from fellow fans of The Alarm that really switched me on to him. I actually didn't think that there was much chance of getting to meet him. I'd looked on his website, and the list of answers to commonly asked questions gave me an impression of someone who might not entertain personal requests. It is, of course, always worth asking, and I was delighted when Frank personally replied to my email request with a positive response, agreeing to meet me on his *Get Better* UK tour towards the end of 2016.

Frank was playing with his band, The Sleeping Souls, at the Reading Hexagon. I was given a five minute slot at 4:30 p.m., which meant working from home during the afternoon and making my way to the venue in plenty of time. I was shown to a small room backstage, and in there I got my first indication of just what a busy day Frank has on tour. On the wall I saw the day's itinerary and, after the journey to Reading, it was full of interviews with the media and a soundcheck crammed in. I also saw my name in there too, which was a nice touch, knowing that I was a small part of this particular day on tour.

I knew that I would have to be quick, so I was well prepared with the camera already set to go. Frank came in and immediately made me feel at ease with a friendly smile and was

very happy to pose for the photograph whichever way I wanted it done. While I was taking photos, Frank told me that the first record he bought was 'The Number of the Beast' single by Iron Maiden. It is no secret that Frank loves his heavy metal music. He went on to say that *Killers*, the Iron Maiden album, was the first record he owned, as it was bought for him by his dad. Just to prove the point he pulled up his trouser leg to reveal an Iron Maiden tattoo.

Of course no sooner had I started then it was time to wrap up proceedings. Frank asked if I was going to the show in the evening, which I wasn't, unfortunately. The concert had long since sold out and sadly, when the tour was announced, my mother's declining health had made booking things up pretty difficult. At this point Frank ensured that my day was going to be even more memorable as he asked his assistant, Tre, to put my name on the guest list. So I headed home for a quick shower and feed before heading back to the venue.

The concert itself was nothing short of outstanding. In over 35 years of going to see live music, this show stood right up there with the best of them. Frank was the perfect frontman, knowing exactly how to work the crowd, but of course you also need a set of decent songs to do this. Hearing his songs live was amazing, because as with all the best live music, they really came to life and went to another level. The two-hour set had the whole audience on their feet, and he played material from all eras of his career. It was really interesting seeing the transformation from the man who I met backstage to the man giving it everything in front of a packed house to a very appreciative audience. I would guess that as much as the audience feeds off Frank's energy and passion, it also works in reverse.

My next opportunity to see Frank play live again was six months later at The Roundhouse in London at his four day Lost Evenings festival. Frank curated the sell-out event, which was a celebration of live music, and a showcase for the next generation of music performers. I went to the final evening, which was Frank's 2059th live show, and it was another fantastic concert. The crowd sang along with every song, and I wondered how on earth they managed to learn all the words. My days of having lyrics cut out from music magazines are many years in the past, and with downloads and streaming you don't get the lyrics on a record sleeve. The night had the added bonus for me of seeing Skinny Lister as a support act.

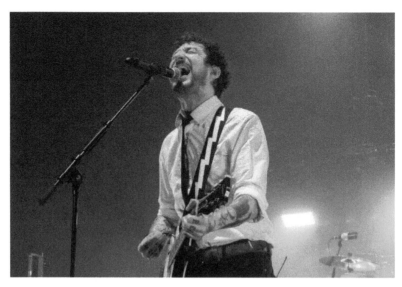

Frank Turner, The Southampton Guildhall, 1 May 2018

In May 2018 Frank released his seventh studio album, *Be More Kind*, and played a UK tour to promote the album's release, before embarking on a world tour. I went to the gig at The Guildhall in Southampton, show number 2163, and I was fortunate enough to get a photo pass to photograph Frank at the start of his set. However, the evening did not get off to the best start, as the venue staff didn't have me on their list when I arrived, so I had a slightly worrying wait before it was resolved.

It was another great experience, and not without its challenges for me. I was using my 50mm fixed lens as the band were a performing a little further back from the front of the stage than some acts that I have photographed, and I had the frustration of the camera not focussing on Frank quickly enough as he moved around the stage. Nevertheless, I got some great photos, and I think that the one I have used fully captures Frank's passion on stage. After the first three songs had finished, I went back into the audience to watch the show. It was phenomenal, and the two-hour set had plenty of songs from the new album, alongside all the classic songs his fans expect. Frank was on great form, in what was pretty much a home town gig for him, as he grew up in nearby Winchester.

I can't thank Frank enough for his support over an 18-month period, from our first meeting in Reading to the Southampton concert. The experience will long live in my memory. He was a true gentleman, and as he emailed me afterwards, "Til next time."

John Coghlan

John Coghlan, 10 November 2016

John Goghlan was the original drummer with Status Quo for twenty years until his departure in 1981. I arranged to meet him in the Oxfordshire village in the Cotswolds where he has lived for thirty years. I was fortunate enough to photograph Status Quo on their second and final *Frantic Four* reunion tour at the Hammersmith Apollo in 2014 for the *Lives & Times* book. John very kindly sent me a video message to help promote that book, so I thought it would be great idea to meet him in person for this book. John's wife Gillie was very helpful in making it happen.

I arrived in good time, so I was able to have a walk around the village to plan where we could take the photo. I was immediately struck by its beauty and charm. The cottages are built from stone in the classic Cotswold style, and the ford in the centre of the village provides a great focal point, with the stream forming a beautiful duck pond.

John soon turned up walking his dog, and we immediately did the photograph. He was such a nice man and very happy to help, but I sensed that he is a fairly private person. He spoke about the sense of community in the village, and it was obvious how settled he and Gillie are there. We touched on the Status Quo reunion concerts. He was happy to be a part of those and really enjoyed playing with the other members of the band again after so many years apart. Sadly, shortly after our meeting, Rick Parfitt from Status Quo passed away.

Interestingly, John bought his first record when 78rpm vinyl was still being produced. He wasn't sure exactly what the first record he bought would have been, but he thought it must have been either Bill Haley or Johnny And The Hurricanes.

John Coghlan, Reading SUB 89, 10 February 2017

I wanted to follow up our meeting in the village with a photograph of John performing on stage. His band, John Coghlan's Quo, were playing a gig in Reading a couple of months later, and they very kindly gave me a photo pass. However, things didn't quite go to plan, as it was not only an early start due to a 10:00 p.m. curfew, but also there was no support band. I arrived at the venue with minutes to spare, only to then discover that my pass was not on the door. By the time it got sorted out the band had begun playing, so I hurriedly made my way to the photo pit to photograph them during the first three songs, as is the rule at these events. I was pretty happy with the resulting photo, and having done that, I was able to retreat back into the crowd to enjoy the rest of the concert. The band concentrates on playing material mainly from the classic 1970s period when Status Quo was one of the biggest bands around. Rather fittingly, John came out from behind the drums to speak very emotionally about Rick Parfitt during the evening, and Rick's passing was obviously something that had affected him very deeply.

Steve Norman and Sabrina Winter

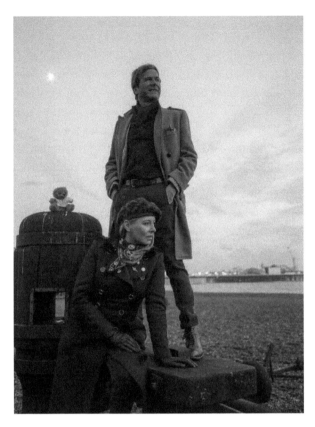

Steve Norman and Sabrina Winter, 17 December 2018

I met Steve Norman and Sabrina Winter in Brighton the week before Christmas. Steve is best known as the saxophonist from Spandau Ballet, and is responsible for creating the iconic saxophone solo on their massive number 1 song 'True'. His partner, Sabrina, is not just an accomplished singer in her own right, but is also Steve's manager, as well as being Head of Radio Promotion for Universal Music in Germany. The couple split their time between Brighton and Berlin.

I was very grateful that Steve and Sabrina had agreed to see me, as Steve's sister Dee had died from breast cancer three months earlier. We had arranged to meet at the entrance to Brighton Pier, but they had got held up in traffic, so Steve suggested we met at The Bath Arms pub located in The Lanes, which is in the historic quarter of the city. It was once the heart of the fishing town of Brighthelmstone, and consists of an amazing series of narrow alleyways. The Bath Arms is the oldest pub in the area dating back over 150 years, and Steve and Sabrina were already there when I arrived.

Sabrina's first record was Kim Wilde's eponymous debut album released in 1981, which reached number 3 in the UK charts. It contained her debut hit single, 'Kids In America', which is a song Sabrina's always loved, and which had a big effect on her. Sabrina lost both her parents when she was young, and was brought up by nuns in a children's home. She said that music played an important part in her life growing up, and was like a

sanctuary for her at the time. Fate can be a strange thing, as some years later she actually got to meet Kim. This meeting led Kim to becoming one of Sabrina's closest friends, and they have performed together on stage. Sabrina said that Kim is one of her inspirations for becoming a singer herself.

Steve bought 'Double Barrel' by Dave and Ansell Collins. The 1970 song became the second reggae single to top the UK Chart when it spent two weeks at number 1 in May 1971. It took Steve ages to save up the money to buy it, but he said it was a record he simply had to have. He lived in a block of flats in an estate close to Leather Lane Market, which is where he bought the record (at Barry's Record Shop). The single was released on Trojan Records, whose studio was in Camden near The Roundhouse. Steve said that at one point his granddad used to earn some extra cash cleaning the studios after he retired.

Steve's musical influences are diverse, and range from hard rock to soul music and Tamla Motown. He told me how, when he was growing up in London, he and his friends were allowed to go to the record shops located in the quadrant during school lunch breaks. Also nearby is the Angel Inn, where they went for spaghetti and chips, and when they got a bit older they would take their school ties off and just have lager instead.

We talked about Spandau Ballet, and Steve surprised me when he said that they were basically a guitar band. He also revealed how he and Gary Kemp used to go and see The Jam, and pogo at their gigs. On their early hits Steve played guitar, saying that he was playing the electronic synths part, which had to be played right on time. This was a period before the style of music developed into full-on electronic with synthesizers. Steve said bands like Spandau were players, with musicians who could actually play their instruments, whereas many of the bands from the electronic period that followed couldn't play. Spandau used real instruments, and the band saved up to buy a CS-10 Yamaha mono synth. It took them a year to pay for it on hire purchase. The band had started out as an R&B group playing Rolling Stones songs in a punk style, but when they discovered electronic music through artists like Rusty Egan in the clubs, they realised that they wanted to change direction and start making music for people to dance to. The CS-10 drove the sound of their music, but was accompanied by the guitars. Steve said they were all going back to their dance roots as they were all soul boys at heart.

Another conscious decision Spandau took was developing their sound. Steve brought in the saxophone, which helped to give their music a richer and lusher sound. His iconic sax solo on the 'True' single is without doubt one of the all-time great pop music moments. In spite of writing the solo Steve never reaped the financial rewards for doing so that he feels he was entitled to.

I wanted to know what Steve's proudest moments in music are. Perhaps unsurprisingly, performing at Live Aid, with Spandau Ballet in 1985, in the biggest concert the world has ever seen, is an obvious one. He also said that Spandau Ballet getting back together in 2009 was another. The band had been apart for 20 years, and had not even been in the same room together during that time. They had no idea how it would go, and when he was backstage before the first reunion show, hearing the crowd erupt as the intro music was being played showed Steve just what the band still meant to people after so many years away. More recently was the gig that Steve played in honour of Dee. It was an amazing

and incredible evening, and the outpouring of love and affection was not just for Dee, but was, Steve said, for anyone lost due to any form of cancer.

As for the future, there are plans for more Spandau Ballet stuff. The guys are all busy with different things, and one of the biggest challenges is to clear their diaries, and get everyone to commit. The one thing Steve did say is that there is still a lot of love in the band for Spandau, and that they all want to do it.

We talked about Steve's career in music outside Spandau Ballet. He lived in Ibiza for about 12 years, and really got involved in the dance scene there. He would play improvised sax and percussion in the clubs with a DJ, sometimes with his old mate Rusty Egan, who – Steve was very keen to point out – is an awful tambourine player. Steve has toured with Bowie Alumni, in a group consisting of musicians who played with the late star, such as Mike Garson, and Earl Slick. He said that getting to play with these guys, who are his musical heroes, was a real ambition realised. Steve added that possibly the biggest box he'd ticked in his career was when he got to appear on stage with Iggy Pop. They hadn't rehearsed anything, and Iggy went up to Steve on stage and said, "I've only got one thing to say to you. I'm a real wild one, wild one, wild one, wild one", and launched into the classic 'Real Wild Child'. It was one of those moments that he will never forget.

These days Steve performs two types of pop-up gigs, a DJ set and a band set. The DJ set features house music, and Steve improvises with his guitar, sax, and percussion. One popular thing he is able to do is pick up an acoustic guitar and drop the chorus of 'True' into a track. For the full live band gigs, Steve is joined on stage by Sabrina, while his son Jack plays bass, and there is also a guitarist, a keyboard player, and a percussionist. The gigs are extremely popular: Steve said that people want to be up close to the artists, and that they enjoy the intimacy of this type of gig.

I'd seen Steve appear with Mike Peters and The Alarm at The Gathering in 2012. He brought a whole new sound to many of the classic songs by the band, which had never been performed with a saxophone before. Steve said that he did have to rehearse these songs, and that it was a memorable weekend. The band performed 'True' with Steve on vocals, and that was something I'd never thought I would see happen in a million years. Steve said although he likes the songs of The Alarm, some of his favourite Mike Peters compositions are solo songs like 'Breathe'.

I wondered what happened when Steve and Sabrina had a difference of opinion in their professional roles as artist and manager. Steve said that he always respected Sabrina's advice and opinions, but that he had the final say. Sabrina agreed with this, but did joke that being a woman she had her ways of convincing him. They told me that they make a great team, don't really argue, and love each other dearly. Sabrina said that after any discussion, the bottom line is that Steve is the artist, and he needs to be one hundred percent behind any decision they make.

We met just a few days before the winter solstice, and the light was fading fast, so we went outside to take some photos. We started outside the pub in The Lanes, and then made our way to the seafront. The deserted beach, at dusk, was a great setting, and fortunately Steve and Sabrina were really enthusiastic to do as many photos as possible to get the best results. Steve has a great eye for a photo, and was constantly coming up with ideas. We had a lot of fun with the photo session. It was a difficult decision to choose the main picture, but we all liked the shot with Brighton Pier in the background. The couple were keen to have photos taken with the remains of the old West Pier, and we also used anything we could find on the beach as a prop, including an old boat.

For Steve the important things in his life are family, fans, and music. Every conversation that he has comes from the heart, and he said the same about every musical note he plays. He admitted that he loves to talk, and throughout our conversation he was full of interesting and amusing anecdotes. Steve and Sabrina were absolutely wonderful throughout, and it was lovely to spend an afternoon in their company.

Hazel O'Connor

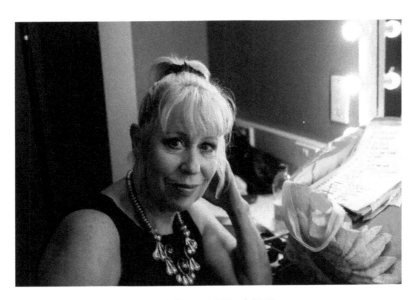

Hazel O'Connor, 7 March 2017

Hazel O'Connor burst on to the British music scene in 1980, when she both starred in and wrote the soundtrack to the film *Breaking Glass*. The album spawned two top ten singles for Hazel, 'Eighth Day' and 'Will You'. I remember buying the 7" single of 'Eighth Day', which I still own today. I went to meet her at The Stables in Milton Keynes, a beautiful venue founded by Sir John Dankworth and Dame Cleo Laine. The last time I had gone to a concert there was back in 2001.

I knew beforehand that my time with Hazel would be limited to five minutes. Work had taken me to Northampton in the afternoon, so I went straight from there to Milton Keynes, which meant I had plenty of time to prepare for the meeting. I was taken down to a hospitality room to meet Hazel, half an hour before she was due to take to the stage. It was pretty busy in there with guests, but Hazel took me to the sanctity of her dressing room to do the photo. While she put on her lipstick and necklace we had a short chat, and then it was very much a case of being on the ball with my camera and taking a few photos. In the photo you can see Hazel's set list, which I thought was a nice touch.

There had not been time to ask Hazel many questions at all, but thankfully the tour was billed as *An Evening With Hazel O'Connor*, and during the two sets she talked honestly, and also with a lot of humour, about her career spanning four decades. On stage Hazel was joined by Sarah Fisher on piano, who has toured with The Eurythmics, and Clare Hirst on saxophone, who has performed with David Bowie, including on his iconic Live Aid set at Wembley in 1985. The threesome rework many of Hazel's best known tracks, and there is more than a hint of jazz in many of the songs. Hazel's voice is still stunning, and there is no doubt she has a great presence on stage.

The first record that Hazel bought was 'Do What You Gotta Do' by Nina Simone. They play this song as part of the set, and Hazel described how she bought it the first time her

heart got broken. Before she found fame, she worked in Amsterdam and The Lebanon, where she was literally dodging bombs as civil war erupted around her. She talked in between songs about the ruthless nature of the record industry, and how she had been made to put pen to paper on a long-term recording contract, without knowing that the lead role in *Breaking Glass*, and the offer to write the soundtrack, would mysteriously arrive the day after she had signed the contract with the record company.

Hazel recounted the story behind a song she had written, which she described as her soppy song. It was a tune that she was unsure about performing live after she had written it. She was supporting Iggy Pop in London on a two-night slot. In the lead up to the gigs she had cut David Bowie's hair, and he had told her that he would come and see her perform. The first night went badly as the audience gave her a hard time throughout and there was no sign of Bowie. Hazel came back for the second night and decided that she had nothing to lose and would perform the soppy song. Once again the crowd gave her a hard time – that is, until she began to play the soppy song, and the audience became transfixed and the abuse and heckling ceased. She also spotted David Bowie watching, and afterwards he told her that he loved the song. She said sometimes you have to let an audience judge a song. The song she had played was 'Will You'.

Cancer has had a big impact on Hazel's life. She spoke about the loss of her Mum, and how she wrote a song at the hospice, as her mother was slowly slipping away. 'I Give You My Sunshine' is a wonderfully crafted and emotional song. Hazel said that although she couldn't make her Mum better, she was able to give her everything she had from within. As I have lost my own mother to cancer, this song strikes a chord within me. Sadly Hazel also lost a very good friend to cancer and she wrote the song 'Rebecca' in tribute. I am full of admiration for someone who can lay their soul open in the public eye and have the courage and guts to perform these songs in front of an audience.

It was an amazing evening, and Hazel told me in the dressing room that she still loved singing. Her performance completely bore that out. I left with one of her CDs, full of admiration for a quite remarkable lady.

Steve Hackett

Steve Hackett, 30 April 2017

Steve Hackett is one of the finest guitar players of his generation. Having first found fame with Genesis, he has forged a hugely successful career as a solo artist since leaving the band in 1977. When I saw that he was bringing his 'Genesis Revisited With Classic Hackett' tour to the Reading Hexagon, I decided to try and make contact. The other reason for doing so was learning of his association with the late Jon Wetton, who was a member of King Crimson and Asia, and who had performed with Steve. I had been hoping to get Jon in this book, but sadly he lost his battle with bowel cancer in January 2017.

I emailed Steve through his website, and I received a lovely reply from his wife, Jo, who was more than happy to help and set things up. She said that she would organise a pre-show pass, which would give me backstage access to Steve's gathering of family and friends. I had to get there an hour before the performance started for this meeting, so I made sure I was there in plenty of time. This was just as well, as there was a little confusion at the box office as to where the passes were. Thankfully everything was soon sorted, and after a short wait I was taken through to the backstage area to meet Steve, who was there with Jo, and also his mother, so it really was a family affair. This was a no-frills area – we were right behind the stage where all the band's equipment cases were stored. Steve was such a nice man. He made sure that everyone was introduced to each other, and he made time to talk to everyone.

From a photographic point of view it was an interesting experience. Steve told me to just take photos while he was talking to his guests, so I didn't do the more traditional style of posed portrait photo. I actually really enjoyed this, although I did have a slight element of pressure and nerves, as I wasn't sure if I had captured that perfect shot at the time. As it turned out I am really pleased with the photo. It shows a man very relaxed just half an hour before going on stage to perform to a sold-out audience.

Steve was able to tell me about both the first single and album that he bought. The first single was 'Man Of Mystery' by The Shadows, which was released in 1960 and got to number 5 in the singles chart. In contrast the first album he bought was Ravel's *Boléro*.

Steve Hackett, Reading Hexagon, 30 April 2017

The concert was amazing, and it was fascinating to watch a genre of music which, by my own admission, I am not overly familiar with. Watching Steve play the guitar with such skill left me in awe, and I had no doubt that I was watching one of the best. In addition he has a fantastic set of musicians playing in his band, which was made up of Roger King on keyboards, Nick Beggs on bass guitar, Gary O'Toole on drums, and Rob Townsend on too many instruments to mention! For the Genesis songs they were joined by Nad Sylvan on vocals.

The band was on stage for two and a half hours. The first half of the performance focused on Steve's solo work, including some songs from his most recent album, *The Night Siren*. The second half of the show was dedicated to celebrating the fortieth anniversary of the 1976 Genesis album, *Wind & Wuthering*. The audience was transfixed throughout and gave the band a richly-deserved standing ovation at the end of the night. It was not easy capturing a photo of Steve on stage, as I was sitting high up in the balcony, so the shot was taken from some distance using my Panasonic Lumix G Vario 45-150mm lens. I was pretty pleased with this effort.

The beauty of the book is that sometimes it takes me to places that I would probably never have otherwise gone to. I think Steve comes into this group. I was probably the only member of the audience who didn't recognise any of the songs he played all evening.

However, that did not diminish my enjoyment – in fact it was a great introduction to Steve's vast catalogue of music, which I will now further explore.

Jules Peters

Jules Peters, 12 March 2019 – Photo Used By Kind Permission of James Roberts

Jules Peters plays the keyboard in The Alarm, and she is married to the band's frontman, Mike Peters. The couple have two sons, Dylan and Evan, and live in North Wales. Jules leads an incredibly busy life, so it took a while for us to speak, but it was certainly worth the wait. The photo was taken on the same day that we spoke on the phone about her life with Mike, the band, and breast cancer, which she was diagnosed with in 2016.

I first met Jules in 2001 when I attended my first Gathering weekend in Llandudno. I have gone every year since, and have recently been to my 19th Gathering on the bounce. During my first conversation with Jules in 2001, I cheekily suggested that the band should get some printed carrier bags done for their merchandise sales, and she liked the idea, so in 2003 I drove to the event with a car boot loaded with bags imprinted with The Alarm's classic poppy logo. Over the years I've always try to grab a quick hello with Jules at events, and she always tries to make time for fans of the band; in fact, she has played a major part in creating this wonderful family of fans from all over the world.

In 2014 I went to Abbey Road Studios to take part in 'The Scriptures' recording session, which became the world's longest song at that time. It marked the beginning of a big change in me, and the start of some very special friendships with fellow fans of The Alarm. There is no doubt that Jules played a part in this, as she made me feel incredibly

welcome, and very much part of the day's events. Jules also organised a photo opportunity for me with Mike for the *Lives & Times* book, which was amazing, especially as we were in such a famous landmark musical location.

The first record that Jules bought was *Arrival* by Abba. It was their fourth album, and was released in 1976. It was a number 1 album in the UK, becoming the best-selling album of 1977, and contained perhaps their best-known hit, 'Dancing Queen'. Jules used to sing and dance to it for hours in the back room at her parents' house, and she still has the record in her collection. Jules described herself as a *Top 40* girl when she was growing up, and loved listening to anything that was in the charts. She mentioned The Bay City Rollers, U2, Tears for Fears, Pet Shop Boys, and Spandau Ballet. (Even these days, if she needs a musical adrenaline charge, Jules will listen to New Order.) She began ballet dancing at the age of five, and although it was quite tough, Jules believes that it set her up in good stead for loving all kinds of music. During her cancer treatment Richard Ashcroft's music struck a real connection with both Jules and Mike.

Jules described how Mike and her son Evan are really into vinyl records, and how they will make a little ceremony of putting the records on when the family has a night in. She leaves the choice of music to Mike, who becomes the DJ for the evening, and he manages to choose stuff that everyone will enjoy. Jules said that she tends to listen to music on Spotify. Her joke is that, as the woman of the family, she has more jobs going on than anyone else, and does not have the time to keep turning records over, especially when she could be anywhere in the house at any time.

Jules told me a little bit about the lead-up to her breast cancer. In 2015 Mike had relapsed with leukaemia for a third time. It was a dreadful period, and she was understandably worried about what was happening with him. Dr David Edwards, who was treating Mike, was looking for something new, as they had reached the end of the road, and a transplant was being considered as options were running out. It was the first time that Jules had seen Mike hit rock bottom emotionally, and she said it was strange for her not to see the positive man she was in love with.

During the summer of 2016 at the Snowdon Rocks event for the Love Hope Strength Foundation, which is the charity co-founded by Mike and James Chippendale, both of whom are cancer survivors, Jules was talking to Emyr Afan, who was making a documentary for the BBC on a year in the life of Mike and Jules. Emyr had been involved in breast cancer fundraising in Cardiff, and he asked Jules if she had checked her breasts, which she found a little annoying as she had been surrounded by cancer since the age of 29, so she told him that of course she did. He appreciated that, but asked if she had really checked herself by digging deep, and it occurred to Jules that maybe she hadn't done so to that degree. The next day Jules was having a beer looking out over Snowdonia, and decided to check herself by digging deeper, whilst still swigging her beer! She found a lump on the end of her nipple, but wasn't too concerned about it. She had been through so much cancer with Mike, there was no way in her eyes that she was going to have cancer too. Jules got Mike to feel the lump, and like her he wasn't worried, but he did suggest that she should get it checked.

The next day she called the doctor, thinking that they would book her in for a check-up in a couple of weeks, but they wanted to see her straightaway. It was pouring with rain, and Jules said that when she got there, she felt her happy-go-lucky world, Mike's leukaemia aside, turn a little bit dark. By the way her GP looked at her during the examination, gut instinct told Jules that she had cancer. She went home, sat on her stairs, and waited for her two young boys to get home. Jules felt so sad that her parents and her kids were going to have to join her on this journey. She felt she needed to put all her upset to one side, and not worry the boys, and just be a mum. For Jules, the role of mum is one of the hardest things she has had to deal with throughout her cancer. There have been times when she has not wanted to get up and do the school run, and just stay under the covers and not have to face people.

A couple of days later Jules went to Bangor Hospital, which is where Mike has all his treatment. Those were the worst two hours of her life, when she was willing and hoping that everything would be okay. Jules said that the two-hour test is designed to give women a very clear picture of what is happening, so they don't have to go home and worry about what is going on. She described her experience as like jumping over hurdles, and at every single one she could see in their eyes that they knew she had cancer. At the point where Jules had to put her arms up in the air, and the consultant was checking her out, it became apparent that her right nipple was slightly inverted. Jules said that she still finds it hard checking herself, but believes looking at yourself in the mirror with arms raised is a good way to start.

At this point Jules' life fell apart, but at the same time she felt a new inner strength. She had been dealing with Mike and all the tests for most of her adult life, so she had developed quite steely nerves as a result. Jules has been through a lot in her own life, including a long and difficult IVF process. She felt that the only way for her to deal with it was to dig deep within herself. Jules found that other people were even more upset about her cancer than she was, which meant that she had to quell their fears, and give them reassurance that she was going to get through it. Jules was determined stay strong, and to approach it differently to the way Mike had with leukaemia, by doing it in a more feminine way. She felt that the cells that were behaving badly inside her were very much part of her, and she believes that her breast cancer was caused as a result of all the infertility treatment she's been through. Jules also pointed out that there isn't enough conclusive evidence yet to support this theory, and she wouldn't want anyone to be put off going through IVF. She went through IVF many times, in a very private way. It was a deeply upsetting experience: she remembered being at one Gathering and having to carry on, knowing that she'd just had a miscarriage. There have been moments when Jules and Mike have been dealing with some really upsetting news when they have had to read rude and vicious comments on social media, and she pointed out that before posting such comments people should perhaps take a moment to stop and think.

Jules kept the news about her breast cancer private for four months. She went to America with Mike, as her surgeon was also away on holiday, so it was business as usual for a while. Jules spent time coming to terms with the diagnosis, and said that her greatest fear was having to go through chemotherapy. She didn't want to lose her hair, her sexuality, or her femininity. She was also distraught over the possibility that she might die, but knew

that with the type of breast cancer that she had, there was a good chance of successfully being treated and surviving. Jules said having a brilliant oncologist, radiologist, and surgeon gave her the confidence that she would get through it. However, she knew that having chemotherapy and radiotherapy would be a massive journey, especially as a woman. It doesn't just end when you finish radiotherapy: Jules has always been very open about the burns she suffered from that treatment and the graphic surgery she had to go through, all of which was shown in the two BBC documentaries that were made. She still has more operations ahead, which involve reconstructive surgery on her right breast. Jules said that it's not easy to wake up each day and look at her mutilated body, in spite of the incredible work that surgeons can do these days. She added that she was more fortunate than some in that she has an exciting life, and pointed out how tough it must be for the women going through cancer who might be in a bad relationship, or have a terrible job, for instance, and for whom life is pretty grim and who then have a cancer diagnosis on top of it all. Jules took a moment here to pay tribute to The Alarm family saying their support has been life-affirming, and talked about how they grabbed her by the hand and helped her through it all. She also described how Mike had her playing in the band while she was having chemotherapy – he needed a keyboard player and Jules was the easy option with her classical training.

On her return from America, all Jules' worst fears were realised. There were three areas of cancer in her right breast, and the consensus from her medical team was for her to have a mastectomy and have the right breast removed. This was something that Jules didn't want to have done if there was any possibility of avoiding it. Fortunately, she said her surgeon fought very hard for her, and believed that he could remove all the cancer with good margins without having to remove the breast, and that he would be able to rebuild it afterwards. Jules will be forever grateful to her surgeon for what he managed to do, which has allowed her to keep her much of her femininity intact.

As Jules began her chemotherapy, Mike was due to go on the road and wanted to cancel all the touring to be with her. Jules made him carry on, and said she knew her decision to send him away was for the best. She believes that sometimes tough love isn't such a bad thing. At one point during her treatment Jules was ill while Mike was in America, although she wasn't actually ill from the chemotherapy. She couldn't do anything for a week, and relied on her parents to sort the kids out, while her best mate Delyth nursed her at home. Jules had developed a really bad urine infection due to complications from the operation. She said that it was good that she was by herself, as she had to dig deep. Jules just wanted Mike to carry on what he was doing, and felt that she could cope, and that he wouldn't really be able to help her by coming home. In the end, when Mike returned, he postponed the remaining dates that year, including some shows in the UK, so that he could be with Jules. She said she was glad that he took control and was by her side while she continued with her treatment. It also gave Jules a much-needed break from organising all the touring, which is another one of her many roles within The Alarm. She added that as a couple they work brilliantly when they are together, and brilliantly when they are apart. Jules described how Mike actually wrote much of The Alarm's *Blood Red* and *Viral Black* albums at her bedside in hospital. Looking back now, Jules is glad that Mike was there

for her. It's those moments that still make her emotional – her voice almost broke as she was telling me this.

Jules also received visits and support from the other band members, James and Smiley, while she was having her treatment. The plan was for The Gathering to go ahead early in 2017, so Jules was organising the event, rehearsing with the band, and having chemotherapy at the same. She said that she was so busy, she certainly had no time to feel sorry for herself. Jules appreciates that there are times when cancer patients have every right to feel sorry for themselves, but also that it helps to try and continue to keep busy, keep moving forwards, and keep making plans. While the outlook for some might not always be positive – and Jules has held the hands of some who have sadly died – she believes that we should use our time left on this planet to have fun and enjoy ourselves.

Her story is an inspiration to many, and Jules now also gives a great deal of support to other cancer patients. I wondered if she found it emotionally draining, especially when it sadly came to seeing some of these people dying. Jules said that, in fact, it was the reverse. One of her close friends, Nicola, who Jules had met through them both having breast cancer, died in 2018. Jules described how Nicola didn't want to die, but right up to the end Nicola was grateful for what she'd had, and determined to enjoy every single last day with her family and friends. Jules took a lot of strength from Nicola and the way she coped with dying. She is swamped with messages on social media from people in similar situations. Helping people cope in these situations is something Jules feels very passionate about, and she continues to do whatever she can to support others in this plight. She said that sometimes all someone wants to hear is that it *is* possible to come through a serious illness. At the same time, Jules said that both she and Mike are very careful not to put out the wrong kind of message. She added that being positive doesn't stop cancer, and lots of amazing people continue to die. Jules said that having done the IVF stuff in private and the cancer very publicly, she feels it is much better to be open and share stuff. Jules and Mike have received so much support from so many, she said the least they can do is give something back. Now Jules is more passionate than ever about life, and said that if you can get through cancer, then life can be sweeter – but she put a big emphasis on the word "if".

Jules might now be part of the band, but she is also a fan of The Alarm, and she first saw them live at the Manchester International II in 1987. She was the young girl from North Wales going out with the singer of the band. Growing up, Jules hadn't been to many gigs, and would usually go out dancing with her mates instead. A gig was a whole new experience for her, and she loved it. Mike told her not to hang around backstage as she would find it boring, and suggested that she went out front and enjoyed the show. What followed for Jules was going all over the world on tour with the band, and she had the most amazing time. She continued to go into the crowd to watch the gigs. No-one knew who she was, and she described how she would tap up big guys to go on their shoulders to watch the band down at the front.

In 1991 Mike left The Alarm, and Jules was like any other fan: she didn't want him to do that and for the band to finish. She also didn't want that brilliant life she enjoyed with the band on the road to come to an end. With Mike starting all over on his own, it was time

for the hard work to begin. Mike decided to put a new band together, and wanted Jules to play keyboards. She admitted she was very reluctant to do so, as with a lot people already hating Mike for ending The Alarm, Jules felt that it would give them more ammunition, saying it would be akin to being put in the village stocks and having tomatoes thrown at you. However, Mike said that was no reason for Jules not to be in the band, and not to give in to negativity, which Jules admitted she was pre-empting having grown up with The Alarm family, and knowing the strength of feeling that Mike's departure had caused.

Jules became part of the new band, which went under the name of Mike Peters & The Poets, and it was brilliant. She said that she would never have gone out on stage if she hadn't been able to play. I can testify from the day at Abbey Road that Jules is a superb pianist. She sat down at the famous piano in Studio 2 and played a wonderful piece, which stopped everyone in their tracks – it was stunning. She toured with the band for five years during the 1990s, and learnt her trade the hard way, becoming a good rock musician. However, Jules stopped playing, in part because she was becoming more involved in the business side of things, and also because she was desperate to start a family.

Mike actually asked to Jules join the current Alarm lineup when she had a cold cap on, and was all wired up for chemotherapy in hospital. He came into the room and told her that he wanted her to play keyboards on the new songs he'd been writing for the band. Jules thought that he was having a laugh. However, Mike was being deadly serious, and James and Smiley were also telling her she should do it. She described how music was really helping Mike during this period, as it was not easy for him either as the carer, which Jules understands all too well having done that for Mike for so long.

Jules started rehearsals with the band in January 2017 at their studios in North Wales. She had no hair on the top of her head, and she admitted that looking in the mirror every morning broke her heart, as she was losing a sense of who she was, so the music was a really good distraction. Jules said that they had just the best time, whilst putting the hours and the hard graft in. She realised that she could do it, and believes that the band has never looked back since. Jules is happy to stand up and be counted in the band, although she admitted that there have been stressful moments, including playing 'Walk Forever By My Side', which is just Mike singing and Jules on the piano, and also the first time she played 'Spirit Of 76' with the band in Bristol. Jules describes herself as a practiser, to the point where the rest of the band just want to stop while she will just want to carry on and on. The Alarm have been performing as this four-piece unit for the last couple of years, and Jules said that they are best mates. They travel on a tour bus, "sleep together", wake up together, and laugh themselves senseless together. I have been fortunate to see the band perform both in the UK and America in the last few years, and the love and chemistry between them is obvious. They've become a really tight unit in every sense. On a lighter note, Jules joked that having a girl in the band means that she keeps the tour bus clean, and that she is bossy, not afraid to speak out, and has added a bit more structure to things. In her experience women are better at organising than men. She did concede that Smiley makes a great cup of tea.

Jules is having the best time of her life. She is grasping at it with both hands after so many dark days. Jules said that she and Mike have incredible lives with so many highs, but

they've also experienced some shattering lows. Mike's dad died in 1990 following a brain haemorrhage, and Jules, who loved him dearly, learnt at a very young age that bad stuff happens. She is a "work hard, play hard" type of person, and occasionally reckless, throwing caution to the wind. Jules is mindful that you never know what is around the corner and what life might throw at you. She focuses very much on positivity, and has no time for any negativity in her life.

It was fascinating talking to Jules. She is such a kind and positive person, and she was so open and honest with me. I've always enjoyed talking to her at gigs if the opportunity has permitted, but this went to a whole new level. I'm sure there are many more adventures ahead for Jules, both inside and outside The Alarm.

Steve "Smiley" Barnard

Steve "Smiley" Barnard, Jagz Bar Ascot, 10 February 2018

Steve "Smiley" Barnard is an all-round talented musician and record producer, who is the current drummer in my favourite band, The Alarm. I photographed him at the launch of his stunning 5th solo album, *Smiley's Friends In The Afterglow*, where he had swapped his drums for a guitar to front a superb live band specially put together for the gig. The songs on the album were taken to a whole new level, and as you can see he was certainly enjoying the evening.

Steve "Smiley" Barnard, 13 March 2017

I'd originally met Smiley almost a year earlier, and that was a case of third time lucky. Our first attempt at the annual Gathering weekend for fans of The Alarm in North Wales ended in failure when he went to the pub to watch his beloved Chelsea! We rearranged to meet at his recording studio in Fleet a few weeks later. On that occasion I turned up to find that he'd taken the family to Brighton for the day. Undeterred, we sorted out another date, and finally met up at his studio.

The first single that Smiley bought was 'Ballroom Blitz' by The Sweet, which reached number 2 in the UK singles chart in 1973. As a really young child he used to set up his little drum kit and play along to the glam rock songs of the era on *Top of the Pops*. We spoke about how, as much as we liked punk music, we were both just a year or two too young and it missed us, so it wasn't the life-changing experience it had been for so many teenagers. We both got into the new wave period that followed punk in the late 1970s.

Smiley had just released his previous solo album, *Smiley's Friends Electric*. He tends to use his musical connections on these albums to get fellow musicians to perform. In fact, on this album, he had used different singers on each of the 12 tracks, and although their names are listed in the notes, he purposely did not reveal who performed on each one, leaving it for the listener to try and work out. Each album has seen a progression, and word has spread with his growing reputation. Smiley said that on his recent albums, he actually had musicians contacting him wanting to be part of it. There is a kind of similarity between us, as Smiley contacts musicians to be on his records in pretty much the same way I ask people to be part of my fundraising books. His thinking is that if you don't ask you don't get, and he isn't scared of asking. There is no doubt Smiley loves making records. He has been releasing them at the rate of one each year, which is a kind of throwback to the days when bands did release albums every year, as opposed to the much longer intervals in between releases that we see these days. Smiley's 6th album, *Smiley's Friends In The Sixth Sense*, was released in February 2019.

Smiley played the drums on tour for From The Jam featuring Bruce Foxton, and got Bruce to play bass on one of the tracks on his second album. He told me how Bruce was playing a different note to the one that the rest of the band were playing. Smiley asked him why he was playing a different note, and Bruce replied, "Because I am Bruce Foxton." He went on to say that although the drumming arrangements were pretty fixed in From The Jam, it was actually quite a tough gig for him, as his own style of drumming is very different from that of Rick Buckler, the original drummer in The Jam. He said that what he did try to bring to the part was Rick Buckler with a bit of Keith Moon, and there's not too much wrong with that.

We spoke at length about him being the drummer in The Alarm, and also of the friendship that he has formed with frontman Mike Peters. He was a fan of the original band in the early days, and saw them in London when they were supported by The Faith Brothers, who were fronted by the late Billy Franks. Smiley said that friendships within members of The Alarm developed really well during the preparations for the 2017 Gathering, as they were put up together in a cottage rather than at a hotel. This meant, for the two and half weeks that they were there, that they all became a lot closer.

Smiley was in store for a busy 2017 with The Alarm: two new albums, two UK tours, and festival appearances, as well as a tour of the United States. In fact Smiley had just received his copy of the first of those Alarm albums that morning. Sadly I wasn't given a sneak preview. He said that when it came to putting the schedule together, Mike asked him what dates he couldn't do, and then literally filled in every gap around those dates. Logistically this would mean Smiley playing dates with another band, Archive, in Europe on one day, and then having to fly to America to play with The Alarm the following day!

The Alarm would be touring during 2017 predominantly as a four piece, heralding a change of the five piece lineup from the past. Smiley said it would be interesting to see how the classic old songs would sound, and how they would balance the new and the old material. He spoke about Mike with real affection, describing him as not having a nasty bone in his body, just one of the genuine good guys. Both Mike and his wife Jules have had cancer, and Smiley really has become like family to them now. It was clear how close a friendship they have built between them. He has developed a great relationship with fans of The Alarm, too, since he has brought his own personality to the band and offers something a little different. He is also very hospitable and accessible to the fans – hence why he ended up watching Chelsea in the pub with them in North Wales, forgetting he'd arranged to chat to me!

Smiley also spent time playing drums for Robbie Williams. It came about at an audition where he was one of twenty-six competing for the post. Lady Luck must have been smiling on him, as Robbie turned up to the auditions at the same time as Smiley. Not only did he get to play with Robbie smashing out a track, Robbie then also asked him for a lift home, which pretty much got him the gig. He ended up playing on a couple of tours and drumming on the B-sides to some of Robbie's biggest hits, including 'Angels' and 'Let Me Entertain You'.

I had to ask him about the "Smiley" nickname. He said it came about with a group of musician friends, when he just became better known as Steve the drummer, the one who

is always smiling, smiley Steve… and from then on the name stuck. He loves what he does for his job. He spent so many years playing the clubs and pubs that he regards everything that he is now achieving as a bonus.

Smiley has had the Sunshine Recording Studio, based in Fleet, for over ten years. It took him a long time to work out how to get the best out of it, and he said that recording his own four albums had greatly helped with the learning curve. He described his role as producer as more of a social worker, since you have to find out about the dynamics of a band, and what makes each member tick. He sees the role of a producer as getting the best out of people rather than being solely about technical ability, and he has picked up many tricks of the trade by watching and learning from the sessions done in his studio over the years.

We ended up talking all things music for over an hour. It was a fascinating experience, and Smiley couldn't have been nicer. Just speaking to someone with such enthusiasm and passion for what he does was absolutely brilliant.

Two years on, and life is never dull for Smiley. Alongside his own music and work as a producer, he continues to perform and record with The Alarm, and with Archive. He also played drums on the most recent album from Ian McNabb, the frontman of The Icicle Works, entitled *Our Future In Space*.

James Stevenson

James Stevenson, 20 October 2017

James Stevenson has been playing in bands for over 40 years. I met up with him in Oxford where he was performing with The Alarm. He took me into the venue before the band's soundcheck, and we were able to take some photos in the empty auditorium. The lighting engineer, Andi Badgeman, kindly lowered the stage lights to allow me to photo James in front of the stage, but this earned me a deserved telling-off from sound engineer Mark Warden, who was busily trying to get everything sorted before the band arrived.

The first record that James bought was *Sgt. Pepper's Lonely Hearts Club Band* by The Beatles, which was released in 1967. This became, of course, a massive number 1 album that stayed at the top of the charts for six months. James was working in his Uncle Eric's bar in Spain that summer on the family holiday, and used his earnings to buy the LP when he got home. He still loves The Beatles, and if he had to pick a favourite album of theirs it would be *The White Album*. Music soon became James' life, and there were many independent record shops where he grew up in West London, including One Stop Records in Richmond, which was one of those classic music stores where you could listen to records using the headphones provided.

James began playing in bands when he was still at school. One of those bands, Metro, did a support slot at The Marquee Club. Also in the bands from those school days was Henry Badowski, who James regards as the closest thing to a genuine musical genius that he has

known. I was interested to find out how James got from playing in bands during the Glam Rock era to playing in punk band Chelsea. He said that the two genres are closely related. He added that one of his favourite guitarists is Mick Ronson, who would also be the choice of many punk musicians, including Mick Jones from The Clash, and Steve Jones from The Sex Pistols. He said that everyone was a Bowie, Roxy Music, and T-Rex fan. James also pointed out that he wouldn't like to be pigeonholed as to who his influences are, telling me that American blues and soul Funk guitarist Johnny "Guitar" Watson is another one of his favourites.

When the punk scene exploded in the UK in 1976, James was already into bands like The New York Dolls, but he believes that the origins of punk can be traced back to The Stooges and MC5 in Detroit during the late 1960s. James became a member of Chelsea after seeing an advert in Melody Maker. He was still at school doing his A-Levels at the moment his life changed forever. James left Chelsea in 1980; however, he said that he has always been lucky, as when one thing has ended something else has always come along. He worked with Kim Wilde, but interestingly as a professional mime guitarist on her videos, as opposed to performing on her records. Other bands James has worked with include Generation X, The Cult, Gene Loves Jezebel, The International Swingers, Holy Holy, and of course Mike Peters and The Alarm. He has also released a superb solo album, *Everything's Getting Close To Being Over*.

James continues to work with any number of artists at the same time. He said this is a bit of a juggling act, and at any one time he would have five different band live sets going on inside his head, but he absolutely loves it. When The Alarm were playing in America during 2017, James had to fly back to the UK to play a gig in London with Holy Holy, and then fly straight back to the States to rejoin the tour. In his words that was "brutal", but he wouldn't have it any other way. James has played more gigs with Mike Peters than he has with anyone else during a 19-year musical association with him. He regarded this particular time with The Alarm in 2017 as the most enjoyable period of all.

James lost his mother to cervical cancer when she was aged just 48. Sadly she died only six weeks before James joined Generation X, and missed all the coverage James enjoyed in the music press. She was also a big music fan, and while James was playing in punk bands, she would listen to Fleetwood Mac, so they used to argue about music.

The concert in at the Oxford Academy was to promote The Alarm's *Viral Black* album. This was the second album released by the band during 2017, following on from the *Blood Red* LP from earlier in the year. The band had settled into playing live shows as a four piece, which meant a big change for James. He had taken over the bass guitar duties, with Mike Peters playing most of the guitar parts. James is no mean bass player either, although he did get to play lead guitar on a few songs during the set. This actually made for a great live set, as the frantic energy maintained throughout the two hours barely gave the band, or audience, time to catch breath. The band very kindly allowed me into the photo pit during the first three songs, so I was able to photograph James in action. The gig was also special because the band and fans dressed up in pink to support the Breast Cancer Now charity's #wearitpink day to raise funds and awareness about the disease. Jules Peters, wife of Mike, and keyboard player in The Alarm, was diagnosed with breast cancer during 2015.

There is no doubting James' passion for music. I must admit to being rather envious of someone who has spent most of his life doing something that he loves. We had spent the best part of a year trying to arrange a meetup, but I think it was right that in the end it was to be a concert where I not only got to see the musician in action, but also met the man behind the guitar.

Amy Macdonald

Amy Macdonald, G Live Guildford, 31 October 2017

Amy Macdonald has sold over 12 million records worldwide following on from the success of her debut album, *This Is The Life*, in 2007. The Scottish singer-songwriter has not looked back, and she spent 2017 touring and promoting her fourth offering, *Under Stars*. I had not seen Amy in concert before, so when she announced a series of dates at smaller venues towards the end of the year, including one in my home town of Reading, I decided to try and make contact with her. Unfortunately the Reading date was on fireworks weekend, which was no good as I had to stay at home and look after my dog Prince during the fireworks. However, she was due to play Guildford, which is also fairly local to me, so I decided to try to see if I could meet her there. Amy's management were extremely helpful, and offered me the opportunity to photograph her first three songs from the photo pit, as well as kindly giving me a ticket to see the rest of the concert. It wasn't possible for me to meet Amy in person, but I was informed that the first record that she bought was *The Very Best Of The Beach Boys*, which was released in 2001.

The evening was almost a complete disaster before it had barely begun. I arrived at the venue, and made my way down to the front to get everything ready. I can't begin to describe the sick feeling in my stomach when I realised that I hadn't charged my camera battery – a real schoolboy error. I had no idea how long it would last, and resigned myself to the possibility of using my mobile phone camera if I had to. Thankfully the battery held out, and I managed to take over 150 photos. I also realised that there was no actual press pit. The audience was seated, so this meant having to take photos from a crouched position in front of the stage, so as not to intrude too much on the view of those behind me. I had bought myself a new lens for my Panasonic Lumix G6 camera, and I was really pleased with the resulting photos.

The concert was outstanding. For the tour Amy performed stripped-backed versions of songs from all her albums, backed by her three-piece band. She played them more in the way that they were originally written, as opposed to the way they ended up on record. It was quite mesmerizing. At times you could have heard a pin drop between songs, but this was more an electric sense of anticipation than anything else.

Amy revealed during the performance that she had been suffering from a nasty stomach bug, and the show had come very close to being cancelled. Thankfully it went ahead, and the full house was not disappointed. Amy also let slip during the evening that she and the band were not very "rock and roll" these days, and that she did her ironing before she came out on stage. It was an unbelievable experience, and to get to photograph such a hugely successful artist up close was pure joy.

Jeremy Cunningham

Jeremy Cunningham, 25 January 2018

I travelled down to Brighton to meet with Jeremy Cunningham, bass player with The Levellers, at their Metway recording studios. If the meeting had been one week later, the whole of the band would have been there rehearsing for their tour to support the *We Are Collective* acoustic album. However, this way worked brilliantly, as I got to spend some quality time with Jeremy talking about the band.

To begin with Jeremy gave me a tour of the studios. The photo was taken where the band rehearse, which is also where they have recorded the vast majority of their albums since they bought the building in 1994. Jeremy told me that the building is much bigger than the type of property they were originally looking for, but they were hunting during the property slump, and it was a lot cheaper than a smaller place they were also looking at in the centre of Brighton. It was originally bought to be used as a rehearsal room with offices, since having the building in Brighton meant that the band didn't have to travel to London to rehearse and to hold office meetings. The band got the idea of bringing everything under one roof from REM, and they used the advance for their fourth album from their record label, China Records, to build the studio. Whilst they remained with the label, the band continued to use advances to update the studios. Jeremy told me the band have had some very talented, driven, and supportive people working with them to make the studios what they are today.

We went down to the bar in the basement, which hosted many infamous parties in its day. Jeremy said that they brought the bar over from Holland, and that the building was originally a brewery. You can still see the gullies in the concrete floor used to drain the waste since the beer was transported by horse and cart. Jeremy is also a very accomplished artist, and has his own art studio located in the building. He has designed all the artwork

for the band over the years, and there were some wonderful pieces of his work on display. Jeremy explained that the recording studios are also hired out to bands, and at other times they have an arrangement with the local college, whose students use the studios. It was absolutely fascinating going round the building: it's a place that Jeremy and the band are immensely proud of.

The first record that Jeremy bought was 'English Civil War' by The Clash, which is also one of the few songs that The Levellers have covered as a band. The single was released in 1979 and reached number 25 in the UK chart. Jeremy remembered that it came with a picture sleeve – which was slightly unusual at that time – and featured a scene from George Orwell's *Animal Farm*. The Clash have had a big influence on The Levellers. Jeremy told me that the band regard themselves as a folk band in the same way that The Clash were at heart a folk band too. Although they sometimes use loud guitars, what they are saying comes under the folk banner. The Levellers also recorded their single, 'Just The One', with the late Joe Strummer playing the piano.

The band's lineup has been pretty constant since Jeremy formed the group with vocalist Mark Chadwick back in 1988. Jeremy told me that after Alan Miles, the band's mandolin player guitarist, left them in 1990, the position went to Simon Friend. He had played some support slots with them, and had a song called 'Battle of Beanfield' which the band wished they had written, so he got the job. The lineup has remained the same ever since, and Jeremy told me that one of the main reasons for this is because each member of the band has always been paid equally, no matter who writes the songs. He told me that they are easy-going people who are all friends, and that they all know that the noise the band makes as a whole is bigger than the sum of its parts. The lineup, therefore, is not something that can be messed with.

I first saw The Levellers during their early days at the After Dark Club in Reading, which at the time regularly staged concerts, so I got to see quite a few up-and-coming bands in the late 1980s/early 1990s. By 1993 The Levellers were high up in the charts, and selling out much bigger venues. I went to see them at Reading Rivermead Sports Centre, which I have to admit is not one of my favourite venues. One thing I will always remember from that concert is that it was the night England lost to Holland in a World Cup qualifying match, meaning they failed to qualify for the 1994 World Cup Finals held in the USA. During the gig the band gave updates on the score from the stage. It was 18 years until the next time I saw them, and that was in Birmingham on the 20th anniversary tour of their classic album, *Levelling The Land*. I've never been to a gig where it was so tightly packed, and Jeremy thinks that that night may well have been over-sold. A couple of years later, I saw the band again, this time at SUB 89 in Reading. I remember it being a fantastic evening, and it was so good seeing the band on top form in a great intimate venue.

We talked about the *We Are Collective* album. Jeremy designed the cover, and for the first time the band used a photo, which is a shot of everyone who worked on the album. It was a decision that everyone, including Jeremy, wanted to go with. The photographer was Steve Gullick, with whom the band have had a long-standing relationship since the early days. The album was recorded at Abbey Road, which is also where the photographs were

taken. Jeremy said that the band were given special dispensation to use the photo as the album cover. Usually photographs taken at the studio can only be used on inside covers.

The band wanted to change everything about the songs on the album, so they came up with totally new arrangements. They would strip the songs on the record back down to their very basic components, and build them from there. Jeremy actually gave me a demonstration of clapping the beat to their song 'One Way', and showed me how they would take that base and rebuild the song from scratch.

The Levellers run their own festival in Devon each year called Beautiful Days. It's an event that is an annual highlight for the band, and something they are very proud of. Jeremy told me about some of the artists that would be playing at the 2018 festival, a month or so before the lineup would be officially announced in the media. It included Manic Street Preachers, Feeder, Shed Seven, and of course The Levellers themselves. Jeremy told me that the band always try to get musicians that they want.

It was a wonderful experience talking to Jeremy, and he was so engaging and helpful. He gave me everything that I'd hoped for, and quite a lot more besides. Before I left the studio, I asked Jeremy if it would be possible to photograph him and the band at one of their concerts. He kindly agreed, and a photo pass was arranged for me at their concert in Basingstoke a few weeks later. However, the tour, and the release of *We Are Collective*, were both put back after the tragic death of the son of Charlie Heather, the band's drummer.

I went to the rescheduled gig a few months later. I had never been to The Anvil in Basingstoke, and once parked up I did have some difficulty finding the venue. However, once there I was greeted by the friendliest staff I have encountered on my adventures. They couldn't have done any more to make sure I had everything I needed. It was a seated concert, and on entering the venue I knew that the photography was going to be a challenge. There wasn't a photo pit, which wouldn't have been such a big problem except that there wasn't even the slightest gap between the front row of seats and the stage. This meant I wouldn't be able to get to the front of the stage and take pictures of the band as close as I would like. One of the roadies setting up also told me that Jeremy would be seated towards the back, so all in all things were not exactly in my favour. However, all this was soon forgotten as I began to feel the usual nervous excitement and anticipation as I waited for the band to come on. I spent the first three songs taking photographs from the left-hand side of the stage. The photo I have used illustrates the problem I had, in particular of getting a decent close-up shot of Jeremy.

The Levellers, The Anvil, 13 July 2018

Having completed my photography I went back to my seat to enjoy the rest of the concert. *We Are Collective* is a great album, but it really comes to life in a live environment. The sound was stunning, and the band were on great form. The songs may have been stripped back for this album, but there was a tremendous power to them, and at times I was completely mesmerised. There is no doubt that most of the fans there were used to watching The Levellers in a standing venue, and enjoying the songs played with the passion and energy of their original forms. It was almost as if the audience weren't quite sure how they should be watching it. Would standing up upset others around them? At times there was a deathly silence between each number, but at the same time the atmosphere was electric with a real sense of anticipation. Towards the end of the evening the band encouraged the audience to get to their feet – no second invitation was needed, and the venue was bouncing for the final few songs.

I can't thank Jeremy and The Levellers enough for their support, and for the wonderful opportunity they gave me with this chapter. The band were looking forward to their 30th anniversary celebrations, and Jeremy told me that songs had already been written for a new album, so there are plenty of exciting times ahead for The Levellers.

Skinny Lister

Skinny Lister, The Garage, 12 December 2018

I made contact with Lorna Thomas, singer with the band Skinny Lister, shortly after I'd seen them live for the first time at The Garage in London towards the end of 2016. The band had been recommended to me by a number of friends who like The Alarm, so I'd bought all three of their albums. I'd immediately become a fan, so I was looking forward to seeing them play live. Their music is folk-based, but with an electric and punky edge. The songs have wonderful catchy melodies, and if you ever need to listen to music to pick you up, then this band will most certainly do that.

The band photo and the concert photography were done 18 months apart, as things never quite went to plan when it came to meeting up with them. The fact that we were trying to arrange it around their London shows didn't help, as things are always very hectic when they play in the capital. On two occasions I waited outside venues, but the meeting didn't happen, and on another occasion winter snow put paid to my travel plans.

We finally managed to meet up in December 2018 at their festive sold-out show at The Garage in Highbury. Lorna told me to get to the venue for about 4:00 p.m., and they would be able to come out and do a photo with me. Fortunately for me things turned out a whole lot better. It was a bitterly cold afternoon, and I was not looking forward to any kind of prolonged wait outside. Thankfully Lorna came out, and asked me if I would like to come inside. She said it would be best if I was OK to wait while the band did their soundcheck first, which meant that I got to spend the best part of two hours watching the band set up their gear, and go through their paces.

It was a fascinating experience seeing everything come together during the soundcheck. It was still pretty cold inside the empty hall, so they were wearing their coats. Each instrument and vocal microphone had to be put through a thorough check, and adjustments made over and over again before the band were ready to launch into a song. At times the

band would stop at the end of a verse to make more adjustments. The attention to detail throughout meant that a few hours later the audience would be treated to the band sounding their absolute best. It was also interesting to see how the songs were performed during the soundcheck compared to the concert. Musically there was little difference, but the change in the band was huge. During the soundcheck they kept a lid on things, and they stood still concentrating much more on the sound. The live set is something else. They explode onto stage captivating the audience, and the band and the crowd feed off each other's energy throughout. It made me realise just how much energy they expend.

A sense of humour within the band was always close to the surface, and at one point I witnessed a very comical scene when they stopped to move Thom's drum kit, to ensure he was positioned dead centre to the band's backdrop behind him. Another amusing moment was when Lorna was so engrossed with her phone that she forgot to sing during a chorus, and Dan had to give her a nudge with his guitar to prompt her.

Once the soundcheck was over we went back to the dressing room to photo, where I was able to tell them a little bit more about my mum, and why I was writing the book. I also got the opportunity to ask them about their first records, and there was a really interesting mix. Lorna bought 'That's What I Like' by Jive Bunny, a number 1 UK single in 1989. Bass player Scott's first purchase was 'Golden Brown' by The Stranglers, which was released in 1981, and made number 2 in the UK chart in February 1982. Lead singer Dan bought *Cloud Nine*, the 1987 album by George Harrison, which made the top 10 in both the UK and US album charts, and was a big worldwide success for the former Beatle. Max, who plays the melodeon, bought 'Living Doll' by Cliff Richard & The Young Ones, which got to number 1 in 1986. Thom, the band's drummer, bought *Fat Of The Land* by The Prodigy, which sold over 10 million copies worldwide, topping both the UK and US albums charts. Guitarist Sam bought the *Lost Boys* soundtrack album on cassette, which was released to accompany the film in 1987.

The gig later that evening was exceptional. The band played material from their three albums, *Forge & Flagon*, *Down On Deptford Broadway*, and *The Devil, The Heart and the Fight*. They also treated the crowd to some new songs from the fourth album, *The Story Is…*, which was released in March 2019. They played a couple of Christmas songs, one of which was with their music label friend and artist Beans On Toast, and at the end of the evening Elvis Presley made a surprise appearance on stage with them. It was a memorable evening, and a very special experience for me that will long live in the memory.

The chapter with Skinny Lister had begun 18 months earlier when Lorna very kindly sorted me out with a photo pass for their biggest London gig up until that point at Scala in King's Cross. It was an amazing night as the band were on great form, playing songs from their back catalogue. It did not get off to the best start for me, though, as the security staff weren't overly helpful, and it took a little persistence and determination to be allowed into the photo pit. The band came out with all guns blazing, and the whole crowd were swept up in the performance. It was as good a gig as I've seen in a long time. In fact, taking photos was not that easy, as I was enjoying the music so much.

Skinny Lister, The Scala, 11 May 2017

At the end of third song I went back into the audience. The band made a comment that they were happy for the photographers to stay, but the grumpy security staff were having none of it. However, as much as it's fantastic being able to photograph the band by the stage, it's always good to then enjoy the rest of the gig as a normal fan. The band, especially Lorna, are known for their crowd-surfing. At times throughout the set she would end up being carried by the audience. The other thing that is always present at their concerts is the passing of the flagons of rum round the crowd. The band have a real connection with their fans, and I'm not sure I've seen a more enthusiastic audience, who feasted on the enthusiasm of the band from start to finish. I think you would be hard-pressed to find anyone watching a Skinny Lister concert and not sporting a huge smile throughout.

I can't thank the band enough for their support, especially for Lorna for making it all come together, despite it happening over such a long period of time. I've always believed that music is at its best performed live, and Skinny Lister are the perfect example of this. Their music in the studio is brilliant, but seeing the songs live really do take them to a higher level. If you ever go and see them, you will not be disappointed.

New Model Army

New Model Army, The O2 Forum, 14 December 2017

I bought New Model Army's debut single, 'Bitter Sweet', on its release back in 1983, having first heard it on night-time radio. During this period I was passionate about discovering new music after the break-up of my then favourite band, The Jam. I thought, and still do, that 'Bitter Sweet' is a terrific song. I got to see New Model Army play live at the Lyceum in London in 1984, and little did I know that it would be another 30 years or so before I would see them again.

Lead singer Justin Sullivan is the only ever-present member of the band since its formation in 1980. The first record that Justin bought was the brilliant 'Till The End Of The Day' by The Kinks which reached number 8 in the UK in 1965. He grew up in the 1960s listening to and loving so much of what was happening, especially the golden years of Tamla Motown, and then through the 1970s the whole Northern Soul scene which led directly on from that. Punk rock was sold to Justin by a radio interview with Poly Styrene, the singer of X-Ray Spec, and later at a gig by The Ruts in a tiny pub in Bradford which remains to this day the greatest gig Justin has ever seen. He has also been through a major reggae phase, a hip-hop phase in the early 1990s, and now he listens to a lot of classical music, Estonian composer Arvo Pärt in particular. He was into the whole desert music scene centred in Mali. Justin said that he could go on forever listing music, and he is

basically open to anything and everything, and loves particular musical moments from anywhere and everywhere.

The band very kindly gave me a photo pass for their Winter Gatherings gig at The O2 Forum in London. The annual Christmas gigs have become a tradition for the band, and they performed two sets, with no support band. This approach allowed them to play songs not often performed, and go right back through their entire history.

There was almost a disaster as I was waiting for the band to come on stage. Flash photography is not permitted in photo pits, but the one of the security guys had questions about the internal light meter on my camera, and initially I thought I might be asked to leave. Thankfully he was placated, and I got to photograph the first three songs of the brilliant opening set. It was probably one of the most relaxed and enjoyable concert experiences that I have had.

Justin is showing no signs of slowing down, and New Model Army have a large and loyal fan base. He still loves being here: playing, writing, and learning music!

Rick Witter

Rick Witter, 28 June 2018

During the 1990s I rather lost touch with live music, which meant that I never got to see Shed Seven. I finally put this right when I went to see the band play at the Northampton Roadmender. I'd contacted the lead singer, Rick Witter, after hearing him being interviewed on BBC Radio 6 Music. Rick lives in York, so we just had to wait for a convenient opportunity and location to arise for meeting up. In June 2018, the band headlined a major outdoor concert at the Castlefield Bowl in Manchester. In preparation they arranged to play a warm-up gig in Northampton the night before, which was perfect for me, being within striking distance of Reading.

I had to get to the venue for late afternoon, which was around the time that the band would be doing their soundcheck. When I got there the front of the venue was closed, but I'd seen the tour bus parked round the side of the building so I sent a message to the band's tour manager Phil, and waited there. I had no idea what would happen, but within a couple of minutes Phil appeared with Rick. No time for nerves, and to be fair Rick was a top bloke and made me feel at ease straight away.

Rick told me that the first record he bought was 'Under The Moon Of Love' by Showaddywaddy. It was a number 1 single in the UK in 1976, and sold just short of a million copies. Coincidentally Rick had seen a poster in the venue advertising a Showaddywaddy gig there, and I think he was pretty proud of this first record. I was

interested in finding out about Rick's musical influences, and he told me it was bands like The Smiths. He also was a big fan of The Soup Dragons, but pointed out that this was during their early days, before their 'baggy' phase that followed. He also likes The Rolling Stones, although mainly the period prior to 1970. He did say that he particularly rated *Goats Head Soup*, the band's album released in 1973.

We spoke a little about Shed Seven. In 2017, the band released their first album for 16 years, entitled *Instant Pleasures*. It's a phenomenal piece of work, and I made no secret of telling Rick just how much I liked it. It's a record that I never tire of listening to. Rick said that the band really enjoyed making it, and he felt that this came across in the music. I certainly wouldn't argue with that.

I have to say that the area around the Northampton Roadmender is not the most scenic of places to take a photo, so we did the photography by the tour bus. I think Rick has to be one of the coolest people I've met and photographed, and it wouldn't have mattered where we'd done it, as he just looks the part. Throughout our chat Rick was full of fun, and more than happy to have a picture taken with the Beating Bowel Cancer tie to help raise awareness about the illness. He was also interested in hearing about my mother, and her bowel cancer. Rick then had to leave to go and do the soundcheck with the rest of the band, but the story didn't end there, as I had the gig to look forward to.

When we arranged the meeting, the date 28 June meant nothing to me. I had, however, made a schoolboy error as the gig clashed with the England versus Belgium match in the World Cup. I wondered how I could combine both, but thankfully the band came to everyone's rescue, as they were in the same position. Rather than having a support band, the venue opened up a little early, and they put up big screens to enable everyone to watch the game. Rather disappointingly England lost 1-0, but it was an enjoyable if not a little unusual way to see it.

The gig itself was tremendous. The band were on fine form, and I couldn't fault any of it from start to finish. The performance was really tight, but they were also really enjoying themselves, as were the very enthusiastic audience. Because of the band's major gig the following evening, they played with a brass section, and backing vocalists. The set, which lasted for just under two hours, saw them play many of their hits from the 1990s, and also plenty of material from the current album.

I don't think I have I ever seen a better frontman in a band than Rick. He has a tremendous rapport with the crowd. He wasted no time in putting the football score to bed, proclaiming that England would still win the World Cup. The banter between songs was brilliant, but as soon as the first chord in a song was struck he was right back on it, and giving it his all. Rick also has a great knack of talking to individual members of the crowd, and there were two really nice moments during the set. He was talking to a young teenager, and when the boy told him he played the drums, Rick invited him up on stage to have a go. The band struck up 'Whole Lotta Love' by Led Zeppelin with their new drummer. A little later Rick spotted an even younger boy, aged just nine, sitting on the top of his dad's shoulders, who was yet another drummer. The boy was too nervous to go on stage and join the band, but at the end of the main set Rick made sure that the young man got one of the customary maracas that he throws into the crowd. It was a fantastic

evening, and as good a live show as I have seen. I can't believe it took me so long to see Shed Seven live, but I shall certainly be going to see them again.

Saxon

Biff Byford of Saxon, Cardiff University, 23 February 2018

Having an older brother who has always liked his rock music has from time to time influenced my own taste in music. One of my brother's favourites was the heavy metal band, Saxon, and as a teenager I bought a number of their singles, beginning with '747 (Strangers In The Night)', one of their biggest hits, which reached the Top 20 in 1980. I was a keen collector of rare records, and a number of Saxon's releases came out as picture discs, which I still have in my record collection.

When I made contact with Biff Byford, the band's vocalist, he immediately agreed to meet me. Biff told me that the best idea would be to meet him at one of the band's concerts. Sometimes timing is everything, and as the band had just released their *Thunderbolt* album, they were playing three dates in the UK before heading out to Europe and America. I managed to get a ticket for their gig at the Great Hall in Cardiff University, and Biff told me to get to the venue at around 5:00 p.m. The first challenge was getting to Cardiff on a Friday afternoon. The traffic around Bristol and over the Severn Bridge was pretty slow, but having allowed myself plenty of time, I arrived at the venue in good time.

The Great Hall is situated inside the Students' Union. Finding the band was not difficult as they were doing their soundcheck when I arrived, and you could hear the sound as soon as you entered the building. I asked one of the road crew if I could see Velby, the band's tour manager, so I was taken inside the hall to meet him, and was greeted by probably the loudest music I've ever heard. With no audience the sound really was bouncing off the walls in the empty arena. Velby took me backstage to Biff's dressing room to wait for him.

Having completed the soundcheck, Biff came back to meet me, armed with his cup of tea. I'd heard that he had a reputation for being a tea drinker, although he did concede that

these days he also enjoys a glass of wine. People were coming and going, and with it being the first night of the tour, the band clearly had a busy evening ahead, so I made use of the time I had with him.

Biff told me that the first record that he bought was 'Please Please Me' by The Beatles in 1963, which got to number 2 in the UK charts. I wondered how big an influence The Beatles would have been on Biff, but he said that it was The Rolling Stones who were more significant for him. Biff played guitar and bass in bands before settling on being a vocalist in Saxon. The band released their eponymous debut LP in 1979, and have since sold more than 13 million records during a career spanning almost 40 years.

I asked Biff about the new album *Thunderbolt*, and he told me that its sales figures in the first of week of release had more than comfortably paid for its making, which meant that the record company were happy. Perhaps surprisingly, the band also benefit more from the album's physical sales than from streaming figures. With decent-sized venues selling out, Saxon are still able to take a fantastic show on the road, and Biff told me that the band still love touring.

When I'd approached Biff to be in the book, he told me that he would do a photo, but that it would be difficult to arrange a photo pass for me. However, just when I was getting ready to photograph Biff in the dressing room, he suggested, to my surprise, that it would be much better for the book if I were able to photograph the band on stage, and promptly sorted out a photo pass for me.

A few hours later I took my place at the front in the photo pit for the first three songs of the band's set. It was an amazing experience. I made full use of the opportunity, and took a couple of hundred photographs. The sound from the monitors on stage was electrifying. As you can see, as well as the photo of Biff, I also captured Paul Quinn, Nigel Glockler, Nibbs Carter, and Doug Scarratt, the other members of Saxon.

The three songs seemed to go by in a flash. I left the photo pit very happy with what I had, and quickly thanked Velby before returning to the audience to enjoy the rest of the performance. It was a brilliant gig, and the hall really was rocking. The band struck a

perfect balance of new and old songs. Biff had earlier told me that they still have a very loyal following from the early days, as well as having picked up a whole new younger audience with their more recent releases.

Biff told me that Saxon would be doing something very special in 2019 to celebrate the band's 40th anniversary. Having waited almost 40 years to see the band, maybe my wait to see them again will be a much shorter one…

The Tearaways

The Tearaways, The Horn, 20 August 2018

There is always something quite special about watching bands perform in small intimate venues. I went to see American band The Tearaways at The Horn in St Albans, so this was a pub gig, although one with a difference. The band perform all over the United States and Europe and can count Tom Hanks among their fans. The quintet's lineup is John Finseth, Dave Hekhouse, Greg Ballier, John Ferriter, and Clem Burke from Blondie on drums. I was especially pleased to get a Blondie connection for the book, as their 1978 album, *Parallel Lines*, was the first record that I bought. I had been given a Phillips cassette recorder by my parents as a birthday present and used my pocket money to buy a copy of the album on cassette tape. Almost 40 years on I still have both the player and the tape. I was too young to see Blondie at the height of their success in the late 1970s and early 1980s, but I did get to see them play in Reading in 1998 after they were back on top of the charts with 'Maria'.

The band were in the UK on a short tour, and, after hearing some excellent reviews of their gig in Edinburgh, I contacted the band's bass player John Ferriter on social media, and he said the band would be happy for me to take some photographs and help me in any way they could. St Albans is about an hour's drive from my home in Reading, and thankfully the M25 motorway was clear, so I arrived at the venue in plenty of time. I am not sure I had ever been to St Albans before, and definitely not to watch a band.

The Horn is an excellent venue. It's small enough for everyone watching to be close enough to the stage to feel really connected to the band. I was able to position myself right at the front. There was no photo pit, but the upside to this was that I was able to take pictures throughout the band's set, and not be restricted to just the first three songs as is normally the case in photo pits. The biggest challenge for the photography was the lighting. In order to get good action shots I tend to have the camera set to a fast shutter speed and have the maximum aperture. In cases where the stage light is not great, as in

this instance, then I have to increase the ISO setting on the camera, which increases the camera's sensitivity to light. However, the higher the ISO value the grainier the photo will appear. I decided to convert the image used here to black and white, and although there is some grain present, I think it all adds to the effect.

The Tearways played a fantastic set. The songs that I'd already heard really came to life in the live environment. I also like watching bands with more than one guitarist, and this band had three, which made for a beautiful, full, and rich sound on stage. I was positioned for the most part in front of Dave Hekhouse, the lead guitarist, and he gave a real masterclass. The band mostly played their own material, but towards the end of the set they played a version of 'Call Me' by Blondie which was brilliant, and it gave Clem the opportunity to showcase his talents on drums.

Once the gig finished I decided to hang around and see if I could get to speak to any of the band. They couldn't have been more accommodating, as they came out to mix with the fans, and were happy to chat and pose for photos. I introduced myself to John Ferriter, and he was really nice. Once again he reaffirmed his offer to help in any way he could. He also told me about his first record, which was 'Tracy' by The Cuff Links, who were an American band from New York. The song was a top ten hit on both sides of the Atlantic. Vocals on the track were done by Ron Dante, who was also the vocalist on the classic 'Sugar Sugar' by The Archies from the same era. John also very kindly gave me some CDs by The Tearaways, for which I was very grateful.

Not surprisingly, Clem Burke was in high demand, so I knew that my chances of getting a photo and having a proper chat with him were slim. However, I did get to ask him about his first record, and he told me that he bought 'I Want To Hold Your Hand' by The Beatles. The song was the band's first American number 1, going to the top of the Billboard Hot 100 on its first week of release in January 1964. The song had already topped the UK charts in 1963, and was the first song The Beatles recorded on a four-track recorder. Clem is still very much a fan of The Beatles, and The Tearaways' sound is heavily influenced by them too.

I would highly recommend seeing this band live. They are five very talented musicians, who put on a cracking show. It's unbelievable that they are touring the UK playing such small and intimate venues, but that is a bonus for those of us lucky enough to be there.

Ryan Hamilton

Ryan Hamilton, 13 April 2019

I met American musician Ryan Hamilton in New York, which actually fulfilled my ambition of doing an overseas meeting for the book. He was there playing support to The Alarm, who I had travelled to see perform on two consecutive nights in this amazing city. I first heard of Ryan's music a year earlier when I bought his excellent album *The Devil's in the Detail*, which he recorded with his band The Traitors, and which was released in 2017. I'd seen Ryan support The Alarm a couple of times in the UK, and he has become a firm favourite with many of The Alarm's fans.

I hadn't planned on meeting Ryan – in fact our meeting came about under a bizarre set of circumstances. I was getting ready to go to see Mike Peters do an in-store Record Store Day performance at Generation Records, when I was tagged in a request from Ryan on social media. He urgently needed somewhere to leave his kit during the day, somewhere within striking distance of the Irving Plaza, where the concert was being held in the evening. My hotel was only a few blocks away, so a relieved and thankful Ryan turned up with his guitar, amplifier, and merchandise. I decided that it was too good an opportunity to pass, so I asked him if he would be prepared to be in the book, and he happily agreed.

The photo was taken outside my hotel, the Carlton Arms, on East 25th Street, and Ryan then told me that the first record he bought was a greatest hits record by Foreigner, which

included one his favourite songs by the band, 'Cold as Ice'. He also told me about the amplifier he was carrying, which he had in fact borrowed from Stevie Van Zandt – also known by the names Little Steven or Miami Steve – who plays guitar and mandolin in Bruce Springsteen's E Street Band. Ryan had to promise Stevie that he would take great care of the amp, and I thought that it was pretty cool that I had something so special in my hotel room.

I managed to pick up a copy of the *Strength Live '85* album released by The Alarm for Record Store Day, which is the annual worldwide event that brings artists, fans, and independent record shops together. Many bands will release vinyl records on the day, with The Alarm's album being one of them. I enjoyed watching a great acoustic set by Mike Peters before getting the record signed by him as well. I then went back to the hotel to meet Ryan for him to collect his kit. He reckoned he would need to make two trips, as he was rather weighed down by all his stuff, so I told him I would be happy to help him in order to save him having to make a second trip. Before we left my room Ryan gave me one of the T-shirts he was selling, which gave me a great memento of our meeting.

It took us about 15 minutes to walk to the venue, and his gear was seriously heavy so we kept swapping stuff to save our arms. This meant that I got my hands on the famous amplifier. Ryan told me about his new album that he'd recorded with his band, now going by the name The Harlequin Ghosts. *This is the Sound* is due for release on 31 May 2019, around the same time that I'm publishing this book. He was very excited about the record, and the first track released from the album, 'Mamcita', was already receiving great reviews and climbing the rock charts.

When we arrived at the venue, I got a few strange looks from the The Alarm's crew, who seemed a little surprised to see me there, and wondered how I had managed to get inside the venue four hours before the doors were due to open. I didn't hang around as Ryan was due to do his soundcheck, and I needed to get myself sorted for the evening's entertainment too. It was nice to see a good-sized crowd for Ryan's excellent support slot. He always strikes up a good relationship with the audience, and seems to revel in the banter.

It's been a long journey for Ryan, full of ups and downs, but it's good to see him finally achieving success and recognition after the years of hard grafting. It was a rather unexpected and unusual way to finish the book, but Ryan was great fun, and I thoroughly enjoyed meeting him.

First Record Contributions from Donators

The following people have made a £1 donation to have their first record listed in the book, with the proceeds raised donated to Bowel Cancer UK.

Donation	First Record	Artist
Pauline Woods	Theme from M*A*S*H (Suicide Is Painless)	The Mash
Stacy Cuthbert	I Love Your Smile	Shanice
Avril Rooney	Diamond Dogs	David Bowie
Terry Hurley	I'm Mandy Fly Me	10cc
Melanie De Castro Pugh	Karma Chameleon	Culture Club
Sue McGinty	To Cut a Long Story Short	Spandau Ballet
Ali Saunders	Is There Something I Should Know?	Duran Duran
Bob Dunning	The Pleasure Principle	Gary Numan
Nancy Langfeld	Greatest Hits	Elton John
Karen Marrubi	Wuthering Heights	Kate Bush
Gary Tarling	The Killing Moon	Echo & The Bunnymen
Gaynor Williams	Sugar Sugar	The Archies
Gillian Scott	Galloping Home (Theme From Black Beauty)	Jack Parnell & His Orchestra
Lily Elsayed	The Psychedelic Furs	The Psychedelic Furs
Cath Dennis	The Dark Side of the Moon	Pink Floyd
Paul Dennis	Live!	Status Quo
Barb Cropper	Joy to the World	Three Dog Night
Tina Atkins	Brown Girl in the Ring	Boney M
Mike Atkins	Skweeze Me, Pleeze Me	Slade
Tizzer	Top of the Pops	The Rezillos
Matt Saunders	Railway Stories by Rev. W. Audrey	narrated by Johnny Morris
Pete Cole	So Good To Be Back Home Again	The Tourists
Sara Williams	Funky Gibbon	The Goodies
Susan Bowles	Ice Ice Baby	Vanilla Ice
Ellis Meredith-Owen	Bohemian Rapsody	Queen
Steve Webster	The Lone Ranger	Quantum Jump

Donation	First Record	Artist
Becky Chambers	I'm Still Standing	Elton John
Janet Cowie	Chirpy Chirpy Cheep Cheep	Middle Of The Road
Helen Johnson	(Marie's The Name) His Latest Flame	Elvis Presley
Bill Johnson	Please Please Me	The Beatles
Mick Mahoney	Trocadero	Showaddywaddy
Alan Hardy	My Sharona	The Knack
Lisa Dunn	Video Killed the Radio Star	The Buggles
Richard Spencer	British Steel	Judas Priest
Michelle Ranicar	Caribbean Queen	Billy Ocean
Adam Green	Stand and Deliver	Adam and the Ants
Geoff Little	Strangers in the Night	UFO
Paul Harbour	Ernie	Benny Hill
Steve Cann	Tom Hark	The Piranhas
Jacky B Summerfield	To Cut a Long Story Short	Spandau Ballet
Pauline Redman	Barbados	Typically Tropical
Cathi Simpson	The First Cut Is The Deepest	Rod Stewart
Pete Logan	Living in the 70s	Skyhooks
Sus Sullivan	Albatross	Fleetwood Mac
Bruce Watermann	Wooden Heart	Joe Dowell
Richard Morgan	A Question of Balance	The Moody Blues
Mark Farmer	Everyday	Slade
Neil Barker	Parallel Lines	Blondie
Paul Cox	Mouldy Old Dough	Lieutenant Pigeon
Kevin Clarke	Piledriver	Status Quo
Mike Starner	War	U2
Michael Winkelmann	Future Legends	Fruupp
Diane Blackburn	In Zaire	Johnny Wakelin

***** THE END *****

Lightning Source UK Ltd.
Milton Keynes UK
UKHW020848080519

342309UK00003B/17/P